Evaluation
of Cellulose Ethers
for Conservation

Research in Conservation

1990

3

R. L. Feller
M. Wilt

Evaluation
of Cellulose Ethers
for Conservation

THE GETTY
CONSERVATION
INSTITUTE

Library of Congress Cataloging-in-Publication Data

Feller, Robert L.
 Evaluation of cellulose ethers for conservation / R.L. Feller, M.
 Wilt.
 p. cm. -- (Research in conservation : 3)
 Includes bibiographical references.
 ISBN 0-89236-099-2 : $16.00
 1. Cellulose ethers. I. Wilt, M. (Myron) II. Title.
III. Series.
QD323.F45 1989
069' .53--dc20 89-16947
 CIP

The Getty Conservation Institute

The Getty Conservation Institute (GCI), an operating program of the J. Paul Getty Trust, was created in 1982 to enhance the quality of conservation practice in the world today. Based on the belief that the best approach to conservation is interdisciplinary, the Institute brings together the knowledge of conservators, scientists, and art historians. Through a combination of in-house activities and collaborative ventures with other organizations, the Institute plays a catalytic role that contributes substantially to the conservation of our cultural heritage. The Institute aims to further scientific research, to increase conservation training opportunities, and to strengthen communication among specialists.

Research in Conservation

This reference series is born from the concern and efforts of the Getty Conservation Institute to publish and make available the findings of research conducted by the GCI and its individual and institutional research partners, as well as state-of-the-art reviews of conservation literature. Each volume will cover a separate topic of current interest and concern to conservators.

Table of Contents

Authors

Dr. Robert L. Feller is currently Director Emeritus of the Research Center on the Materials of the Artist and Conservator, Mellon Institute, Carnegie Mellon University, Pittsburgh, Pennsylvania following a career of thirty-eight years of research concerning the long-term stability of organic polymers and pigments related to the conservation of museum objects. He is coauthor of the book *On Picture Varnishes and Their Solvents*, reprinted in 1981, and editor of Volume 1, *Artists' Pigments, A Handbook of Their History and Characteristics*, published in 1986 by the National Gallery of Art, Washington, D.C. He is a Fellow of the International Institute for the Conservation of Historic and Artistic Works and an Honorary Fellow of the American Institute for the Conservation of Historic and Artistic Works.

Dr. Myron H. Wilt, who carried out the major laboratory studies on this project, was section supervisor and research consultant on polymer characterization and physical testing at the Research Laboratory, United States Steel Corporation, Monroeville, Pennsylvania for twenty-two years prior to his retirement. Earlier, he was associated with the Monsanto Company working on special polymers and also with the Kappus Company and the United States Steel Fellowship at the Mellon Institute on a variety of research problems that led to numerous patents and publications.

Disclaimer

In order to specify accurately the particular materials and experimental procedures employed, various commercial products are specifically named throughout this publication. Such identifications do not imply recommendation, endorsement, or condemnation by the authors or by the publisher, nor do they imply that particular products are the best available for the purpose.

The present research was not focused on evaluating one particular product relative to another but was intended instead to illustrate the properties of the various generic chemical types of cellulose ethers. In order to ascertain whether differences between two similar products are indeed significant, many more measurements on each individual sample would have had to have been made, the experimental variability noted, and the statistical significance of the results evaluated. This was rarely done in this survey. Instead a number of chemically similar polymers varying in commercial source, molecular weight or degree of substitution were chosen in order that the behavior of a given generic type of polymer, and the range of variation that might be encountered, would be revealed. The identification of the specific polymers tested has been retained so that the number of materials evaluated would be apparent and so that, when different properties were measured on the same material, this too would be apparent.

Acknowledgments

The Research Center on the Materials of the Artist and Conservator, Mellon Institute, Pittsburgh, is pleased to have had the exceptional opportunity, through a contract from the Getty Conservation Institute, to investigate the stability of a broad class of polymer that has hitherto received only limited evaluation in the conservation literature: cellulose ethers. The authors appreciate the kindness of manufacturers in generously supplying samples, literature and answers to questions. Special thanks go to Dr. Robert Gelman of Hercules Research Laboratory and to Dr. Nitis Sarkar of the Dow Chemical Company for their valuable advice and criticism concerning numerous technical matters throughout the manuscript. Professor Cathleen Baker kindly read and criticized the initial draft. Comments of F.B. Crowder of Union Carbide are also much appreciated. Various publishers are gratefully acknowledged for their kindness in granting permission to use graphs of data that have been previously published.

Dr. Jonathan Arney graciously gave permission to present key results (Chapter 4) from the investigation sponsored by the National Museum Act in 1980–1981, previously unpublished. As well as preparing the infrared spectra, John Bogaard carried out experiments on the discoloration of thin films and also of sizes applied to paper (Figures 6.4–6.7). Mary Curran assembled and checked the bibliographic entries and Sandra Melzer typed the many drafts with much patience and skill.

Foreword

Since the scientific research program of the Getty Conservation Institute began, it was considered to be very important to undertake studies in the long-term stability of conservation materials, specifically surface coatings, consolidants, and adhesives. We were therefore very pleased that the Research Center on the Materials of the Artist and Conservator of the Mellon Institute, under the direction of Dr. Robert Feller, agreed to undertake a study on the aging behavior of cellulose ethers, since they are widely used and have never been fully evaluated.

This report is the result of a three-year research program. It describes the chemical character of cellulose ethers as a general class of polymers and establishes an approximate ranking of the relative stability of each generic chemical subclass. Ranking the thermal stability of the polymers with respect to color change and loss in degree of polymerization led to the conclusion that as generic chemical classes, methylcellulose and carboxymethylcellulose appear to be the most stable of the cellulose ethers. Water-soluble ethylhydroxyethylcellulose apparently also possesses good stability. Of questionable long-term stability are hydroxyethylcellulose and hydroxypropylcellulose. Ethylcellulose and organic-soluble ethylhydroxyethylcellulose proved to be of poor stability, potentially undergoing marked changes in twenty years or less under normal museum conditions.

An important additional conclusion reached here, as well as in an earlier investigation, is that considerable variations in stability can occur within a generic chemical class from differences in the basic raw material, a natural product from plants, which is not a uniform, manufactured, chemical substance. Further variations can exist due to different manufacturing processes or commercial sources. Hence, commercial products must be evaluated individually to determine the most stable of a given generic type. Nonetheless, we believe the conclusions expressed here to be valid with regard to the relative stability of the generic chemical classes of cellulose ethers.

We hoped that more definitive answers could have resulted from this initial enquiry, however, this report still constitutes the most comprehensive presentation of the properties of this class of materials as it relates to conservation. Hopefully it will be an important tool assisting in the daily decision process in the conservation laboratory.

Frank D. Preusser
Associate Director, Programs
Getty Conservation Institute

1 Introduction

Cellulose ethers, particularly those that are water-soluble, constitute a class of polymers that have attracted considerable interest for certain conservation applications. Unfortunately, only limited information has been available concerning their potential long-term thermal and photochemical stability. Moreover, there are many varieties of commercially produced cellulose ethers, and numerous questions have arisen concerning the suitability of particular products for given applications. This monograph first reviews the physical and chemical properties of cellulose ethers as reported in the technical literature and second, it reports the results of a series of studies on their thermal and photochemical stability. In particular, accelerated aging tests were conducted to evaluate the tendency of these materials to discolor and to diminish in molecular weight. Included in this report are studies on the water-soluble polymers: methylcellulose (MC), methylhydroxypropylcellulose (MHPC), hydroxypropylcellulose (HPC), water-soluble ethylhydroxyethylcellulose (WS-EHEC), sodium carboxymethylcellulose (CMC), and hydroxyethylcellulose (HEC). Laboratory studies and a literature search were also conducted to evaluate the stability of two organic-solvent-soluble types: ethylhydroxyethylcellulose (OS-EHEC) and ethylcellulose (EC).[1]

Objectives

The first objective of this report is to provide information about the chemical nature of the many cellulose ethers available; the processes by which they degrade under the influence of heat, light, and enzymes; and the reasons one product often differs from another. References to pertinent technical literature are provided so that those wishing to explore the subject further can learn more about the advanced techniques applied in the study of these materials.

The second objective of the study—the primary objective of the laboratory program—is to propose a relative ranking of eight generic chemical classes of cellulose ethers with respect to (1) thermally induced discoloration, (2) loss of weight, (3) loss of degree of polymerization, and (4) formation of peroxides and to make a judgment as to the potential long-term response of these materials. These experiments are presented so that the conservator and conservation scientist can perform additional tests in order to elucidate specific questions raised by these introductory studies. No attempt has been made to determine precisely the merit of individual commercial products of the same generic chemical class with respect to their relative stability, nor has it been an objective of this report to evaluate their utility or effectiveness in particular conservation practices.

A search of the chemical literature was made to assemble information concerning the preparation, degradation resistance, and chemical, physical, and mechanical properties of the ethers. While these topics are addressed reasonably well in the brochures supplied by the manufacturers and in a few textbooks, much of the available information requires interpretation in order to serve the specific needs of the conservator. Information on the degree to which the available hydroxyl groups in cellulose have been converted to ether structures is of particular interest because this affects solubility in various solvents as well as resistance to enzymatic attack. This fundamental aspect, the "degree of substitution" (DS) of cellulose, is discussed at length in "Properties of Cellulose Ethers" (Chapter 2).

AATA Survey

Background information on the uses of cellulose ethers in conservation is based on a search of *Art and Archaeology Technical Abstracts (AATA)* for the period 1966 to 1988. This information is supplemented by a questionnaire sent to members of the Book and Paper Group of the American Institute for Conservation. The present report, however, stresses the physical and chemical properties of the materials, rather than the ways in which they can be or have been applied in conservation practice.

Art and Archaeology Technical Abstracts (AATA) provides a valuable resource of practical information on which ethers have been used and for what purposes. The details and results of the survey are given in Appendix A. The ethers most widely used by conservators are methylcellulose (MC), hydroxypropylcellulose (HPC), and carboxymethylcellulose (CMC). Applications include use as adhesives, sizes, consolidants, and poultices. A useful bibliography of applications in conservation, about twenty-five references, appears in Horie's *Materials for Conservation* (1987).

Questionnaire to Conservators

To provide state-of-the-art information, a questionnaire was sent to 467 members of the Book and Paper Group of the American Institute for Conservation. Details concerning the questionnaire and the replies appear in Appendix B. The responses were most gratifying; many thoughtful comments were made and questions asked reflecting the concerns about the long-term stability of cellulose ethers. Certain issues raised by the respondents were incorporated into the plans of the laboratory research described herein. The conservators' responses had great influence on the design of this report as an introduction to the chemistry of cellulose ethers as well as reference book for the practitioner.

Reported Aging Studies on Cellulose Ethers

Only a few publications in the conservation literature have reported extensive tests on the aging of cellulose ethers. Some of the better known references are cited here. Zappala-Plossi (1976/1977) found, following 9 and 18 days of aging at 80 °C and 65% relative humidity (RH), that methylhydroxyethylcellulose (Tylose® MH from Hoechst)[2] and two pure methylcelluloses did not lose solubility or increase the loss of the degree of polymerization (DP) of cellulose in test papers polymer-coated to the extent of 2 to 11% gain in weight. The treated papers may possibly have been protected from loss of DP. Two of the products tested, however, were initially somewhat colored and were observed to discolor significantly when thermally aged. When the container of these was inspected after three years under normal storage conditions, considerable yellowing had occurred. Such observations serve to emphasize the fact that products of low quality can be encountered.

In another study (Zappala-Plossi and Santucci 1969), a formulation based on hydroxyethylcellulose (HEC, Gutofix® 600 manufactured by Kalle A.G.) proved to be satisfactory. A brief study of consolidants used in the treatment of illuminated manuscripts led Zappala-Plossi and Cirsostomi (1981) to conclude that methylcellulose (MC) with a high degree of substitution (DS), when dissolved in a mixture of two organic solvents—methylene dichloride and methanol—resulted in the least color change in porous paint, compared to ethylcellulose (EC), cellulose acetate, and poly(vinylacetate).

Employing carbon-arc exposures of 450 hours, Schaffer (1978) studied the photochemical aging of cellulose ether films applied to glass slides. The ethers included in her investigation were sodium carboxymethylcellulose (Cellosize® CMC P-75-M) and hydroxyethylcellulose (Cellosize WP-09), both products of Union Carbide. After aging, the ether films were still soluble, a not unexpected situation with materials that do not crosslink or tend to chain break. Blends with 10% to 20% polymers other than cellulose ethers were also mentioned: poly(vinylpyrrolidone), poly(vinylalcohol) (PVOH), and poly(ethylene oxide). A film of hydroxyethylcellulose (HEC) containing 10% poly(vinylalcohol) turned brown and became insoluble after aging. In boiling water this film produced a brown suspension without dissolving completely. The PVOH may have been responsible for the intense discoloration.

In a study devoted primarily to hydroxypropylcellulose (HPC), Hofenk-de Graaf (1981) included tests on sodium carboxymethylcellulose (CMC) and methylcellulose (MC) as well. In her investigation, 2% solutions of the ethers were brushed onto rag paper, which was then aged for three days at 105 °C. Although the strength and folding endurance of the paper was increased initially by the treatment, after aging, the papers (with the exception of the one treated with CMC) showed a marked reduction in those same properties. The effects of thermal aging upon the ethers themselves may have been masked in these experiments by the properties of the

paper. Several interesting case histories of the use of hydroxypropylcellulose (HPC) were also cited.

In a study by Baker (1984), Whatman #1 filter papers treated with two CMC products and one MC product were aged at 90 °C and 56% RH for 16 days. The treated papers showed a marked increase in folding endurance before aging. After aging, the papers treated with CMC showed a decided decrease in folding endurance, while the papers treated with MC did not. Papers treated with Cellofas® B-3500 (CMC) yellowed slightly after 16 days of aging. Although the precise weight of polymer added to the paper was not reported, the folding endurance data indicate that the properties measured were related more to the cellulose ether in the paper than to the paper itself. The acidity of the paper was relatively unaffected by treatment with the cellulose ethers.

At an annual meeting of the American Institute for Conservation, Feller (1981a) reported that, based on heat-aging studies, methylcellulose (MC) and carboxymethylcellulose (CMC) were found to be sufficiently stable for use in long-term applications; hydroxypropylcellulose (HPC) and hydroxyethylcellulose (HEC) were judged to be of intermediate stability. These conclusions were based on studies at the Research Center on the Materials of the Artist and Conservator at the Mellon Institute carried out by Jonathan Arney (Feller 1981b) in which the change in reflectance of cellulose ether powders at 95 °C was measured as a function of time. These data are supported by experiments in which the oxygen uptake of polymers aged by heat or under "daylight" fluorescent lamps was measured (see "Summary of Previous Investigation Supported by the National Museum Act," Chapter 4). At the completion of the 1981 meeting, the need for further work was stressed, a realization that led in part to the present report.

Masschelein-Kleiner and Bergiers (1984) tested a number of water-dispersible polymers used to protect silk during exposure to a xenon-arc lamp. The silk was treated with 2% solutions of the polymers. The authors concluded that methylcellulose (MC, Perfax® Methyl from Henkel) and methylhydroxyethylcellulose (MHEC, Tylose MH300 from Hoechst) posed no risk to the silk. Hydroxyethylcellulose (Natrosol® from Hercules) proved to be the only cellulose ether tested that seemed to have a damaging effect on the silk. Carboxymethylcellulose (CMC) was rejected as having no particular merit in these tests. It had been found unsatisfactory in previous studies (Masschelein-Kleiner 1971/1972).

This summary of previous accelerated aging tests on cellulose ethers indicates that some products may occasionally discolor. However, many of these tests were carried out on papers or textiles using solutions of the polymer so dilute that relative discoloration or embrittlement of the cellulose ether might scarcely have been noticeable. Because the behavior of the various products may not have been evident at so low a concentration, the tests that follow were designed specifically to measure the changes that cellulose ethers themselves undergo. Samples of sufficient size, mostly of the bulk powder, were employed so that the relative tendency of various

products to discolor, gain weight, develop peroxide, or decline in degree of polymerization could be determined.

Notes 1. Because of the repeated need to refer to particular polymers throughout the text, most of which have long names, they will sometimes be referred to by their abbreviations.

2. The registered trademark symbol, ®, will follow the product only the first time it appears in the text.

2 Properties of Cellulose Ethers

It would require several hundred pages to describe adequately the properties and uses of cellulose ethers. In the references, a few such texts are cited, but in general they do not present the information in a way that serves the conservator or conservation scientist effectively. The most authoritative discussions of convenient length can be found in the *Encyclopedia of Polymer Science and Technology* (1968) and in the *Encyclopedia of Chemical Technology* (Kirk, Othmer et al. 1968). Most of the remarks in the following brief review are based on these two sources.

The Structure of Cellulose

Cellulose is the primary constituent of wood, paper, and cotton. It is a carbohydrate made up of glucose units. These have an empirical formula, $C_6H_{12}O_6$, and can be given a cyclic structure, sometimes designated as a beta-D-glucopyranose or anhydroglucose unit (AGU):

Figure 2.1. Cyclopyranose structure of glucose.

When these units are hooked together through a "condensation reaction" in which a molecule of water is lost in forming each link, the structure of cellulose becomes:

Figure 2.2. Structure of cellulose where n equals the number of anhydroglucose units.

In this structure cellulose is shown, not as a polymer of glucose, but more precisely as a polymer of cellobiose. This compound is made up of two anhydroglucose units having alternating orientation with respect to the bridge oxygen bond. Nonetheless, the degree of polymerization (DP) of cellulose is customarily designated as the number of AGUs in the chain. The structure of cellulose is known as a "beta glucoside" as distinguished from starch, an alpha glucoside, the true polymer of glucose. In starch, the orientation of AGUs with respect to the oxygen bridge does not alternate.

For convenient reference, the locations of the carbon atoms in the glucose molecule are numbered as shown in Figure 2.1. Each AGU contains three hydroxyl (OH) groups. At carbon 6, there is a "primary" hydroxyl group; the OH there is attached to a carbon atom having at least two hydrogens. The hydroxyls on carbons 2 and 3 are classified as "secondary" hydroxyl groups; the OHs there are attached to a carbon with only one hydrogen. When cellulose is etherified, the hydroxyls are substituted by the etherifying reagent. The average number of hydroxyls substituted per AGU is known as the degree of substitution (DS), a key aspect in characterizing cellulose ethers. With three OH groups present, the maximum DS is three.

Etherifying reagents such as ethylene oxide (CH_2CH_2O) and propylene oxide introduce a hydroxyl group (see Fig. 2.3 and Equation c in Fig. 2.4). This can further react with the etherifying reagent, making it possible for each AGU to react with more than three molecules of such a reagent. In this situation the total number of alkylene oxide molecules that react with each AGU is known as molecular substitution (MS). Theoretically, there is no upper limit on MS. The DS and MS terminology is illustrated by the structure for a hydroxyethylcellulose (Fig. 2.3).

Figure 2.3. One of the possible structures for a cellobiose segment of cellulose substituted with hydroxyethyl groups.

In this diagram showing two AGUs, three of the six hydroxyl groups are substituted; hence the degree of substitution (DS) is 3/6 x 6/2 or 1.5. Note that this number is an average. Five molecules of ethylene oxide have been introduced into the two AGUs; again an average value, the molecular substitution (MS), is 5/2 or 2.5. The molecular weight of a cellulose ether molecule is dependent both on the average degree of polymerization of the cellulose and on the amount of substitution and the molecular weight of the substituent groups.

Substitution rarely occurs exclusively on one particular OH group in the AGU. Instead, it occurs at all three positions, but to different degrees. A detailed discussion of this process in various ethers is presented in Appendices G and H.

Manufacture of Cellulose Ethers

The presence of hydroxyl groups readily suggested to chemists that cellulose might be converted to useful derivatives by etherification. This reaction is expressed by the following:

$$ROH + R'Cl \longrightarrow ROR' + HCl$$

alcohol alkylchloride ether hydrogen chloride

where R is an organic radical such as the methyl (CH_3-), ethyl (C_2H_5-), or a more complex structure. The alcohol, ROH, represents one of the three OH groups in an AGU. In 1912 and 1913 the first experimental work was done on the methyl and ethyl derivatives of cellulose. This was soon followed by research that produced carboxymethylcellulose and hydroxyethylcellulose. In the 1920s the ethers were produced commercially in Germany and in the 1930s in the United States. After World War II they became well established, and conservators became interested in their possibilities.

There are many possible variations in the process of making cellulose ethers. In general, purified cellulose, derived from wood, cotton, or related scrap materials, is converted to "alkali cellulose" (Step a in Fig. 2.4) and then reacted with an etherifying reagent such as methyl chloride (Step b). During the preparation of alkali cellulose with concentrated sodium hydroxide and subsequent etherification, the crystalline regions of cellulose are usually extensively lost because of the disruption of the intermolecular hydrogen bonding.

Simplified general equations for the preparation of cellulose ethers are as follows (the desired product—an ether, ROR' —appears in Steps b or c):

Figure 2.4. Chemical steps in the synthesis of cellulose ethers.

Formation of alkali cellulose

$$R - OH + NaOH \longrightarrow RONa + H_2O \tag{a}$$

Formation of cellulose ether

$$R - ONa + Cl\,CH_3 \longrightarrow R - O - CH_3 + NaCl \tag{b}$$

or

$$R - OH + R_1CH - CH_2 \xrightarrow{\text{NaOH}} R - O - CH - CH_2OH \tag{c}$$

where R = anhydroglucose radical and R_1 = H or CH_3

If a mixed ether such as ethylhydroxyethylcellulose is to be produced, the two reagents—ethyl chloride (C_2H_5Cl) and ethylene oxide (CH_2CH_2O)—can be added either consecutively or as a mixture. The nature of the resultant product is dependent upon the molar ratio of the two etherifying agents (the ratio of the number of molecules of one to the other) and on the method of their addition (see "Solubility of Ethylhydroxyethylcellulose" below).

In general, an excess of etherifying agent over the minimum required for the desired degree of substitution must be used because organic by-products are formed. Table 2.1 provides a list of some typical reagents, co-products, and by-products. No major co-product such as NaCl is formed in etherification with ethylene oxide or propylene oxide because the alkali (NaOH) is only a catalyst (Equation c, Fig. 2.4). In any case, the alkali used must always be neutralized with an acid such as hydrochloric or acetic and the resultant salt must be removed from the reaction product. This is one of the principal reasons why a specification for minimum ash (inorganic) content is usually found in product descriptions.

Cellulose Ether	Etherifying Agent	Co-product	By-Products (Name and Formula)
Methyl (MC)	CH_3Cl	NaCl	Methanol, CH_3OH; Dimethyl ether, CH_3OCH_3
Ethyl (EC)	C_2H_5Cl	NaCl	Ethanol, C_2H_5OH; Diethyl ether, $C_2H_5OC_2H_5$
Hydroxyethyl (HEC)	Ethylene Oxide	None	Ethylene glycol, CH_2OHCH_2OH, and polymers thereof
Hydroxypropyl (HPC)	Propylene Oxide	None	Propylene glycol, $CH_3CH_2OHCH_2OH$, and polymers thereof
Carboxymethyl (CMC)	Chloroacetic Acid $Cl–CH_2–COOH$	NaCl	Glycolic acid, $HO–CH_2–COOH$

When purifying crude cellulose ethers, advantage can be taken of the fact that many are insoluble in hot water. These include the methyl, hydroxypropyl, and water-soluble ethylhydroxyethyl ethers. The approximate temperatures at which these ethers become insoluble in water (i.e., the cloud point) are given in Table 2.2. As will be discussed in later sections, the cloud point phenomenon is an important consideration in the preparation of cellulose ether solutions as well as in achieving satisfactory reversibility in applications by conservators. In general, the cloud point decreases as the degree of substitution of methyl and ethyl groups increases. In the range normally encountered, molecular weight has little effect on cloud point. A more extensive discussion of temperature and solubility effects is presented in "Solubility-Temperature Relationships" below.

Table 2.2. Typical cloud points of certain cellulose ethers.

Cellulose Ethers	Cloud Point °C
Methyl (MC)	56
Hydroxypropyl (HPC)	40–45
Ethylhydroxyethyl (WS-EHEC)	50

Comparison of Cellulose Ethers with Cellulose

It may seem possible to consider the water-soluble cellulose ethers as a water-soluble form of cellulose. However, cellulose ordinarily has a higher degree of polymerization (DP) than many of the ether products. For cellulose derived from cotton, for example, the number-average degree of polymerization (DP_n) may be about 2000 or even higher; for

cellulose derived from wood, the DP_n may be about 1000. Many of the low viscosity grade products have a weight-average DP (DP_w) of about 400; the DP_n may be less than half this value. For some commercially available cellulose ethers, DP_n may be as low as 50. (A discussion of the meaning and relationship of various expressions for DP and molecular weight appears in Appendix I.)

As mentioned, in the preparation of cellulose ethers the crystallinity of the cellulose tends to be destroyed by treatment with alkali. In addition, in order to produce various viscosity grades of cellulose ethers, the DP of the starting cellulose can be selected or the DP can be diminished by air oxidation or by treatment with chemical oxidizing agents before etherification. Further loss in DP can occur during the chemical processing that leads to etherification. Thus, cellulose ethers tend to have a lower DP than the cellulose from which they are derived. These are the initial reasons why cellulose ethers cannot be regarded simply as water-soluble versions of cellulose.

In a more fundamental sense, the process of etherification "dilutes" the cellulose with the etherifying group so that the final product contains only a proportion of the starting cellulose structure (having the empirical formula $C_6H_{12}O_6$). To illustrate this point, the content of the anhydroglucose structure in some cellulose ethers has been calculated and presented in Table 2.3. As can be seen, the cellulose content of some types is surprisingly low. Clearly, it is difficult to consider hydroxypropylcellulose as a water-soluble cellulose.

Table 2.3. *Content of cellulose structure in various commercial cellulose ethers.*

Ether	DS	Average Molecular Weight (MW) of Substituted AGU*	Percent Cellulose Component in Substituted AGU
Methylcellulose (MC)	1.8	187	86.6
Sodium carboxymethylcellulose (CMC)	0.75	223	72.6
Hydroxypropylcellulose (HPC)	2.1**	406	39.9

* AGU = anhydroglucose unit, $C_6H_{12}O_6$ minus H_2O; formula weight 162.

** Molecular substitution, 4.5.

One final aspect of cellulose ethers, already alluded to, makes them considerably different from cellulose: they are less crystalline. They are generally more amorphous and rarely exhibit the crystalline morphology or fiber structure of cotton and bast-fiber cellulose.

In summary, the water-soluble cellulose ethers should not be regarded simply as water-soluble forms of cellulose. The ethers are derivatives of cellulose, containing only a fraction of the original cellulose structure in their molecular make-up. An idealized structure of some common cellulose ethers is given in Figures 2.3 and 2.5.

Specifications and Typical Properties

Some of the better-known brand names and manufacturers of cellulose ethers are listed in Table 2.4. The brochures supplied by the manufacturers (see Table 2.5) contain a wealth of information on the properties and commercial uses of the ethers. In reading these, the conservator should be aware of the difference between data on *typical properties* and *specifications*. Typical properties, such as viscosity and molecular weight, are aspects of representative products. Specifications are properties, such as ash, moisture content, or color, that are guaranteed by the manufacturer.

Specifications for the color of cellulose ether powders range from white to off-white. Noticeable color is generally undesirable for conservation applications. However, when applied at the low concentrations used in many conservation practices, color is often scarcely noticeable. Nonetheless, the color of some commercial products can be significant. Remember, when a substance is finely divided, it will appear lighter in color. It is wise to test the relative stability of the color of any cellulose ether, or for that matter any polymer, that is initially off-white.

Moisture specifications (as packed) can be as high as 8%. Because of the hygroscopicity of the ethers, it is recommended that they be stored in air-tight containers. Those that have high equilibrium moisture contents can become inconveniently soft at high humidities.

Figure 2.5. Idealized structure of some common cellulose ethers.

Hydroxypropylcellulose (HPC)

Carboxymethylcellulose (sodium salt) (CMC)

Methylcellulose (MC)

Table 2.4. Some brand names of cellulose ethers.

Cellulose Ether	Brand ®	Manufacturer
Methylcellulose (MC)	Methocel A	Dow
	Culminal	Aqualon
	Tylose MB	Hoechst
	Methofas M	ICI
Methylhydroxypropylcellulose (MHPC)	Methocel E, F, J, and K	Dow
Sodium carboxymethylcellulose (CMC)	Cellulose Gum	Aqualon
	Cellofas	ICI
	Tylose C	Hoechst
Hydroxypropylcellulose (HPC)	Klucel	Aqualon
Ethylhydroxyethylcellulose (EHEC)	EHEC (organic solvent soluble, OS)	Hercules
	Modocoll E, Ethulose (water soluble, WS)	Mo och Domsjo
Hydroxyethylcellulose (HEC)	Natrosol	Aqualon
	Cellosize	Union Carbide
	Tylose H	Hoechst
Ethylcellulose (EC)	Ethocel	Dow
	Ethylcellulose	Hercules

Table 2.5. Cellulose ether manufacturers' brochures reviewed.

Manufacturer	Product Name	Year
Hercules, Inc. 910 Market Street, Wilmington, Delaware 19899	Ethylcellulose	1974
Aqualon Company PO Box 15417, Wilmington, Delaware 19850	Natrosol	1979
	Klucel	1979
	Cellulose Gum	1978
	Culminal	
Dow Chemical Co. Midland, Michigan 48640	Ethocel Handbook	1978
	Methocel	1975
Union Carbide Corporation, Chemicals and Plastics Division 270 Park Avenue, New York, New York 10017	Cellosize	1978
Hoechst Frankfurt am Main, W. Germany	Tylose	1981
Mo och Domsjo A.B. Ornskoldsvik, Sweden	Modocoll Handbook	1978

With the exception of sodium carboxymethylcellulose, ash specifications are usually low. A maximum ash content of 0.5% has been specified for standard grades of Klucel (HPC); 0.2% (excluding silica) is specified for food grades. Aqualon specifies a maximum ash content of 5.5% (as Na_2SO_4) for their hydroxyethylcellulose product, Natrosol.

The ash content of CMC, an ether usually encountered as the salt of an organic acid, depends on the degree of substitution, because this influences the amount of sodium present in neutralizing the carboxylic acid groups. This product is nearly always sold as the sodium salt of carboxymethylcellulose and is used in this readily soluble form. However, in common parlance, the material is referred to simply as carboxymethylcellulose (CMC), with the understanding that it is the sodium salt. Throughout this text the reference will always be to the sodium salt, unless specifically noted otherwise. Nonetheless, the more common designation, CMC, will usually be employed, without specifying each time that we are referring to the sodium salt.

In these as with most polymeric products, a key specification is the "viscosity grade." This provides a rough indication of the size of the molecules and the degree of polymerization. Manufacturers often sell the polymers in high (H), medium (M), or low (L) viscosity grades. Viscosity measurements of water-soluble cellulose ethers are generally based on 1 or 2% solutions, frequently ranging from 20 to 100,000 centipoise (cP) at 25 °C. Conservators customarily employ grades ranging from 400 to 4000 cP at 25 °C. In Figure 2.6 the viscosities of solutions of several grades of methylcellulose are compared with the viscosities of solutions of three natural gums familiar to the conservator.

Most polymers have a product code that is related to their major properties. For example, CMC 7H4 from Hercules (now supplied by Aqualon) has a DS of about 0.7 (indicated by the 7), a high viscosity (H), and a maximum 1% solution viscosity of 4000 cP (indicated by the 4). Methocel A4C from Dow is a methylcellulose (designated by the A) with a solution viscosity of 400 cP (4C). A list of products familiar to conservators is in Appendix C.

Figure 2.6. Comparison of viscosities of solutions of several grades of methylcellulose and three natural gums (after Mantell 1985).

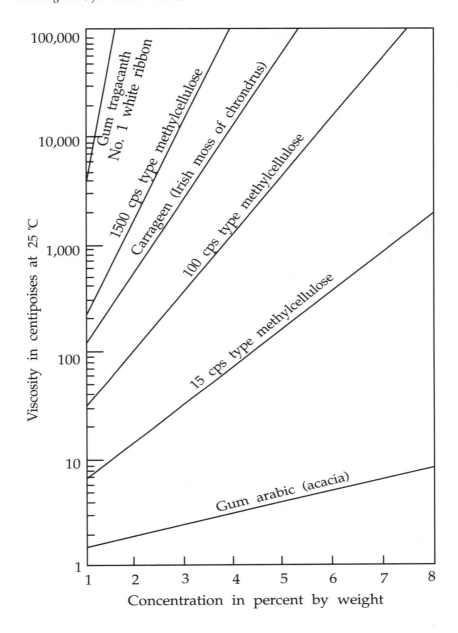

Solubility of Cellulose Ethers

Influence of Degree of Substitution (DS)

Cellulose ethers of moderate to high molecular weight are insoluble in water. As a rule, as the DS increases, the polymers gradually pass through a stage of solubility in dilute alkali (those with a DS of up to about 1.0), then through a water-soluble stage (about DS 1.0–2.3), and finally attain an organic-solvent-soluble stage (DS 2.3–3.0). Such DS ranges are, of course, only approximate.

The trend toward organic-solvent solubility is gradual and differs for individual ethers. The ionic character of CMC, for example, makes its behavior exceptional. Moreover, the uniformity of substitution along the cellulose chain can have a major influence on solubility. Nonetheless, some representative figures are cited, taken from Kirk, Othmer et al. (1968).

Methylcellulose (MC) of DS 0.1 to 1.1 tends to be soluble in dilute (6 to 8%) sodium hydroxide. The DS is about 1.4 to 2.0 for water solubility, the range commercially available and often used by conservators. Almost completely substituted methylcellulose (DS 2.4–2.8) is insoluble in water, but soluble in organic solvents. The latter types can often be applied in mixtures of chloroform or methylene dichloride and methanol or ethanol. An idealized structure is shown in Figure 2.5c.

Ethylcellulose (EC) of DS 0.8 to 1.7 is water soluble, but control of ethylation to obtain such a product is difficult. Highly substituted EC (DS 2.4–2.8) is soluble in organic solvents. Hercules offers a K-type polymer with a DS of 2.28 to 2.38, an N-type with a DS of 2.42 to 2.53, and a T with a DS of about 2.53. Ethylcellulose products are rarely used by conservators. As will be discussed later, technical studies show that the products oxidize readily.

The sodium salt of carboxymethylcellulose (CMC) is water soluble, a property enhanced by its ionic nature. Sodium salt is the form in which the polymer is generally sold and used; the acid form is insoluble. Commercial products have a DS in the range of 0.4 to 1.4, with a DS of 0.7 to 0.8 perhaps the most common. At a lower DS, 0.05 to 0.25, the product is soluble only in aqueous sodium hydroxide. Products with a DS as high as 2.8 have been prepared, but their properties have not been extensively reported. An idealized structure is shown in Figure 2.5b.

In the preparation of hydroxyethylcellulose (HEC), the introduction of ethylene oxide into cellulose generates a primary hydroxyl group at a new site that is more reactive than the secondary hydroxyls of cellulose. As a consequence, poly (ethylene oxide) "side chains" result. This can be seen in the two longest substituent chains in the molecular structure illustrated in Figure 2.3. The term "molar substitution" (MS) has been coined to describe the average number of moles (gram molecules) of a reagent such as ethylene oxide that have attached to each anhydroglucose unit (AGU). Hydroxyethylcelluloses of DS 0.11 to 0.31 (MS 0.17–0.42) are soluble in 7% sodium hydroxide; those of DS 0.66 to 1.66 (MS 1.0–4.1) are soluble in water. In

any manufacturing process, the MS bears a relationship to the DS. For example, when producing an ether with a ratio of 10 moles of ethylene oxide to one mole of anhydroglucose units, the result is a polymer with a DS of 1.66 and MS of 4.1. Many commercial products have a DS of about 0.66 to 1.33 and an MS of 1.5 to 3.0. The production of hydroxyethylcellulose with a high DS has not been reported extensively. The following section contains a further discussion concerning the solubility of ethylhydroxyethylcellulose. (Details regarding the position of substitution are discussed in Appendix G.)

The introduction of propylene oxide into cellulose to produce hydroxypropylcellulose (HPC) introduces an additional type of secondary hydroxyl group (see Equation c, Fig. 2.4). At a low MS (0.15–0.35), hydroxypropylcellulose products are soluble in dilute alkali. Commercially available water-soluble products have an MS range of 3.5 to 4.5. Products in the high MS range are soluble in many organic solvents. Specific information on the DS and MS of HPC polymers is not always provided by the manufacturer. Although hydroxypropylcelluloses have been used by conservators, their properties and aging behavior have not been reported extensively. An idealized structure is shown in Figure 2.5a.

In summary, the ranges of DS cited in these examples is only approximate because solubility is influenced by the distribution of molecular weights of various fractions in a given product and by the extent and uniformity of substitution within particular products or molecular weight fractions. Sarkar (1979) provides an excellent discussion of how such factors influence the incipient precipitation temperature (IPT) and the cloud point of methyl and hydroxypropylmethyl ethers.

Solubility of Ethylhydroxyethylcellulose

Two types of ethylhydroxyethylcellulose (EHEC) are available. An organic-solvent-soluble (OS) variety has been produced for some years (first by Hercules, now by Aqualon) under the designation EHEC. The other is a water-soluble (WS) type, which conservators have encountered as Ethulose, currently the trade name used in the United States for Modocoll products, the brand name of Mo och Domsjo A.B., Ornskoldsvik, Sweden.

In an article by Jullander (1957), the Modocoll-type polymer, produced commercially since 1945, is shown to contain both ethyl and hydroxyethyl ether groups. The possibility of hydroxyethyl (HOC2H4-) groups being present is suggested by the fact that 25% of the ethylene oxide reacted is reported to be attached to a previously introduced hydroxyethyl group. Literature available from Aqualon indicates that their product contains ethyl and ethylhydroxyethyl groups, but no hydroxyethyl groups. This difference in structure helps explain the differences in solubility between the two products.

Cohen et al. (1953) indicate that the organic-soluble type has a much higher degree of ethyl group substitution (DS 1.9–2.2) than ethylene oxide substitution (0.35–0.65). For the water-soluble ether, Modocoll E, on the other hand, the respective

values are 0.68 (ethyl) and 0.87 (ethylene oxide). Thus, the OS-EHEC has a much higher ratio of ethyl (hydrophobic) to ethylene-oxide-derived (hydrophilic) groups (about 4) than does Modocoll E (about 1.8). Mo och Domsjo also produces a Modocoll M grade, which is said to be soluble in both water and organic solvents. This product is reported to have a DS of 1.33 of ethyl, and 0.51 of hydroxyethyl; the ratio of ethyl to hydroxyethyl is thus 2.60. The brief process descriptions for the preparation of OS-EHEC and the water-soluble Modocoll product are similar, yet it is obvious that a much higher ratio of ethyl chloride to ethylene oxide is used in the preparation of OS-EHEC or that it is prepared by ethylation of hydroxyethylcellulose. A patent issued to E.D. Klug of Hercules (1952) contains details of the preparation of OS-EHEC and confirms the above speculations.

From the Jullander (1957) article, it appears that the water-soluble Modocoll polymers may have been developed as products to be competitive with the water-soluble methylcelluloses or hydroxyethylcelluloses. Whether to avoid patent problems or to make greater use of ethyl chloride, the synthetic approach to Modocoll takes advantage of the increase in water solubility achieved by partial ethylation of cellulose with ethyl chloride and then further enhances the solubility in water by reaction with ethylene oxide.

Organic-soluble EHEC is sold by Aqualon as "a film former designed for use with aliphatic hydrocarbons." It is recommended for use in printing inks (screen process and rotogravure), as a clear coating for metallized plastics, wood floors, and paper, and as an additive to prevent pigment from floating and to control flatting of varnishes.

Stability of Cellulose Ethers as Reported in Manufacturers' Brochures

All manufacturers indicate in their literature that ethers are subject to degradation by heat, light, and enzymatic agents. One may assume they refer to the stability of cellulose ethers under the often severe conditions of industrial usage. Unfortunately, the literature does not address the long-term stability of ethers under the rather mild conditions of application that are of major concern to the conservator.

From the technical literature, one gains the impression that etherification of cellulose tends to lead to a loss of thermal stability with respect to oxidative deterioration. This tendency increases with the degree of substitution and particularly with the extent of molar substitution. The process of etherification can result in a decrease in the degree of polymerization, a loss of crystallinity, and an increase in organic "pendant" groups attached to the cellulose structure. Intentional oxidation of the cellulose chain is the common method of lowering molecular weight during manufacture. In the process, carbonyl groups may be inadvertently introduced, leading to increased instability. It is these factors that contribute to the impression that cellulose ethers tend to be less thermally stable than, for example, cotton cellulose. Methylcellulose may be regarded as an exception.

At ambient temperatures, the materials are regarded as relatively stable. However, if the ethers (or their solutions) are used at moderately high temperatures (50–150 °C), manufacturers recommend the incorporation of antioxidants. If ethers are molded or extruded, stabilizers must be added to prevent degradation at processing temperatures of 275 to 350 °C. Manufacturer's literature rarely indicates whether or not products contain heat stabilizers; the implication and general evidence is that they usually do not.

Cellulose ethers are generally regarded as "resistant" to exposure to sunlight. Nonetheless, if a cellulose ether is to be exposed outdoors for long periods, the commercial literature usually recommends the use of an ultraviolet light stabilizer.

The need to protect aqueous solutions of the ethers from the enzymes released by microbiological agents is well recognized, particularly when large volumes of solutions (100–1000 gallons) are involved in an industrial application. If the solution is to be used over a period of days or weeks, the addition of a biocidal agent is recommended. It is generally known, however, that the more highly substituted the ether and the more uniform the substitution, the more resistant the solution is to degradation by enzymes. Further comments on enzymatic attack will be found in Appendix E. In the experimental phase of the present investigation, no tests of microbiological sensitivity were made.

It is the ambiguity between what the industrial literature states about the stability of cellulose ethers in practical applications, usually involving modest lifetimes, and the question of their potential long-term stability under normal museum and archival conditions that prompted the Getty Conservation Institute to sponsor the present investigation.

Effect of pH on Cellulose Ether Solutions

The pH of a cellulose ether solution is of importance for two reasons; first, because of the effect on hydrolytic breakdown, and second, because of the possible effect of pH on solution viscosity. With the exception of CMC, all of the water-soluble products give solutions with relatively stable viscosity over the range of pH 3 to 11. Carboxymethylcellulose is an exception because it is ionic in character (the sodium salt of weakly acidic groups). The solution viscosity of CMC increases below pH 4, when the free acid is formed. At about pH 3, the free acid is converted further into a cyclic form (lactone).

All cellulose ethers are susceptible to the hydrolytic effect of both acid and alkali. Because the ethers are derivatives of cellulose, the chemical process is much the same as with cellulose itself.

If possible, the conservator should maintain substrates close to neutrality (pH 7) before and after treatment with a cellulose ether. Excessive acidity or alkalinity will lead to a decrease in the molecular weight of the polymer, lowering its physical strength.

Degradation by Acid

Vink (1966) of the University of Uppsula investigated the rate of hydrolysis of several cellulose ethers in hydrochloric, nitric, and sulfuric acids. He found the activation energies for HEC, MC, and CMC to be similar: 31.1, 31.7, and 31.0 kcal/mole, respectively. These values are in good agreement with previously reported values for the hydrolysis of the glycosidic bond in cellulosic materials.

The rate constants of hydrolysis were shown to be related not to the molar concentration of the acid in solution but more precisely to Hammett's (1970) acidity function, H_o. This function is based on the absorption of a colored acid-base indicator dye in the acid-containing solution in which H_o = constant – log absorbance of indicator dye. H_o is thus similar to pH, which is –log (H_3O^+), the negative logarithm to the base 10 of the hydrogen ion concentration.

The rate constants among the three ethers differed by no more than a factor of 1.86. Thus, in 2M hydrochloric acid at 25 °C, the relative rate constants (expressed as 10^7 K per minute) were 6.73 (HEC), 8.13 (MC), and 4.43 (CMC). In an earlier publication, Vink (1963) stated that the constants for the rate of degradation of HEC and CMC at concentrations of HCl from 0.25M to 3.5M were "nearly the same." The HEC polymer involved was from Union Carbide with DS 0.88, MS 1.67 and viscometric DP (DP_v) ca. 2200. The MC polymer was Methocel 8000 from Dow Chemical International; DS 1.74, DP_v ca. 2000. For the CMC: DS 0.96, DP_v ca. 4400.

The rate of chain breaking was approximately linear with time, obeying the equation

$$2/DP_{v,t} - 2/DP_{v,o} = kt$$

at least up to a point where the weight-average DP (DP_w, similar to DP_v, see Appendix I) had fallen from about 2500 to about 450. In this equation $DP_{v,o}$ is the initial value, and $DP_{v,t}$ is the value after the passage of time, t; k is the specific reaction constant (the significance of this equation in the acid hydrolysis of cellulose has been discussed by Feller, Lee, and Bogaard 1986).

Gibbons (1952) carried out an extensive investigation of the degradation of methylcellulose at 20 to 50 °C in 1.2N to 1.8N hydrochloric acid. He concluded that the rate of hydrolysis decreased to about half when the methoxyl content was increased from 17 to 30%. Because one of the principal mechanisms of degradation of cellulose and its ethers is by acid hydrolysis, Gibbons' results imply that the cellulose ethers are more stable in this respect than cellulose.

One factor that must be taken into account is that the ethers are almost completely noncrystalline and in water are molecularly dispersed; hence, the bonds are more accessible to acid attack than they would be in the case of cellulose fibers. Even so, because the strength of a linear polymer will be reduced to a negligible level by breakage of less than 1% of the bonds, it is likely that the difference in crystallinity between the ethers and cellulose itself has little practical effect on the rapidity of loss of tensile strength due to acid attack.

In testing the effect of pH on the degradation of cellulose ethers in solution, steps should be taken to reduce the possibility that any observed fall in molecular weight may be due to enzymatic attack. A biocide should be added to inhibit possible contaminants.

In summary, one may conclude from a study of the technical literature that the rate of acid-catalyzed hydrolysis proceeds by the same mechanism in cellulose ethers as with cellulose and that the rate is not much affected (perhaps no more than a factor of two) by the type of ether or degree of substitution. Are cellulose ethers more resistant to acid attack than cellulose? When both are in solution, the evidence suggests that they are. But it is not an easy matter to make this judgment when comparing the behavior of an amorphous cellulose ether to a heterogeneous case involving acid attack on cellulose fibers.

Initial pH

When cellulose ethers as received from the manufacturer are dissolved in distilled water, the pH of the resulting solutions may not be neutral. Zappala-Plossi (1976/1977) was one of the first conservation scientists to report the example of pH values in methylcellulose solution varying from 3.4 to 8.73. In the present studies, pH values of 6.0 to 5.8 were measured in Ethulose (WS-EHEC), 5.7 to 5.0 in Culminal (MC), and 8.2 to 7.0 in Natrosol 250MR (HEC) solutions. The pH of solutions often increased or decreased within this range over a period of three to seven days. Kirk, Othmer et al. (1968) report that CMC in which every –COOH group has been reacted to form the sodium salt will have a pH of 8.25. (The reader may recall an interest at one time in deacidifying books through the application of CMC; Raff et al. 1966,1967.)

The reasons for divergence from strict neutrality are not difficult to understand. Often there are traces of impurities such as sodium acetate present in commercial products. In general, however, the solutions are not likely to be strongly buffered; instead, the pH is likely to drift in a matter of a day or two and to be significantly affected by other substances that may be present in a size or adhesive formulation. Nonetheless, attention is drawn to the slight variations in pH that can be encountered in dilute solutions of cellulose ethers.

Properties of Films

Mechanical Properties

Properties of some typical cellulose ether films are summarized in Table 2.6, based on information taken from manufacturers' brochures. In general, the data show the films to have appreciable strength and flexibility. The folding endurance of some of the films may seem high relative to unsized paper of similar DP. However, these are amorphous flexible aqueous gels, whereas paper is a heterogeneous construction of fibers; it is difficult to make an objective comparison of relative strength. Moreover, tests of flexibility and tensile strength are often carried out at 50% RH; that is, when the films hold considerable moisture. These properties increase as molecular weight increases, but even films of the lowest molecular weight grades generally have considerable flexibility. When other properties are suitable, conservators have chosen a molecular-weight grade slightly greater than the very lowest grade available, to assure reasonable strength of the films.

Table 2.6. Representative mechanical properties of cellulose ether films (data from commercial brochures).*

Polymer	Type	H_2O Content (%)	Approximate Viscosity (cPs) @ 2%	Thickness (mils)	Tensile Strength (psi)	Ultimate Elongation (%)	Flexibility MIT Double Folds
Cellulose Gum (CMC)	7L	18	30	2	8,000	8.3	93
	7M	18	400	2	13,000	14.3	131
	7H	18	3,000	2	15,000	14.3	513
Natrosol (HEC)	250L		15	2	4,000	30	>10,000
	250G		280	2	3,700	41	>10,000
	250M		5,000	2	3,900	35	>10,000
	250H		25,000	2	3,900	14	>10,000
Klucel (HPC)	J	4	15	2	2,000	50	>10,000
Methocel (MC)	A		100	2	10,000	12	>10,000
Ethylcellulose (EC)	N			3	19,000	10	1,000
EHEC	?			3	5,500	8	700

*Tested at 25 °C and 50% relative humidity.

?Type not specified.

Equilibrium Moisture Content

Films of cellulose ethers are hygroscopic; that is, they will pick up moisture under humid conditions. This is of importance to the conservator; at high relative humidities the films may become tacky. Klug (1971) has provided a table showing that many of the properties of these materials—the temperature of their cloud point, their solubility in salt solutions, and surface tension—tend to decrease with a decrease in the equilibrium moisture content. In contrast, solubility in organic solvents tends to increase when hydrophobic groups such as methyl and ethyl groups are introduced.

The equilibrium moisture content seems to be a function of the hydrogen bonding between the hydrogen of water and the oxygens that are available in the modified celluloses. Figure 2.7, taken from Klug, shows this relationship. (The HPMC in this diagram is a hydroxypropylmethylcellulose, methylcellulose containing a slight amount of hydroxypropyl substitution.) The high moisture absorption of carboxymethylcellulose (CMC) is largely due to its ionic character. Figure 2.8 provides data published by Davidson and Sittig (1962) in which the equilibrium water content of poly(vinylalcohol) and poly(vinylpyrrolidone), well known for their hydrophilic character, is compared to that of carboxymethylcellulose.

As the degree of substitution in hydroxyethylcellulose and hydroxypropylcellulose increases, the equilibrium moisture content decreases slightly, as can be seen in Figure 2.9. In contrast, with carboxymethylcellulose, the equilibrium water content increases sharply as the number of carboxyl (COO^-) groups increases (increased DS), as can be expected with increasing ionic character.

The moisture-holding ability of cellulose ethers has been used to advantage in formulating hydrolic cements and paint removers, in molding ceramic ingredients prior to firing, and in increasing the "open" or working time of adhesives. However, increased moisture content in such vehicles as Klucel and CMC may increase the rate of fading of organic pigments such as carmine lake (Bailie, Johnston-Feller, and Feller 1988).

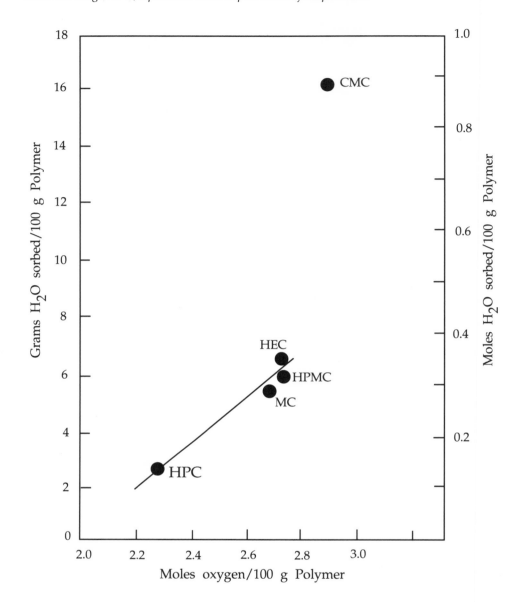

Figure 2.7. Effect of oxygen content on equilibrium moisture of water-soluble cellulose at 25°C, 50% RH. Klug (1971), reproduced with the permission of the publisher.

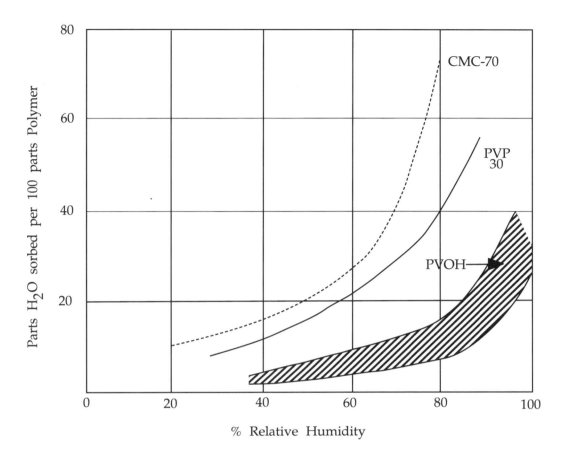

Solubility/Temperature Relationships

Unlike many materials, most common nonionic water-soluble cellulose derivatives exhibit inverse temperature-solubility behavior; that is, they are soluble at room temperature or below, but are insoluble at some higher temperature. The reason for this behavior seems to be that solubility is due to an association between the ethers and water; as the temperature is raised, the association becomes less strong and the polymers separate from solution. A detailed discussion of the gelling of methylcellulose solutions is given in Appendix D.

The nature of the substituent groups markedly influences the affinity for water. For example, as the MS of hydroxyethylcellulose (HEC) increases, its hydrophilic character increases. This can be seen in Figure 2.10a, where, at MS 5, the presence of more than twice as much acetone in water can be tolerated before the polymer comes out of solution as compared to material with MS 1.5. The opposite effect can be seen in Figure 2.10b in which the cloud point, the temperature at which the solution becomes cloudy, need not be so high—indicating that compatibility with

Figure 2.9. Effect of substitution on equilibrium moisture content of cellulose derivatives at 50% RH, 25 °C. Klug (1971), reproduced with the permission of the publisher.

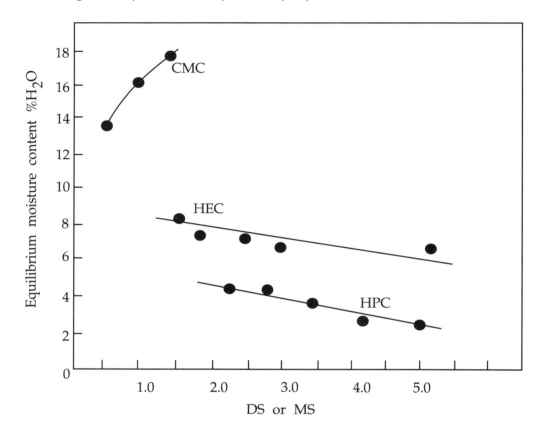

water decreases (the hydrophobic character is increased) as the amount of hydroxy-propyl substitution (MS) increases in hydroxypropylcellulose. On the other hand, when hydroxyethyl groups are used to modify ethylcellulose or hydroxypropyl cellulose, the hydrophilic character of the polymer increases due to the introduction of OH groups; as a result the cloud point increases with the introduction of hydroxyethyl groups.

The polymers are usually less compatible with water with increasing salt content. Thus, the presence of salts lowers the cloud point of aqueous solutions of the nonionic cellulose ethers; an example can be seen in Figure 2.11. Klug (1971) comments on the fact that for hydroxyethylcellulose (HEC) of a given level of MS, there is almost a linear relationship between the concentration of salt in the solution and the cloud point. The cloud point also decreases (the compatibility with water decreases) with increasing DP of the HEC up to about DP 1,000. Beyond this, further increases in molecular weight have little influence.

Increasing DP or increasing DS can influence the cloud point; hence, to demonstrate the effect of either one, the other must be held constant.

Figure 2.10 a,b. Effect of substitution on cloud point. The lower the cloud point or higher the content of acetone needed, the lower the compatibility with water. (a) Effect of MS on volume of acetone required to cloud 100 cc of 2% solution of hydroxyethylcellulose at room temperature. (b) Effect of MS on cloud point of 2% aqueous solutions of hydroxypropylcellulose. Klug (1971), reproduced with the permission of the publisher.

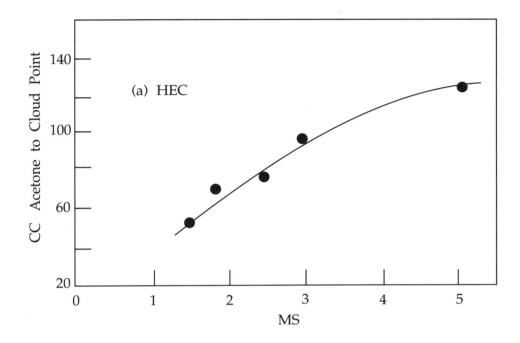

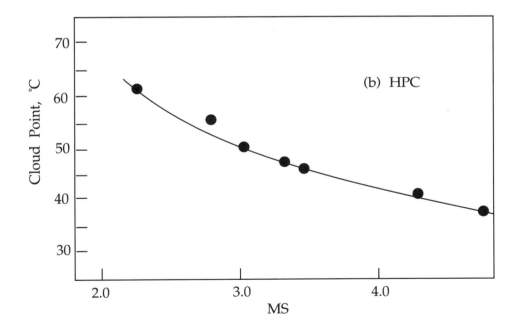

Figure 2.11. *Effect of MS and salt content on the cloud point of 2% aqueous solutions of hydroxyethylcellulose. Klug (1971), reproduced with the permission of the publisher.*

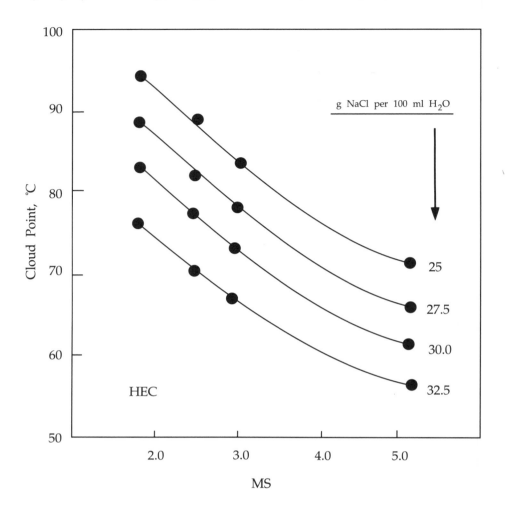

Effect of Carboxyl Groups (Carboxymethylcellulose)

Because most of the water-soluble cellulose ethers are nonionic, their properties, particularly the properties of their solutions, are not markedly influenced by pH. With long-term maintenance at pH levels below 3.5 and above 8 or 9, however, the ethers tend to degrade much as cellulose would (see "Effect of pH on Cellulose Ether Solutions" and "Degradation by Acid" above).

As mentioned earlier, the exception to the general rule is carboxymethyl-cellulose (CMC). The introduction of only slightly more than 4 COOH groups per 100 anhydroglucose units (AGUs) into a polymer such as hydroxypropylcellulose (HPC; at MS 4.2) makes the cloud point sensitive to pH. In his Figure 14, not given here, Klug (1971) shows an example of the effect of only 7 COOH groups per 100 AGUs in raising the cloud point of the HPC polymer. If the substitution is raised to 18 groups per 100 AGUs, the cloud point is dramatically influenced by pH even in the acid range of 3 to 6. The amount of substitution in these examples is much lower than that which would be encountered in the usual commercial product. The latter would

range from about 38 to perhaps 145 carboxyl groups per 100 AGUs (DS 0.4 to 1.5). Of course, CMC must be in the form of the sodium salt in order to be soluble in water; in the acid form, it is insoluble.

Viscosity/Temperature Relationships

In general, the viscosity of solutions of various cellulose ethers decreases as the temperature increases to the point where incompatibility sets in (the polymer comes out of solution). Methylcellulose of DS 1.8, for example, gels at about 55 °C; this, of course, results in an abrupt increase in viscosity. Hydroxypropylcellulose (HPC) does not gel at its cloud point but instead precipitates from the solution. Klug states that the difference in this behavior may be due to the difference in the affinity for water. Methylcellulose, having a greater oxygen content per unit weight, holds the water in the form of a gel, whereas the more hydrophobic HPC separates from the water as a precipitate.

The introduction of small amounts of ionic substituents (carboxyl groups) has a profound effect on the viscosity-temperature curve. As mentioned, in the case of a hydroxypropylcellulose having an MS 4.2, the introduction of carboxymethyl groups at only a DS level of 0.04 increases the viscosity considerably. Most of the carboxymethyl groups are in the highly ionized form in this situation. The shape of the viscosity-temperature curves for such a polymer is influenced by the pH, the extent of carboxymethyl substitution, the molecular weight, solution concentration, and presence of inorganic salts.

Rheological Behavior of Solutions

As the molecular weight (reflected in the viscosity grade) increases, cellulose ether solutions tend to become increasingly non-Newtonian in behavior; that is, their apparent viscosity varies with the applied shearing force rather than being independent of shear (the ideal or Newtonian case). Their solutions can be described as pseudoplastic (Fig. 2.12). In products having viscosities below 600 centipoises (cP; 25 °C) at 2% concentration, this behavior is scarcely significant.

A particular change in viscosity with time is known as thixotropy. It is characterized by an increase in apparent viscosity when a shear force is removed. Thixotropy can be attributed to the formation of a three-dimensional network structure by large molecules. At rest, the network forms and viscosity increases. When a shearing force is applied to such a system, the network is disrupted and viscosity decreases. Once the network is completely disrupted, the decrease in viscosity levels off.

Thixotropy is a useful property in formulating paints when one does not want the paint to flow down a wall once it has been brushed on. Solutions of high and medium viscosity grades of carboxymethylcellulose tend to possess thixotropic behavior, but grades are available that exhibit little or no thixotropy.

Figure 2.12. Relationship between shear rate, shear stress, and apparent viscosity in the case of Newtonian (ideal) and pseudoplastic fluids.

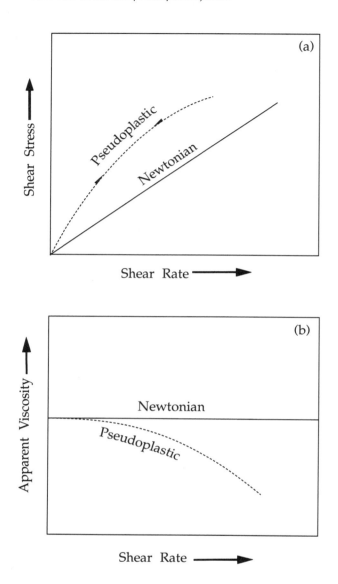

Properties Not Related to Hydrophilicity

Many intrinsic physical properties of the polymers are not related to their hydrophilic characteristics. For example, HEC and HPC have lower moduli and tensile strength than MC and CMC, probably due to their large percentage of substituents. CMC and MC tend to be harder and stiffer than HEC and HPC. In Figure 2.13, the effect of increased MS in the physical properties of HEC is shown. In Figure 2.14 one sees that stiffness, as measured by the modulus, rapidly decreases as MS increases.

Above an MS of about 3, HPC exhibits good thermoplastic flow and therefore can be shaped and formed by the standard methods of injection molding and extrusion. The organic-soluble ether, ethylcellulose (EC), should have a DS of about 2.5 for its optimum properties of plastic flow.

Figure 2.13. Effect of MS of hydroxyethylcellulose on tensile strength and elongation of 2-mil thick films conditioned at 50% RH, 25 °C. Klug (1971), reproduced with the permission of the publisher.

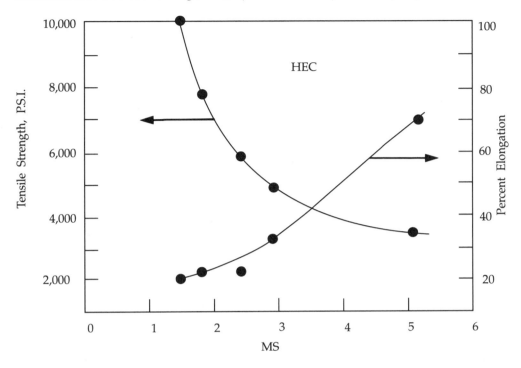

Figure 2.14. Effect of MS of hydroxyethylcellulose on modulus (a measure of stiffness or rigidity) of 2-mil thick films conditioned at 50% RH, 25 °C. Klug (1971), reproduced with the permission of the publisher.

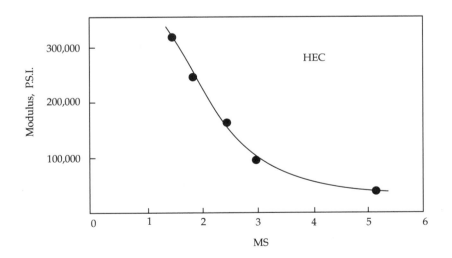

3 Standards of Stability

The principal purpose of the laboratory tests was to rank six generic classes of cellulose ethers with respect to their thermal and photochemical stability and to project their potential long-term stability under museum conditions.

The word "stability" must be defined. In this context, it refers to the resistance to change in terms of physical or chemical properties. The usual measure of stability is the time it takes for an unacceptable change in properties to occur. In the present studies, little attention was directed toward defining and measuring what constitutes an unacceptable degree of change. Instead, the laboratory program attempted to rank the materials according to their rate and degree of change. This ranking establishes the relative tendency of the materials to degrade. No judgment has been made here as to the appropriateness of the materials for particular applications; they are only ranked in stability relative to one another or to a material reference standard (discussed below).

When three classes of photochemical stability were proposed some years ago (Feller 1975), attention was drawn to the fact that some materials of interest to the conservator are intended to be only briefly in contact with an artifact being treated. A class of usage was proposed, Class T, to specify situations in which a material is in contact with an artifact temporarily—less than six months. Many uses of (or applications of) cellulose ethers fall into this category and therefore the issues of long-term stability investigated here need not apply. Nonetheless, the present objective is to investigate potential long-term stability.

The stability of a material can be measured with respect to the action of heat, light, chemical or biological agents, or other significant factors.

Resistance to Photochemically Induced Degradation

There are few, if any, accepted standards of stability for coatings, consolidants, and adhesives used in conservation. Some years ago the Research Center on the Materials of the Artist and Conservator suggested three classes of photochemical stability: conservation-quality materials should remain stable and largely unchanged for at least 100 years under normal museum conditions of illumination; "unstable" materials would be those that significantly changed their properties in 20 years or less; and those that failed in 20 to 100 years would be classified as having "intermediate" stability (Feller 1975).

Establishing a standard for photochemical stability is a relatively easy matter because the character of the illumination source can usually be well defined, and the number of lux hours or footcandle hours of exposure that a material can be expected to endure under museum or archival conditions can also be determined. (Objects on a gallery wall that receives a daily average intensity of 300 to 350 lux of diffuse day-

light through window glass, for example, are subjected to about one million lux hours (Mlxh) of illumination per year.) It is also relatively easy to determine the millions of lux hours of illumination from an artificial source of illumination comparable to diffuse daylight that a given material will withstand before an unacceptable change in properties occurs. The months or years of normal exposure that it would take to accumulate this amount of exposure can then be calculated. In making such an estimate, one generally assumes that equal photochemical damage will occur in an equal number of lux hours. However, if this "reciprocity principle" is not obeyed, one need only determine the relationship between exposure and damage that *does* apply.

More will be said about the photochemical stability of cellulose ethers later but, except for ethylcellulose (EC) and organic-soluble ethylhydroxyethylcellulose (OS-EHEC), the ethers tested did not prove to be particularly sensitive to photochemical degradation, that is, to exposure to the visible and near-ultraviolet radiation emitted by daylight fluorescent lamps.

Resistance to Thermally Induced Degradation

Most of the tests that will be described in the experimental section concern thermal stability. Again, there are no widely accepted standards in conservation. Perhaps the most convenient point of reference in the present context is the familiar statement that 72 hours of aging of paper at 100 °C is equivalent to about 25 years of storage under normal room conditions (Winger and Smith 1970). This is equivalent to stating that 288 hours at 100 °C would generate a degree of deterioration approximately equal to 100 years of natural aging; 58 hours, to 20 years. This was the criterion chiefly used in evaluating the stability of cellulose ethers. To calculate the expected behavior at temperatures other than 100 °C, an activation energy of 30 kcal/mole was used, an average value between that determined for cellulose ethers by Vink (1966) and that used by Winger and Smith (1970) for the hydrolysis of cellulose. This will be discussed further in "Standards of Thermal Stability" below.

A number of material reference standards can also be employed in rating the relative thermal stability of polymers to be used in conjunction with paper. Wood-pulp-based newsprint, a known unstable material, represents one extreme; analytical-grade filter paper, a relatively stable material, represents the other. Thus, one can compare the rate of discoloration, chain breaking, or oxygen uptake in a cellulose ether with the same changes in these familiar materials when subjected to the same experimental conditions. Poly(vinylalcohol), a known unstable material, was used for comparison in some of the tests.

Microbiological Resistance

Another aspect of long-term stability is the resistance of materials to insects and microbiological agents. As with cellulose, cellulose ethers are subject to hydrolysis by the action of enzymes released by fungi and mold. Resistance to this form of deterioration was not investigated here, but the considerable information on this subject that exists in the literature is briefly reviewed in Appendix E. In general, the higher the degree of substitution in the water-soluble cellulose ethers and the more uniform the substitution along the chain, the greater the resistance to enzymatic attack. Manufacturers frequently offer enzyme-resistant varieties of their products.

Behavior of a Generic Chemical Class of Commercial Product

There are millions of chemical substances available. The chemist cannot hope to test each one to learn its individual behavior. Instead he relies heavily on the fact that all alcohols behave much the same way, all aldehydes much the same, etc. Most doubly-unsaturated fatty acid esters, for example, tend to oxidize much as linseed oil. Thus, polymers of a particular chemical class can reasonably be expected to behave chemically in the same manner. For example, regardless of the manufacturer, without the presence of inhibitors, normal butyl and isobutyl methacrylate polymers tend to crosslink when exposed to near-ultraviolet radiation, while poly(vinylacetate) may tend to chain break.

It was intended at the start of this project that generalizations would be made regarding the stability of the several classes of cellulose ethers studied and, to a degree, general statements can indeed be made. Nonetheless, the matter is complicated in the present case because the starting material, cellulose, is a product of nature and is, therefore, seldom pure. Some varieties of cellulose ethers are made from cotton cellulose, others from wood. Xylose, for example, has been found in carboxymethylcellulose made from hardwood and softwood pulps (Bach Tuyet, Iiyama, and Nakano 1985; Niemela and Sjöström 1988).

Even if highly purified cellulose is used, the nature of the reactions forming the ethers is not unique. Instead, as will be discussed later at some length, ether formation is the result of statistical substitution along the cellulose chain and among the three hydroxyls in the anhydroglucose ring. Thus, first of all, a cellulosic polymer can vary in the degree of substitution (DS)—the extent to which alkyl groups have been introduced into the molecule. Second, because of differing methods of manufacture, the character of the raw materials and the uniformity of substitution can vary. It is well known that minor variations in structure can affect the stability of products. Traces of carboxyl groups, for example, have been found in products that are nominally ethylcellulose (*Encyclopedia of Polymer Science and Technology* 1968:480).

If the alkali used to make alkali cellulose is not uniformly distributed throughout the pulp during the manufacturing process, methylcellulose will be non-

uniform and may even contain unreacted fibers (*Encyclopedia of Polymer Science and Technology* 1968:493). Photomicrographs of cellulose fragments seen in films of Culminal (MC) are shown in Figure 6.3.

Theoretically, the various types of irregularities in the structure of a polymer can be specified. In practice, however, it is almost impossible for a commercial manufacturer to provide all the vital details of structure that have an influence upon stability. This is one of the most important conclusions to have come from this research: One cannot rely completely on the generic class of cellulose ether to indicate stability. In any given chemical type, some proprietary products will exhibit a significant difference in stability. One can see this illustrated in the accompanying graphs describing the rate of discoloration of ethyl and hydroxyethyl celluloses (Figs. 4.2 and 4.3). Without detailed chemical analyses of the individual commercial products, it is usually not possible to provide an explanation for the differences in behavior observed in the present study. The complexity of the problem in describing the structure of cellulose ethers is explained more fully in Appendix G and in Appendix H (see "Determination of Molar Substitution by Nuclear Magnetic Resonance").

Upgrading

The reader may ask: Why not recommend to conservators some of the more stable types of poly-(vinylalcohols), ethylcelluloses, or organic-soluble hydroxyethylcelluloses that this investigation has uncovered? In addition, could not borderline products be upgraded? The reason for taking a conservative position—not recommending one particular product over another at this stage of our knowledge—is that one cannot at this time state exactly why one particular commercial product appears to be more stable than another. Even within nominally the same class (particularly when it is known to be potentially unstable owing to its chemical structure), no member of that chemical class should be strongly recommended until much more is learned about its properties. After all, there are already a variety of polymers of exceptional stability available for use in conservation; hence, there is no immediate or pressing need to use materials for long-term applications when they do not possess the very highest standards of stability. Moreover, the behavior of any "apparently acceptable" commercial product in the present series of tests could change for the worse due to variations in manufacturing techniques in the future.

Many of the materials that have been presently classified as being in the "unstable" or "intermediate" classification could perhaps be improved by the inclusion of small amounts of antioxidants, ultraviolet absorbers, or other stabilizers. Undoubtedly the employment of such additives will be significant in future conservation practice. At this stage in the testing and knowledge of conservation materials, however, the research laboratory wishes to focus attention primarily on materials that are intrinsically "stable" owing to their particular chemical structure (Feller 1987a). The question of the utility and suitability of employing antioxidants and

other stabilizers in conservation practice is a subject that must be considered more fully at another time.

Standards of Thermal Stability

In designing tests to evaluate the stability of materials, the type and degree of change that should be selected as a standard of acceptability or unacceptability must be determined. The change may be chemical (discoloration, loss of molecular weight or viscosity grade, loss of solubility) or physical (development of brittleness). This investigation measured changes in the three chemical properties.

The polymers examined in this series have been placed in only three classifications of thermal stability: unstable, intermediate, and stable or excellent. The classes of thermal stability chosen here do not correspond precisely to those proposed previously for photochemical stability (Feller 1975; see Figures 6.22 and 6.24, for example).

The classes of thermal stability used in the present investigation are essentially based on the old and very approximate rule of thumb that heating paper 72 hours at 100 °C yields results similar to those experienced after 25 years of aging under normal museum conditions. In the calculations for the estimated rate at temperatures other than 100 °C, an activation energy of 30 kcal/mole was used. This is approximately the mean between the value of 31.3 kcal/mole derived from the studies of the acid hydrolysis of HEC, MC, and CMC by Vink (1966) and the value usually cited for the acid hydrolysis of paper, 28.6 kcal/mole (Winger and Smith 1970).

In such calculations, the Arrhenius equation is used:

2.303 [\log_{10} rate at temperature, T_2 − \log_{10} rate at 20 °C] =

$$-\frac{E_A}{R}\left(\frac{1}{T_2} - \frac{1}{T_1}\right)$$

or, in the present case:

$$-\frac{30,000}{1.986}\left(\frac{1}{T_2} - \frac{1}{293}\right)$$

The temperature is expressed in terms of degrees kelvin (273 plus the temperature in degrees centigrade) and R is the gas constant, 1.986 calories per mole. The number of hours necessary to heat a material at 90, 95 and 110 °C that would be equivalent to 4 x 72 or 288 hours of heating at 100 °C is inversely related to the rate. Using the energy of activation, E_A, as 30 kilocalories per mole, one can calculate that 58 hours at 100 °C (equivalent to approximately 20 years of natural aging of paper) would be equivalent to 177 hours at 90 °C; about 100 hours at 95 °C. Heating for 288 hours at 100 °C (roughly corresponding to 100 years of natural aging of paper) would be equivalent to about 880 hours at 90 °C and about 500 hours at 95 °C.

In addition to this very rough estimate of heating times equivalent to about 20 or 100 years at normal temperatures, we have used a few material reference standards: newsprint paper (unstable), poly(vinylalcohol) films (unstable), and Whatman #42 filter paper (stable). These reference materials were exposed simultaneously with the cellulose ether samples; their rate of discoloration was the principal comparison made.

The many factors that must be considered when conducting accelerated-aging tests were recently reviewed (Feller 1987a). Of these, humidity is a major factor. It should be noted that in the present series of tests, thermal aging tests were generally carried out without humidity control, in other words, on materials that were relatively dry. Future thermal aging tests should include humid conditions.

The photochemical tests were, however, conducted under daylight fluorescent lamps with ultraviolet filters in a constant-temperature room at about 50% relative humidity and 25 °C. The number of lux hours constitutes another measure of exposure: the wall of a typical museum gallery often receives about one million lux hours (Mlxh) per year (Feller 1964; Thomson 1978). It is also known that the ISO R105 blue wool cloth No. 3, a standard measure of the "unstable" photochemical class (Feller 1975), will fade appreciably in about 15 Mlxh. In addition, the relative tendency of a material standard, filter paper, to chain break under daylight fluorescent lamps was compared to that of Klucel G (Fig. 6.22).

If a cellulose ether tests poorly in both thermal and photochemical stability as conducted here, there is little question that it should be considered carefully, if not rejected, for long-term applications in conservation. Conversely, if stable under both conditions, a material can be regarded as having appropriate stability. A material that falls in an "intermediate" class of stability between these two extremes also requires additional consideration (Feller 1987a). Using only three classes of stability is intentionally conservative. This is sensible because a material that falls in the "intermediate" class in a test of thermal stability might easily be caused to degrade more rapidly if, as generally expected, exposure to light should shorten its thermally induced induction time, placing the polymer then in the "unstable" class.

Remember that a series of tests regularly yields a bell-shaped distribution of data; most results will fall in a general range, but a few will be much higher or lower than the majority. Thus, in the desire to place cellulose ethers in only three distinct classes of stability, it is expected that a few products will fall in the next higher or lower classification. This overlapping of a few values into a higher or lower classification can be clearly seen in the results for the discoloration of ethylcellulose (Fig. 4.2) and hydroxyethylcellulose (Fig. 4.3). Hence, the placing of a generic chemical class of cellulose ether into one of three general classes of thermal stability recognizes that one is referring to the expected behavior of the average or majority of such products and that there will be exceptions.

A Simple Test of Thermal Aging

Because cellulose ethers derived from different manufacturing sources are likely to exhibit different degrees of thermal stability, a simple test will be suggested that can be used to evaluate specific products. Many laboratories have air-circulating ovens set at 100 °C; hence, for convenience, it is suggested that testing be done at this temperature rather than at 90 or 95 °C as in the tests reported here. This is a test of thermal aging under dry-oven conditions. In the future it may prove useful to also carry out tests under moist conditions.

If an oven is not available, evaluations can be made by placing samples in a hot attic in the summer, on top of a radiator, or in a home-made hot box, possibly heated by light bulbs. Care must be taken that all samples are nearly equally heated; the location of the samples on a shelf or tray can be changed periodically so that samples spend about equal time in each position, thus compensating for unequal temperatures at different locations. If the average temperature is much below 90 to 100 °C, longer periods of time than those suggested below will be required before useful results can be attained. This will be on the order of twice as long for each 10° the average temperature is below 100 °C.

It is advisable, at least until experience is gained, to repeat the test twice. For more refined distinctions, it may be useful to repeat four times.

Effect of Exposure to Light

Cellulose ethers, especially the water-soluble types, appear to be about as stable with regard to exposure to visible and near-ultraviolet radiation as is cellulose of sufficiently high grade that there is scarcely any lignin present, no more than a few percent. For this reason, light exposure tests are not suggested at this time. Moreover, because light often causes bleaching of discolored cellulosic materials, care should be taken that exposure to light is kept at a minimum in carrying out tests of thermal stability.

Proposed Test of Thermal Stability

Samples as received from the supplier should be used in sufficient quantity to cover the bottom of a shallow glass or aluminum dish, 2 to 4 inches in diameter with about a 1/2-inch wall (glass Petri dishes or aluminum milk-bottle-cap weighing pans are suitable). Two types of tests can be carried out readily: weight loss and relative discoloration. Heating is done with the dishes uncovered.

The weight of the pans and samples should be known, at least to the nearest hundredth of a gram. About 10 to 20 grams of powdered resin can be introduced, sufficient to spread evenly in the bottom of the pan to a depth of at least 3/8 of an inch. The weight of the added powdered resin should be determined. The objective is to be able to detect changes in weight of the resin of about 0.1%. At 10 grams, this would

require the ability to weigh 0.01 gram; at 20 grams, weighing should be to a sensitivity of 0.02 gram.

Samples should be heated at 100 ℃ for 5 hours and the percentage loss in weight determined. The loss at this point can be considered to be moisture. The sample in its pan, now assumed to be practically free of moisture, should be returned to the oven and heated at 100 ℃ for 58 hours, after which it is removed, weighed to determine the percentage weight loss relative to the weight after 5 hours of heating (the dry weight), and the powdered sample visually examined to evaluate discoloration. The sample is returned for another 58 hours, after which it is again weighed and its discoloration noted. If the sample has scarcely changed at this point, heating can be continued until a total of 288 hours has accumulated.

Samples that seriously discolor or lose weight after a total of 58 hours of heating can be considered "unstable," possibly undergoing a similar change after approximately 20 years under ordinary room conditions with minimal exposure to visible and near-ultraviolet radiation. If the change at this point is so slight that a decision regarding the relative stability of a series of cellulose ethers cannot be made, experience suggests that it may be possible to make such a decision in about twice that time, that is, after about one week of testing. If time is limited, one can detect "unstable" products and generally establish a relative ranking among several products in about 58 or 116 hours. As a rule of thumb, however, cellulose ethers that should remain thermally stable for roughly 100 years will require testing for at least 288 hours at 100 ℃.

It must not be forgotten that the rule of thumb—assuming that 58 hours, 72 hours, and 288 hours of heating paper and possibly related cellulose products at 100 ℃ of will yield the same aging results at 20, 25, or 100 years of aging at normal room conditions—is only the crudest of estimates. The primary result of the heating tests will be to establish a ranking of cellulose ethers with respect to discoloration or loss of weight under the test conditions; no more than that. If changes in properties are observed, or not observed, a crude estimate has been made, by means of the stated rule of thumb, of the amount of time that one should heat the samples before a material can be deemed potentially unstable or highly stable under ordinary conditions. No claim can be made, however, as to the reliability of the suggested potential long-term stability.

The Encyclopedia of Chemical Technology (Kirk, Othmer et al. 1968:641) mentions a test to be used with ethylcellulose that involves heating at 120 ℃ for 16 hours. Such a test, however, would only detect or evaluate materials in the "unstable" to "intermediate" class.

Controls

It is suggested that two to four "control" samples be exposed along with the specific products being evaluated. Klucel M or L is a material that will discolor notably under these conditions. A poly(vinylalcohol) might also serve, a type about 88% hydrolyzed

as opposed to 99%. A highly stable methylcellulose product could serve as a standard that would scarcely change even after 288 hours. As experience and familiarity with the behavior of various products is gained, particular cellulose ethers can serve as reference standards of personal interest.

Objective Measurement of Discoloration

The test objective is only to establish a ranking of stability of one product relative to another. Relative discoloration can be judged visually. If desired, comparisons can be made to Munsell chips. If an instrumental method is desired, a method can be devised similar to that used by Arney (see Chapter 4, "Summary of Previous Investigation Supported by the National Museum Act").

Weight Loss

The primary feature being monitored is the tendency to discolor. It is not necessary to measure weight loss, nor does weight loss necessarily parallel discoloration. Such a test, however, can be carried out without elaborate equipment. It provides a simple and objective ranking of products when slight differences in behavior might otherwise not be apparent. The results in Table 6.1 suggest that, over and above the loss of moisture, weight losses can be expected to vary from less than 1% for highly stable materials to as much as 20%.

Viscosity Loss

The measurement of decreases in intrinsic viscosity or viscosity grade requires a much more sophisticated test procedure than the evaluation of discoloration or loss in weight. Nonetheless, the viscosity of 1 or 2% solutions and aged bulk products can be measured if desired.

The possibility of incomplete solution, particularly in the aged product, must be checked. One way to do this would be to evaporate a known weight of the clear solution that may exist above any precipitate that may form in order to determine if the intended solution contains less than 2% solids.

4 Summary of Previous Investigation Supported by the National Museum Act

Introduction

In a project supported by the National Museum Act in 1980-1981, Dr. Jonathan Arney and his assistant, Kate Novak, heated various cellulose ethers at 95 °C and ranked them according to degree of discoloration. Their method of color measurement was not elaborate, but it provided an objective measure of the thermally induced discoloration of the polymers. Oxygen uptake was also measured. The ranking of the generic classes of the polymers thus achieved was similar to the qualitative and semiquantitative ordering that Dr. Wilt achieved in the present project.[1]

The relative degree of instability of the materials was judged by their degree of discoloration following thermal aging at 95 °C. By this criterion, cellulose ethers, with the exception of ethylcellulose, proved to be of sufficient stability to warrant further testing and evaluation. Methylcellulose and carboxymethylcellulose proved to be the most stable. Poly(vinylalcohol), ethylcellulose, poly(vinylpyrrolidone), and certain natural gums were considered unstable; they discolored more rapidly than newsprint. Hydroxypropylcellulose, hydroxyethylcellulose, and water-soluble ethylhydroxyethylcellulose were considered to fall into an intermediate class of stability.

Measurement of Reflectance at 500 nm

In the 1980–1981 investigation, the dry powders were gently packed in a 1-inch-tall cylinder cut from 1/2-inch-diameter glass tubing that was sealed on the bottom with a microscope cover glass attached with epoxy adhesive. The diffuse (nonspecular) reflectance of the powder packed against the cover-glass bottom of the cylinder was measured using a Bausch and Lomb Spectronic® 20 integrating-sphere spectrophotometer. By thus measuring the reflectance of powdered resins periodically during aging, a numerical index of the severity of discoloration was obtained: the decrease in reflectance (ΔR) with the monochromator set at 500 nm. Although reflectance values obtained on granular powders provide only a qualitative indicator of color change in resins, the measurements nonetheless were able to distinguish between severe, moderate, or insignificant discoloration. Figure 4.1 presents the preliminary measurements taken on several materials.

Figure 4.1. Change in reflectance at 500 nm (ΔR) of cellulose ether powders and reference materials aged at 95 ℃. Data of J. Arney.

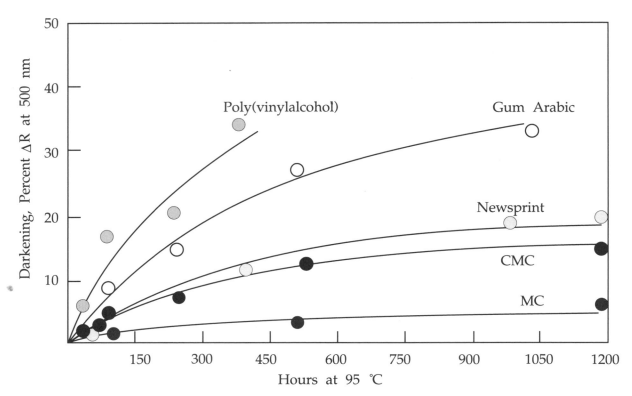

Principal Test Procedure

Accelerated aging was conducted on products as received from suppliers. Glass cylinders containing powdered or granulated cellulose ethers were placed in a circulating-air oven at 95 ℃. As described, the bulk-powder reflectance of each material was determined periodically at 500 nm. Most of the materials discolored (yellowed) evenly and progressively during the aging tests.

A few materials yellowed in a manner that differed significantly from the more typical behavior illustrated in Figure 4.1. For example, the ethylcellulose samples tended to go through an induction period in which no discoloration was observed after which severe and rapid discoloration occurred. Figure 4.2 shows some representative results with ethylcellulose products; further comment will be made below.

Other polymer types yellowed severely during the first day of aging at 95 ℃ and then discolored only slightly thereafter, or sometimes lightened in color. This behavior is illustrated in Figure 4.3. While the reason for the initial rapid discoloration and subsequent bleaching has not been determined, this distinctive behavior is cited for the benefit of those who may be planning similar tests.

The different shapes of the yellowing-versus-time curves—with and without an induction time, with and without rapid initial discoloration of the type seen in Figure 4.3—make difficult an unambiguous determination of relative thermal stability of the different products. For this reason, two indices of stability were noted in the 1980–1981 tests: (1) the darkening that occurred at 95 °C after 27 hours and (2) the net degree of change after 1250 hours. The point-to-point plots in Figures 4.2 to 4.6 appeared in the quarterly reports prepared by Arney and Novak.

Figure 4.2. Decrease in diffuse reflectance (ΔR) at 500 nm in ethylcellulose (EC) upon heating powders at 95 °C. Data of J. Arney.

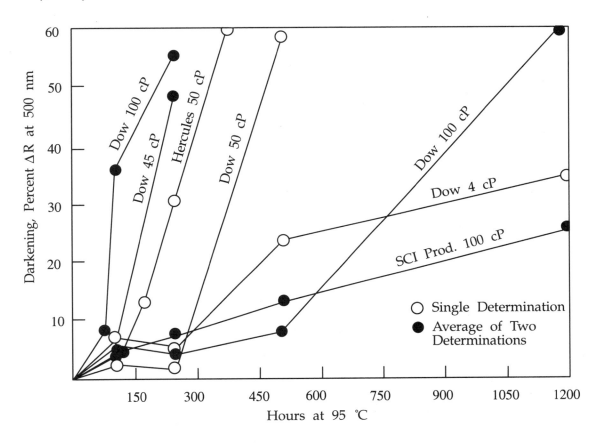

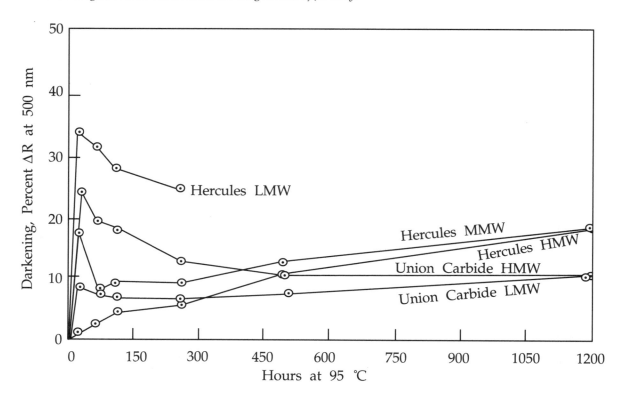

Figure 4.3. Decrease in diffuse reflectance (ΔR) at 500 nm of series of hydroxyethylcelluloses (HEC) upon heating powders at 95 °C. Note the rapid initial discoloration often seen with these materials. HMW, high molecular weight; MMW, medium molecular weight; and LMW, low molecular weight. Data of J. Arney.

Results

Table 4.1 summarizes the results of the thermal aging tests. To provide convenient reference, several material-standard controls are included with the cellulose ethers. Basically, the cellulose ethers seem to fall into three classes of stability: stable (minor discoloration less than $\Delta R = 6$), intermediate (more than twice as much darkening, $\Delta R = 13$–28), and unstable (greater than $\Delta R = 40$). One can consider a change of 5 in ΔR as an acceptable change; a ΔR of 20 or more, unacceptable.

The behavior of specific commercial products is evident in the figures and discussions that follow. Nonetheless, as stated earlier, the experiments are not designed to provide ratings on the relative merits of specific commercial products, but rather to illustrate aspects of common behavior and to suggest the variability that one may expect in commercial products nominally of the same generic chemical type.

Table 4.1. *Average values of decreased reflectance (ΔR) at 27 and 1250 hours after thermally aging powdered polymers in air at 95 °C. Data of J. Arney.*

Type of Polymer	Number of Samples Averaged	Average Value of ΔR (Decrease in Percent Reflectance at 500 nm)	
		After 27 Hours	After 1250 Hours
Rag and Filter Papers*	2	0.0	4.5
Cellulose Esters (acetate and acetate-butyrate)*	5	0.4	4.7 (± 4)**
Methylcellulose (MC)	5	1.1	5.6 (± 2)
Ethylhydroxyethylcellulose (EHEC-WS)	1	2.4	13
Carboxymethylcellulose (CMC)	7	0.7	19 (±4)
Newsprint*	1	0.0	18
Hydroxyethylcellulose (HEC)	5	16***	13 (±4)
Hydroxypropylcellulose (HPC)	2	16***	28 (±1)
Ethylcellulose (EC)	7	2.6	>40
Poly(vinylalcohol) (PVOH)*	5	6.4	>50

*For comparison

**Standard deviations in parentheses

***Note the high initial discoloration

Ethylcellulose (EC)

The data in Figure 4.2 show considerable variation in the tendency of commercial ethylcellulose to discolor. Some products discolor extensively after only a short induction time; others are quite resistant to discoloration. The reasons for these differences in behavior are not known at this time, but the results reinforce one of the conclusions of the 1980–1981 project: One must test individual products to evaluate their relative stability. Thermally stable materials should change little in 500 hours at 95 °C.

Hydroxyethylcellulose (HEC)

Figure 4.3 presents the results of thermal aging tests on hydroxyethylcellulose. The data again indicate the range of behavior one can observe in testing nominally similar materials. Rapid initial discoloration, followed by apparent bleaching, was observed in many HEC polymers. Note that Hercules polymers fall in the order of their molecular weight; the lowest (LMW) darkened the most; the highest (HMW), the least. It is a risk, however, on such limited evidence, to generalize regarding the effects of molecular weight; the opposite behavior seems to be true in the case of the two samples from Union Carbide.

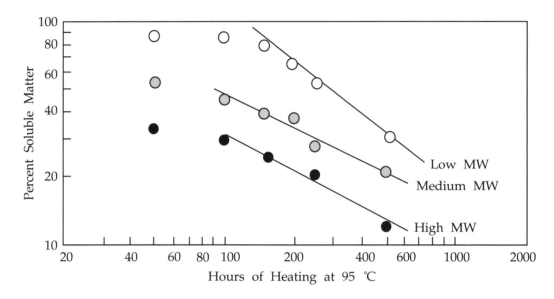

Figure 4.4. Loss of solubility of hydroxyethylcelluloses (HEC) upon heating powders at 95 °C. Data of J. Arney.

Figure 4.4 indicates that, besides discoloration, HEC polymers can lose their solubility on thermal aging. Other cellulose ethers with complex alkyl or hydroxy-alkyl groups may also exhibit similar behavior when heated for long periods of time, but particular note of this was taken in the testing of HEC.

Carboxymethylcellulose (CMC)

Figure 4.5 presents the results of thermal aging of carboxymethylcellulose powders. As seen in Figure 4.1, the CMC discolored less than newsprint. However, samples of CMC darkened generally more than filter paper, which reached a ΔR at 500 nm of only 3 after 1000 hours at 95 °C. The results indicate the range of stability that one encounters.

The uncertainty of individual measurements of decrease in reflectance is about 3% to 4%. Nonetheless, it is perhaps significant that the five CMC samples from Hercules that discolored the most fell in decreasing order of their degree of sub-stitution (type 4 being in the range of DS 0.38 to 0.48; type 7 in the range of DS 0.65 to 0.85; and type 12, DS 1.2 to 1.4). The Hercules 7 series (nominally all of the same DS) essentially fell in order of their molecular weights, the lowest discoloring the most.

Figure 4.5. Decrease in diffuse reflectance (ΔR) at 500 nm of various carboxymethylcelluloses (CMC) upon heating powders at 95 ℃. Data of J. Arney.

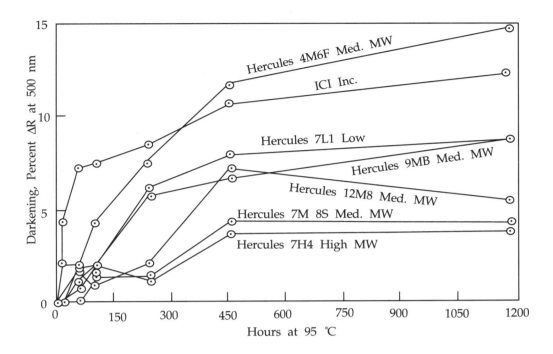

Figure 4.6. Decrease in diffuse reflectance (ΔR) at 500 nm for three methylcelluloses (MC; Biddle Sawyer a, Dow 4000 and 15000 cP), a hydroxypropylmethylcellulose (HPMC; Biddle Sawyer b) and two hydroxypropylcelluloses (HPC; Klucel, SCI) at 95 ℃. Data of J. Arney.

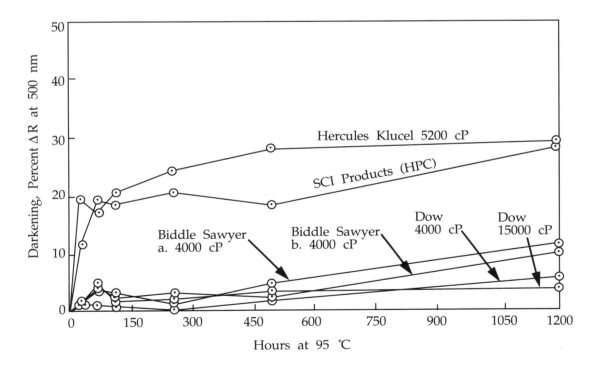

Hydroxypropylcellulose (HPC)

In Figure 4.6 the discoloration of two examples of hydroxypropylcellulose are shown. Both behave similarly, showing a rapid initial rise in color, leveling off at a greater net change in reflectance than most of the HEC samples shown in Figure 4.3.

Methylcellulose (MC) and Hydroxypropylmethylcellulose (HPMC)

One Biddle Sawyer sample and two from Dow provide examples of the behavior of methylcellulose (Fig. 4.6). This polymer is generally resistant to thermally induced discoloration. The Biddle Sawyer sample (b) is a hydroxypropylmethylcellulose (HPMC), having 28% methoxy and about 6% hydroxypropyl groups. This mixed ether exhibited thermal stability similar to, or better than, methylcellulose.

Oxygen Uptake

Arney measured the degree to which the polymers oxidized by sealing samples in a glass vial with air, subjecting them to heat or light, and then measuring the decrease in the amount of oxygen. The results of these tests are difficult to interpret; at times harmful vapors may be trapped under the sealed-tube conditions and affect the results. Moreover, not unexpectedly, the relative ranking of their change under conditions of heat and light is reversed in certain instances. Nonetheless, the results of the oxygen-uptake tests essentially confirm the ranking of the various generic classes of cellulose ethers established on the basis of thermal discoloration.

Conclusions

The principal conclusions regarding the testing of water-soluble polymers in this investigation were that methylcellulose (MC) and carboxymethylcellulose (CMC) were found to be of sufficiently high quality that their use by conservators in long-term applications can be seriously considered (Feller 1981a). It was further recommended that poly(vinyl-alcohol) (PVOH), ethylcellulose (EC), and poly(vinylpyrrolidone) be rejected or used only with the utmost consideration for long-term applications in conservation on the basis that materials of significantly higher stability with similar properties are available.

As stated in Chapter 3 (see "Standards of Thermal Stability"), if one wishes to consider the rule of thumb that aging of paper for 72 hours at 100 °C is roughly equivalent to 25 years of aging under normal museum and archival conditions (Winger and Smith 1970), then 100 years of normal aging would be equivalent to 288 hours of aging at 100 °C. Converting this by the Arrhenius equation to equivalent aging conditions at the temperature used in these experiments, using an average activation energy of 30 kcal/mole, we find that 20 years at normal conditions would be equivalent to about 100 hours (4 days) at 95 °C and that 100 years would be equivalent to about 500 hours (21 days). From this point of view, one might consider

materials that discolor more than ΔR 20 in less than 100 hours to be "unstable," those that discolor less than 5% to 10% ΔR in 500 hours to be "excellent," and those in between of "intermediate" stability (Figs. 4.1 to 4.6) .

The ranking of the generic classes of polymers into three classes of thermal stability can be seen in a general sense in the data presented in Figures 4.2 to 4.6 and in Table 4.1. Several—hydroxypropylcellulose (HPC), hydroxyethylcellulose (HEC), and ethylhydroxyethylcellulose (EHEC)—were considered to be of intermediate stability. Only one sample of the organic-soluble EHEC was tested, however. At the end of the 1981 study, it was recommended that the properties of these three ethers be further evaluated before they are considered for long-term applications in conservation.

The second and perhaps most important general conclusion from this investigation was that, in evaluating the relative stability of these particular water-soluble polymers, specific commercial products must be considered individually. It had been hoped at the beginning of the investigation that one could reasonably characterize the behavior of the generic chemical class of polymer—hydroxyethylcellulose, poly-(vinylalcohol), etc.—with perhaps a further specification concerning the degree of polymerization (DP) and the degree of substitution (DS). The laboratory regretted to conclude that this would rarely be possible. Instead, within any given general chemical class of these water-based polymers, as yet unaccounted for variations in stability exist between products. Thus, certain commercial products of the type of polymer generally considered to be unstable can, on occasion, be found to be reasonably stable, and vice versa.

As a convenient point of reference, Arney drew attention to the fact that methylcellulose and carboxymethylcellulose, the most stable classes of cellulose ethers, tended to exhibit thermal stability with respect to discoloration comparable to cellulose itself, as represented by the behavior of Whatman #1 filter paper (a material standard control) or at the very worst, newsprint.

In summary, the conclusion of the 1981 investigation of cellulose ethers was that methylcellulose and carboxymethylcellulose were stable materials; ethylcellulose, unstable. Hydroxypropylcellulose (Klucel), hydroxyethylcellulose, and organic-soluble ethylhydroxyethylcellulose were rated intermediate, warranting further study.

Note

1. The tables and graphs in this chapter have been assembled from the final report submitted to the National Museum Act, July 1981 (Grant No. FC-005057), titled "The Thermal and Photochemical Stability of Water-Soluble Resins" (Feller 1981a). The data have not been published elsewhere, although the essential findings were presented at a workshop on adhesives arranged by the Objects Specialty Group at an annual meeting of the American Institute for Conservation in Philadelphia (Feller 1981b).

5 Description of Materials and Experimental Procedures

This chapter and the following (Chapter 6, "Results and Discussion") describe the testing and evaluation of cellulose ethers by Dr. M. Wilt at the Research Center on the Materials of the Artist and Conservator, Mellon Institute, in 1986–1987. Some supplementary tests on the darkening of cellulose ethers when cast as films on glass or sizes on paper were carried out by John Bogaard (Figs. 6.4–6.7).

Materials

The cellulose ethers listed in Table 5.1 were employed in the technical studies sponsored by the Getty Conservation Institute. Most of the samples were obtained early in 1986. Whenever possible, a number of ethers of the same generic chemical type, but from different manufacturers, were selected in a range of molecular weights (that is, various viscosity grades). The objective was to determine, if possible, their characteristic behavior. All samples were generously supplied by the manufacturers. Products were tested as received; no special purification procedures were used.

Experimental Procedures

Weight Loss and Color Change of Powders

To determine weight loss, about 10 grams of various cellulose ether powders were put into either 4-ounce jars or 90-millimeter-diameter Petri dishes, which were then placed in a circulating-air oven at either 90 °C or 110 °C. Changes in weight and color of the samples were noted at intervals. The initial weight loss observed after heating overnight was considered to be moisture rather than thermal degradation. Powders that had discolored markedly in initial tests of thermal aging were not evaluated extensively in further studies.

Weight Loss and Color Change of Films on Glass

In addition to the tests on bulk samples, films of some of the ethers were prepared on glass plates. In these experiments, about 2 milliliters of 2% solution were applied to small glass plates, coating an area of approximately two square inches. Samples were allowed to air dry for an hour and a half and then were put in an oven for two hours at 50 °C. Each slide was then relayered and dried in the same manner until a coating of approximately one-mil (0.001") thickness was achieved.

Table 5.1. Cellulose ethers tested.

Polymers (Designated by Registered Trade Names)	Chemical Composition (Generic Class)	Viscosity, Centipoise 2% Solution in Water, 25 °C
Ethylhydroxyethylcelluloses		
EHEC-Low	EHEC-OS	3.5–5.0*
EHEC-High	EHEC-OS	15–25*
Ethulose 400	EHEC-WS	400
Ethylcelluloses		
Ethocel S-100	EC	8*
Ethylcellulose N-14	EC	2.8*
Methyl- and methylhydroxypropylcelluloses		
Methocel A4C	MC	400
Methocel A4M	MC	4000
Methocel E4M	MHPC	4000
Methocel K100-LV	MHPC	100
Culminal	MC	1000
Hydroxyethylcelluloses		
Natrosol 250L	HEC	50–70
Natrosol 250LR	HEC	50–70
Natrosol 250MR	HEC	4,500–6,500
Natrosol 250HR	HEC	20,000–35,000
Hydroxypropylcelluloses		
Klucel L	HPC	10–15
Klucel G	HPC	150–400
Klucel M	HPC	4,000–6,000
Klucel H	HPC	14,000–18,000
Sodium carboxymethylcelluloses		
Cellulose Gum 7L1	CMC	18
Cellulose Gum 9M8	CMC	400–800
Cellulose Gum 7H4	CMC	2,500–4,500
Cellulose Gum 7HF	CMC	12,000–16,000
Cellofas B-3500	CMC	3,500

*Viscosity in 4/1 Toluene/95% Ethanol at 25 °C.

Eleven prepared test films were thermally aged for a total of 706 hours at 90 °C. In addition, a blank glass plate was used as a control for weight and color measurements, particularly to monitor spectrophotometric readings. Reflectance measurements were made relative to a $BaSO_4$ planchet covered with a piece of the same glass. All samples were measured backed by a stack of six Millipore® sheets as a standard white background (98.7% luminous reflectance relative to $BaSO_4$); the specular component was excluded. The Kubelka-Munk K/S values were calculated from the reflectance (R) measurements at 460 nm where $K/S = (1 - R)^2/2R$. Yellowness Index (YI) values were also calculated from the X, Y, and Z tristimulus values using the following formula recommended by ASTM Standard D1925:

$$YI = (128X - 106Z)/Y.$$

Color Changes of Cellulose Ethers Applied as Paper Size

Solutions were prepared at 1% concentration in water, with the exception of Klucel G, which was prepared both in water and in ethanol. In addition to the cellulose ethers, a poly(vinylalcohol) sample, a relatively unstable polymer, was tested to provide a point of reference. The polymers were applied to unaged Whatman #42 filter paper sheets by means of a stainless-steel draw-down bar (4-mil spacing). The sheets were placed on a glass surface, about 2 milliliters of each solution were applied to the paper with a pipet and drawn down quickly, with the excess pulled off the sheet. The sample area amounted to approximately 3 x 5-1/2 inches. The less viscous polymer solutions yielded considerable excess after draw-down; the more viscous solutions (Cellofas, Elvanol, and Methocel A4M), little or none. The samples were allowed to air dry overnight, and were not recoated. For comparison, a draw-down was made on a piece of filter paper using only deionized water.

Prior to aging, the samples were inspected visually. The water-treated samples had curled somewhat upon drying; the samples with the ethanol-based application of Klucel, which dried very rapidly, did not curl. The samples were divided in two: one set was aged at 90 °C under "dry oven" conditions; the other was exposed to daylight fluorescent lamps at room temperature in a constant environment room. Thermal aging was carried out for a total of 731 hours. Light exposure was carried out for 735.7 hours, amounting to something on the order of 10 million footcandle hours (about 100 Mlxh).

Spectrophotometric reflectance measurements were made relative to $BaSO_4$ using a Color-Eye® 1500 abridged spectrophotometer (Kolmorgen Company). Because the samples were translucent, they were placed over a white background comprised of a stack of six Millipore sheets. The specular component was included. As mentioned, reflectance values at 460 nm were used to calculate K/S values.

Peroxide Determination

For this determination, approximately one gram of cellulose ether was dissolved in an appropriate solvent. After the addition of 5 milliliters of glacial acetic acid and 1.0 milliliters of saturated aqueous sodium iodide, the solution was allowed to stand for one hour after which the liberated iodine was titrated with 0.1 N or 0.01 N $Na_2S_2O_3$. During the titration, the solution was stirred with a magnetic stirrer and the $Na_2S_2O_3$ solution added drop by drop.

Peroxide determinations were made in this manner on samples of powders aged at 90 °C in a circulating-air oven and on powders aged at 90 °C and 50% relative humidity in an environmental chamber. Determinations were also made on commercial samples that had been on the shelf for a number of years. Films coated on glass and exposed to daylight fluorescent lamps at 23.5 °C and 50% relative humidity were also checked for peroxide content.[1]

Viscosity Determination

Intrinsic Viscosity

For measurements of loss in intrinsic viscosity, one-gram samples of the powders were placed in four-ounce jars and aged at 90 °C. The aged samples, as well as some unaged samples, were dissolved in an appropriate solvent in the same jar (to decrease materials handling) using a magnetic stirrer. When solution was complete, the contents of the jar were transferred to a volumetric flask and diluted 100 milliliters to volume with the solvent being employed. This solution was then diluted further, usually one to five or one to ten to obtain a series of diluted solutions whose viscosities were subsequently determined and the limiting viscosity at zero concentration of polymer determined from a graphical plot. Initial studies were made using a Size 200 Cannon-Fenske viscometer immersed in a constant-temperature (\pm 0.1 °C) water bath. After allowing the viscometer and its contents to reach the bath temperature, viscosity measurements were made until three consecutive runs differed by no more than 0.1 second. Normally even this slight variation was not observed. Later, viscosity measurements were determined simply with a Brookfield viscometer (see below).

To determine the viscosity of carboxymethylcellulose, a 0.1 N solution of NaCl was used as a solvent. This is done to repress ionization; otherwise, the apparent viscosity will increase with dilution.

To determine the changes in the viscosity of polymers exposed as films, solutions of the ethers at 10% concentration were prepared in appropriate solvents and poured into 8 x 11-inch glass baking dishes to evaporate. The bottoms of the outside of the dishes were marked off in one-inch strips and the amount of solution adjusted so that, when it was cut out of the dish, a one-inch strip yielded about 1.0 gram of polymer. The outside of the bottom was covered with aluminum foil in order to reflect the light and thus increase the amount of light passing through the coating.

The dishes were placed so that the films were about three inches from a bank of daylight fluorescent bulbs. Periodically, samples were removed, cut into small pieces, weighed, dissolved in an appropriate solvent, and the intrinsic viscosity (or peroxides) determined.

Brookfield Viscosity Determination

Many of the cellulose ethers proved difficult to handle in capillary viscometers. The solutions often contained traces of insoluble matter or developed insoluble matter upon aging. Such particles are usually detected only after the capillary viscometer becomes clogged. Determination of viscosity of 1 or 2% solutions in a Brookfield viscometer (a spindle-type viscometer) is regularly used by manufacturers in quality control, and it was decided to use the Brookfield to monitor most of the later degradation studies.

The Brookfield viscometer was a Model LVF which, with a combination of four speeds and four spindles, can be used to measure viscosities from 1 to 100,000 cP. Because no calibration curve was available, three standard silicone oils were purchased from the Brookfield Engineering Laboratories, Stoughton, Massachusetts. The temperature of the oils was adjusted to 25 °C in a constant-temperature bath before determination of their viscosities. Data obtained showed that the viscometer was in excellent condition.

To prepare a solution, a cellulose ether powder usually must be physically dispersed in the solvent before appreciable solvation occurs. If this is not done, the powdered material will agglomerate and thereafter dissolve slowly. Once the ether is solvated it dissolves readily. Some ethers show a cloud point (the temperature at which they become insoluble). Advantage can be taken of this phenomenon in preparing solutions of some ethers by first achieving a good dispersion of the powder in hot water, in which they do not tend to dissolve, and then adding the remainder as cold water. Thus, the ethers in Table 5.2 were first dispersed in hot water at about half the amount needed to give a solution of desired final concentration (1 or 2%); temperatures were those recommended by the suppliers.

Table 5.2. Water temperature used for dispersion.

Polymer	Temperature
Methycellulose (MC)	70 °C
Hydroxypropylcellulose (HPC)	55 °C
Ethylhydroxyethylcellulose (EHEC)	70 °C
Hydroxypropylmethylcellulose (HPMC)	70 °C

After the polymer was well dispersed in the warm water (3–5 minutes), the remainder of the water was added at room temperature and agitated for one hour. Solutions of CMC and HEC were prepared by slowly adding them to agitating water at room temperature.

A Waring blender with a 40-fluid-ounce jar was used to agitate the water. To avoid excessive agitation, the blender speed was set to low and the movement further reduced with a transformer (a 20-volt setting produced a slight vortex). Violent agitation was avoided because it could generate foaming or reduce solution viscosity. Once prepared, the solutions were stored overnight in 16-ounce, wide-mouth jars to allow the solution to de-aerate.

To determine the viscosity, a jar of solution was submerged as far as possible and then clamped down in a constant-temperature bath at 25 °C. As the temperature was being adjusted, the solution was gently agitated with a glass thermometer. When the temperature of the solution reached 25 °C, the jar was placed beneath the viscometer and the viscometer lowered into the solution until the level reached the specified depth mark on an appropriate spindle; the viscometer speed was adjusted and readings made after one to three minutes. The viscometer reading was multiplied by the appropriate factor (depending on spindle number and viscometer speed) to convert the reading to centipoise. Two to four readings were made for each solution.

Exposure to Light

For exposure, samples were placed on steel-grid shelves at a distance of three inches from a bank of six daylight fluorescent lamps (General Electric F48T12/D/HO) in a room maintained at a constant temperature (23.5 °C) and constant humidity (50%). Sample temperatures under these circumstances reached about 25 to 28 °C. Emission from the lamps contained about 2% near ultraviolet radiation. The intensity on the specimens was about 14,445 lux (1350 footcandles).

Note
1. A discussion of reports in the literature concerning the formation of peroxide in ethyl-cellulose appears in Appendix F.

6 Results and Discussion

Discoloration and Weight Loss

Thermal Aging of Powders at 110 °C

A preliminary study was done to determine the most obvious effects of aging and to provide an initial ranking of the polymers with respect to thermal stability. Approximately 10 grams of each granular-powdered sample, as received from the manufacturer, were placed in an uncovered Petri dish and exposed in a circulating-air oven at 110 °C for a total of 139 hours. Cellulose (Whatman #42 filter paper) was included as a control.

After a relatively rapid loss of weight during the first three to five hours (regarded as moisture loss), the samples lost weight at a constant rate (Table 6.1). The amount of weight polymers lose during aging is often a useful indication of their potential long-term stability (Berg, Jarosz, and Salathe 1967).

All of the cellulose ethers proved to be less stable than cellulose with respect to discoloration and weight loss. In general, the degree of discoloration of the samples paralleled weight loss (Fig. 6.1). The alkoxyalkyl ethers (EHEC, HPC) were less stable than the simple alkyl ethers (MC, EC).

The small differences in the weight losses in Table 6.1 may be disregarded. The results simply establish three principal categories of stability with respect to weight loss.

Thermal Aging of Powders at 90 °C

Because heating at 110 °C may be considered to be unsuitably severe, a second set of samples were aged at 90 °C (Table 6.2). Two organic-solvent-soluble ethers, EHEC-High® and Ethocel S-100 (EC), showed large weight loss and EHEC exhibited a marked change in color. Three of the water-soluble ethers—Cellulose Gum 9M8 (CMC), Methocel A4M (MC), and Methocel A4C (MC)—showed only slight weight loss and remained colorless.

Klucel M (HPC) showed both a large weight loss and a marked color change (Fig. 6.2). Natrosol 250MR, the only hydroxyethylcellulose (HEC) in this test set, showed only a modest weight loss, but there was a significant change in color. The yellowing of Tylose hydroxymethylcellulose under accelerated-aging conditions has been reported (Verdu, Bellenger, and Kleitz 1984). Again, about three categories of thermal weight loss are noted.

Table 6.1. *Weight loss and color change of cellulose ethers at 110 °C.*

Sample	Weight Loss mg/hr*	Color of Powder as Received	Color After 139 hrs.
Whatman #42 Filter Paper (control)	0.004	White	White
Methocel A4M (MC)	0.18	White	White
Methocel E4M (MHPC)	0.26	White	White
Ethocel S-100 (EC)	0.67	White	Very Light Tan
Natrosol 250LR (HEC)	1.3	Light Tan	Light Tan
Natrosol 250MR (HEC)	1.9	Very Light Tan	Light Tan
Natrosol 250HR (HEC)	1.2	Very Light Tan	Light Tan
Klucel L (HPC)	0.54**	White	Tan
Klucel M (HPC)	2.7***	White	Tan
Klucel H (HPC)	2.3***	White	Tan
EHEC-Low (OS-EHEC)	3.6***	Very Light Yellow	Dark Tan
EHEC-High (OS-EHEC)	3.4***	Very Light Yellow	Dark Tan

*Determined from the slope of the weight loss line between 19 and 139 hours, i.e., after an initial loss in weight that is considered loss of moisure content.

**This sample did not fuse as did the other two Klucels.

***Powders had fused, becoming translucent.

Table 6.2. *Moisture content and weight loss of powdered cellulose ethers on aging at 90 °C for 26 days (624 hours).*

Ether	Moisture, %	Percent Weight Loss After Initial Drying	Color	
			Before Aging	After Aging
Cellulose Gum 9M8 (CMC)	9.8	0.42	Water-white	Water-white
Methocel A4C (MC)	3.6	0.48	Water-white	Water-white
Methocel A4M (MC)	2.3	0.62	Water-white	Water-white
Natrosol 250MR (HEC)	5.1	1.2	Very light tan	Light tan
Ethulose 400 (WS-EHEC)	4.5	1.19	Water-white	Off-white
Ethocel S-100 (EC)	0.8	9.75	Water-white	Water-white
EHEC-High (OS-EHEC)	1.1	11.7	Yellow tint	Fused, light tan
Klucel M (HPC)	3.3	19.6	Off-white	Fused, light tan

Figure 6.1. Samples of cellulose ether powders after heating for 139 hours at 110 °C.

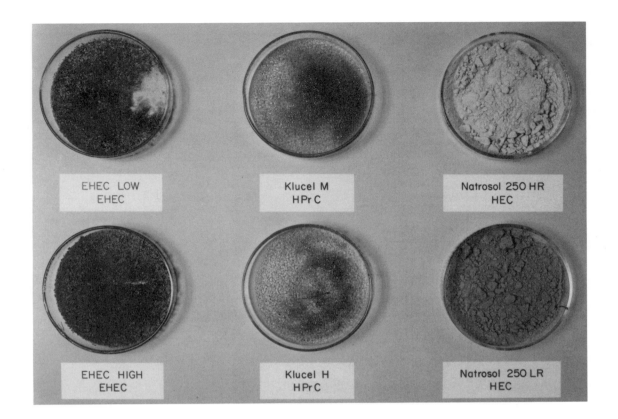

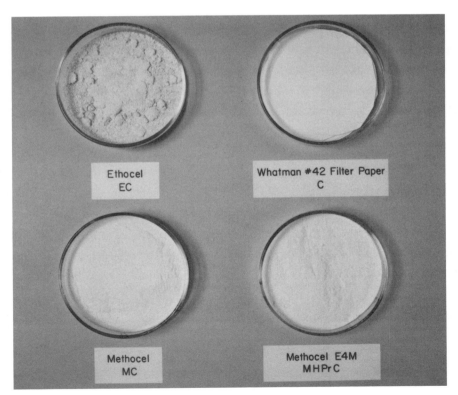

Figure 6.2. Weight losses experienced at 90 °C. Hydroxyethylcellulose (Natrosol 250MR) compared to hydroxypropylcellulose (Klucel M).

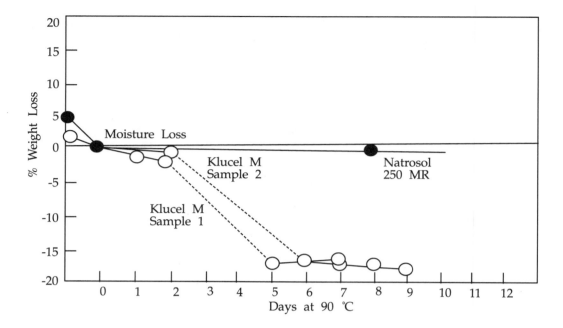

Figure 6.2. Weight losses experienced at 90 °C. Hydroxyethylcellulose (Natrosol 250MR) compared to hydroxypropylcellulose (Klucel M).

Films on Glass After Aging at 90 °C

Color change is readily apparent in bulk samples. In thin films, however, the change may scarcely be noticeable. Therefore, in a follow-up series of tests, films were coated onto glass plates to an approximate thickness of 0.001 inch. A visual and microscopic examination of each dried film was made prior to thermal aging at 90 °C. For each ether type, low or medium molecular weight grades formed the best appearing surface. The higher viscosity grades tended to trap air bubbles, resulting in craters or holes in the surface as the films dried. This problem was minimized, however, when the solutions were allowed to stand for some time before attempting to cast films.

Microscopic Examination

Differences in quality among commercial products are sometimes apparent when a drop of solution or dried film is examined under the polarizing microscope. To the naked eye, all the Klucel hydroxypropylcelluloses formed films that were clear and smooth. Under the microscope, the low viscosity types, L and G, were particularly clear and transparent. Type M, however, showed some tendency towards orientation; microcrystallites were visible when observed with a polarizing microscope with a sensitive-tint retardation plate in place. Type H films had even more oriented areas.

The film of Ethulose 400 (water-soluble ethylhydroxyethylcellulose, WS-EHEC) was smooth, but a bit frosty looking, as if it had a small amount of fine particulates in it. Under the polarizing microscope, the film was observed to exhibit considerable birefringence.

The three methylcellulose films referred to in Figure 6.5 had a distinct frosty or matte appearance. Insoluble in hot water, methylcellulose will yield a clear solution in cold water (5 °C) that becomes cloudy if warmed to room temperature; force-drying the films at 50 °C causes them to be higher than the gelation temperature. Nonetheless, the frosty appearance of the films was much the same even when the coatings were allowed to dry at room temperature. It appeared as though the "fines" had separated out, but were held in suspension at room temperature. Under the polarizing microscope, the higher viscosity grade Methocel A4M exhibited more fibrous structure than the lower viscosity type, A4C. In contrast to methylcellulose, hydroxypropylcellulose (Klucel, or HPC), also insoluble in hot water, yielded a clear solution at room temperature. Under the microscope, the dried films appeared slightly birefringent.

The carboxymethylcelluloses were the most difficult to apply to the glass evenly. The resultant films also appeared slightly frosty. When examined under the microscope, some birefringent orientation was revealed, but no fibrous structures (Fig. 6.3). Again, the higher viscosity sample showed more orientation.

Figure 6.3. Photomicrographs of insoluble fragments sometimes seen in cellulose ether films. Magnification 440x.
(a) Typical structure of cellulose fiber partially swollen by alkali along with unreacted fibers in Culminal film.
(b) Unreacted cellulose fiber bundle in Culminal.

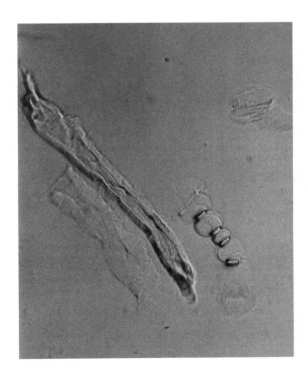

Color Change

The results after aging at 90 °C, illustrated in Figures 6.4, 6.5, and 6.6, indicate that, when applied as thin films, most of the coatings exhibited little or no color change. The dotted line in Figure 6.4 shows the color change for cellulose thermally aged under similar conditions. From the results, it can be seen that most films of the cellulose derivatives were more resistant to color change than a sheet of filter paper. The exceptions are the two highest molecular weight grades of Klucel, M and H. It was shown earlier that dry powders of these hydroxypropylcelluloses darken considerably upon thermal aging; here, when exposed as thin films, the darkening was most pronounced along the edges. The lower molecular weight grades of Klucel did not darken discernibly in these tests, whereas noticeable darkening occurred when the same materials were heated as powders (Tables 6.1 and 6.2).

Figure 6.4. Discoloration of 1-mil thick coatings of various Klucels (HPC) on glass plates compared to the rate of discoloration of Whatman #42 filter paper at 90 °C, expressed both as change in yellowness index (YI) and Kubelka-Munk K/S values at 460 nm.

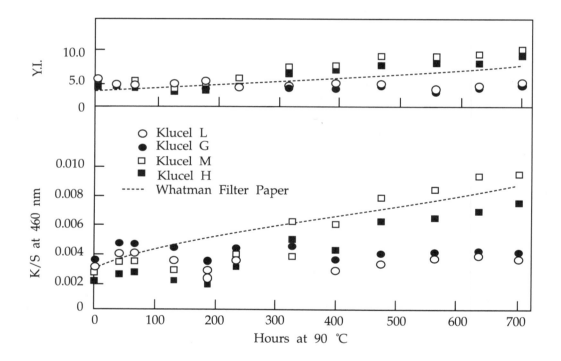

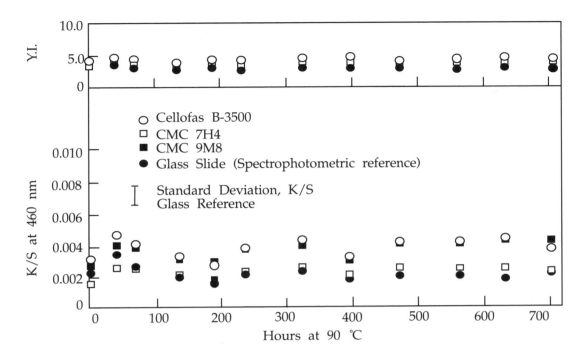

Figure 6.5. Negligible discoloration of 1-mil thick coatings of carboxymethylcelluloses (CMC) on glass plates heated at 90 °C expressed in same terms as in Figure 6.4.

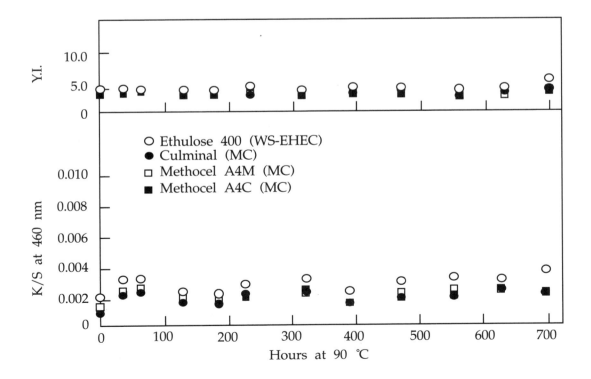

Figure 6.6. Negligible discoloration of 1-mil thick coatings of various cellulose ethers on glass plates heated at 90 °C expressed in same terms as in Figure 6.4.

With all the other samples there were variations in the color measurements owing to experimental errors, but no significant tendency to darken. To measure yellowness, the films on glass were backed with Millipore filters as a standard reference white. In the resulting high reflectance range (about 80%), the K/S values are very low (0.02 and less); the graphs magnify the changes out of proportion to the expected error in the measurements. A 1% error in reflectance at 460 nm, for example, would amount to a change of about 0.002 in K/S. The experimental variations in K/S are illustrated by the results on the blank glass slide backed with Millipore filters (Fig. 6.5); for reference, the size of the standard deviation of the measurements on the piece of window glass that served as a control is indicated. For further comparison, one may note that the reflectance at 460 nm, similar to Tappi brightness (Feller 1987b), of the filter paper in Figure 6.4 decreased from about 93% to 88% (K/S from 0.003 to 0.008). The only instance of noticeable darkening is with the two highest molecular weight grades of Klucel.

The initial weight of the samples varied from 0.07 gram to 0.11 gram. Changes in weight on the order of 1% or less would not have been confidently detected in this experiment designed primarily to measure discoloration. Nonetheless, the largest changes were observed with the yellowed Klucel samples, which lost about 20% in weight, and the carboxymethylcelluloses (CMC), which lost about 10%. There were no trends toward a continued weight loss for any of the samples. All cellulose ethers have an equilibrium with absorbed moisture of about 10% (up to 18% for CMC). Thus, much of the weight variation can probably be attributed to accidental variations in moisture content that occurred during weighing. The loss of weight in the yellowed Klucels, on the other hand, can be considered significant, reflecting thermal degradation.

The conclusion from these tests is that, in thin films, color development is scarcely noticeable, except in the case of the two hydroxypropylcelluloses of the highest molecular weight. These yellowed about as much as a good grade of filter paper.

Color Change on Sized Paper

After experiments showing that discoloration of ethers was often scarcely noticeable in thin films, it was decided to monitor color changes in papers coated with size based on these polymers. The results, shown in Figure 6.7, reveal that for the most part, when typical low concentrations of these materials are applied as size, there is little thermally induced discoloration. Supplementary tests showed that none of the samples darkened when exposed to daylight fluorescent lamps.

In every case, thermal aging produced darkening (Fig. 6.7). However, only two samples seemed to darken more than the blank filter paper itself: Elvanol poly(vinylalcohol) and Cellofas B-3500 (CMC). The result is not surprising. Poly-(vinylalcohol), taken as a material standard, is known to be a poor material with respect to discoloration. The darkening of Cellofas-treated sheets is interesting since this material did not darken appreciably when thermally aged on a glass slide. It may

be that the thinner film and accompanying greater surface area when applied as a size allowed greater vulnerability of Cellofas to oxidative attack. It may also be true that Cellofas appeared darker than some of the other resins because there was a larger quantity applied to the paper. The sized specimen darkened more than the untreated paper.

Conservators have known for some time that Cellofas B-3500 tends to discolor more readily than some other CMC products (Baker 1984). Nonetheless, there is a general statement regarding the discoloration of CMC as a size on cloth that is worth noting:

> In the attempt to avoid some of the disadvantages of starch, the carboxyalkyl celluloses, represented by carboxymethylcellulose typically in the form of its sodium salt, have been employed as a substituent for starch. While this product offers various advantages over starch, it has the disadvantage that it undergoes at least incipient pyrolysis and discoloration at temperatures substantially lower than those employed in ironing most fabrics which are starched. In an attempt to deal with this problem, some commercially packaged products carry on the label a legend advising the user to set the temperature of the iron at one fabric position lower than that which it would ordinarily be set . . . this approach is undesirable in that even when such instructions are followed, scorching can occur easily (Meltzer 1976).

In Figure 6.7, differences in behavior are practically indistinguishable. Nonetheless, the two Methocels and Klucel G appear to be stable materials. There was no difference in darkening whether the Klucel G was dissolved in water or ethanol; both did equally well.

The treatment with water alone did not seem to cause any extensive darkening, except that a distinct, brown "tide line" formed at the upper edge of the treatment area after aging. A brown edge was also seen as the result of thermal aging of the poly(vinylalcohol), which also produced a slight grey appearance at the edge on exposure to light. The other samples seemed to darken at about the same rate as the paper itself. They did not darken at the edges. The greater darkening of the paper "control" (greater change in K/S) in these experiments (Fig. 6.7) compared to the filter paper shown in Figure 6.4 may have been due to the fact that the paper in Figure 6.7 had been treated with water prior to aging.

Figure 6.7. Increase in yellowness index (YI) and K/S value (discoloration) upon heating at 90 ℃ of filter papers to which 2% solutions of various ethers have been applied compared to color change of filter paper control.

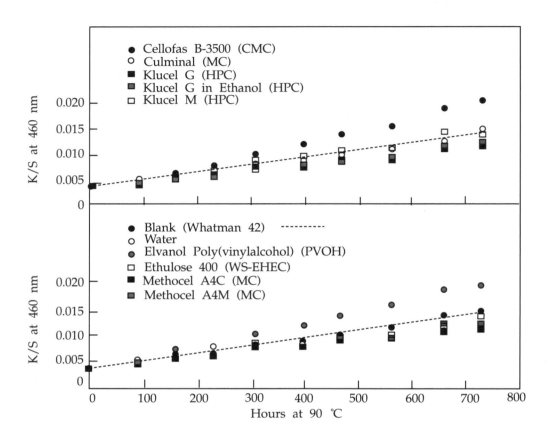

Figure 6.8. Peroxide formation in ethylcellulose (EC) and organic-soluble hydroxyethylcellulose (EHEC) polymers thermally aged at 90 ℃.

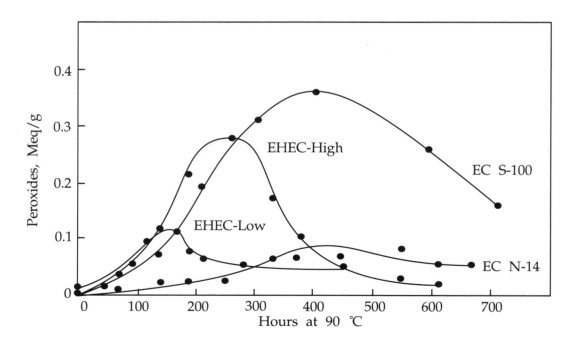

Conclusions

The results of these tests of thermally induced discoloration, particularly in bulk samples, demonstrate that conservators have been wise to avoid the organic-soluble ethers, ethylcellulose and ethylhydroxyethylcellulose. These particular polymers either exhibit notable weight loss when heated or they discolor markedly. Similar comments apply to organic-soluble hydroxyethylcellulose and to the higher molecular weight Klucels (HPC). The HECs fell into an intermediate category. Methylcelluloses and carboxymethylcelluloses would represent sound choices by the conservator with respect to their intrinsic stability.

Peroxide Formation in Cellulose Ethers

Thermal Aging at 90 °C

The formation of hydroperoxide groups during the aging of polymers can lead to a chain of chemical reactions that results in weight loss, discoloration, and degradation of molecular weight. It has been known for some time that ethyl and higher alkyl cellulose ethers tend to form peroxides; Appendix G discusses a number of studies reported in the literature. In the present research, it was considered desirable to examine the possible tendency of other types of cellulose ethers to form peroxides.

Initial experiments involving EHEC-Low, EHEC-High, Ethocel S-100, Ethocel N-14, and Klucel L are summarized in Table 6.3 and illustrated in Figure 6.8. The concentration of peroxide, assumed to be largely in the form of hydroperoxide (ROOH), is expressed as milliequivalents per gram of cellulose ether (meq/g). As anticipated, thermal aging of the ethers in this test series revealed a gradual increase in peroxide content, which reached a maximum and then declined. The exception was Klucel L, which showed no peroxide formation at 90 °C (Table 6.3) and only a trace of peroxide formation at a late stage under fluorescent lamps (Table 6.4). In the case of both organic-soluble polymers, ethylhydroxyethylcellulose and ethylcellulose, the material of higher molecular weight showed the higher maximum concentration of accumulated peroxide. EHEC-High showed a maximum peroxide content of 0.278 meq/g, while EHEC-Low showed only 0.110 meq/g. Ethocel S-100 had a maximum peroxide accumulation of 0.367 meq/g, while the lower molecular weight Ethocel N-14 showed a maximum of 0.077 meq/g. As seen in Figure 6.9, peroxide formation usually began almost immediately.

A concentration of 0.367 meq/g of EC is equivalent to saying that about 6.4 peroxide groups are present per 100 anhydroglucose units in an ethylcellulose having 47% ethoxyl content, or about 3 per 100 ethoxyl groups. Koz'mina and his coworkers found almost the same maximum in a sample of ethylcellulose heated at 110 °C (Kozlov 1961: fig. 2).

Table 6.3. Peroxide formation during thermal aging at 90 °C ; peroxide, meq/g (see also Figure 6.8).

Time, hours	EHEC-Low (OS-EHEC)	EHEC-High (OS-EHEC)	Ethocel N-14 (EC)	Ethocel S-100 (EC)	Klucel * (HPC)
0	0.015	0.003	0.011	0.001	0.00
24	0.030	–	–	0.003	0.00
48	–	–	–	0.017	–
72	–	0.035	0.022	0.023	–
96	–	–	–	0.055	–
120	0.095	–	–	–	0.00
144	–	0.121	0.036	0.074	–
168	0.110	–	–	0.113	0.00
192	0.075**	0.214	0.045	–	–
216	0.064	–	–	0.196	0.00
264	–	0.278	0.044	–	–
288	0.056	–	–	–	0.00
312	0.056	–	–	0.316	–
336	–	0.167	0.071	–	–
384	–	0.102	0.069	–	–
408	–	–	–	0.367	–
456	0.045	0.048	0.073	–	0.00
552	–	0.027	0.077	–	–
600	–	–	–	0.271	–
624	–	0.020	0.056	–	–
672	–	–	0.056	–	–
744	–	–	–	0.160	–

*Note that Klucel is the only water-soluble example.

**Sample had fused; solutions had a slight yellow tint before peroxide determination.

Because the water-soluble polymer in this series, Klucel L, showed little peroxide accumulation, a number of other water-soluble cellulose ether powders were tested in a subsequent series in which samples were aged 96 hours at 90 °C. The group included Methocel A4C (MC), Methocel K100-LV (MHPC), Natrosol 250L (HEC), and Cellulose Gum 7L1 (CMC). None showed peroxide development. In another experiment, the water-soluble ethylhydroxyethylcellulose (WS-EHEC), Ethulose 400, showed no accumulation of peroxides after 1344 hours at 90 °C. Because this compound contains ethyl ether groups, this result was unexpected.

Table 6.4. *Peroxides in cellulose ether films coated on glass and exposed under daylight fluorescent lamps at 23.5 °C and 50% relative humidity; peroxide, meq/g.*

Time, hours	EHEC-Low (OS-EHEC)	Ethocel S-100 (EC)	Klucel L (HPC)
0	0.015*	0.00	0.00
48	0.040	0.006	0.00
96	0.058	0.004	0.00
264	0.178	0.010*	0.00
432	0.383	0.020	0.00
600	0.579**	0.026	0.00
768	0.744	0.036	0.003
936	0.848	0.047	0.006
1104	–	0.080	0.005
1368	–	–	0.006

*Film had separated from glass.

**Film very brittle, shattered on cutting.

It was concluded that the accumulation of significant amounts of peroxide during thermal aging at 90 °C is a phenomenon exhibited principally by the organic-solvent-soluble cellulose ethers. This does not necessarily mean that there is no peroxide mechanism involved in the degradation of water-soluble types; it may simply mean that the concentration is too low to be detected by the method of analysis used.

Cellulose Ether Films Aged Under Fluorescent Lamps

Shown in Table 6.4 and Figure 6.9 is the effect of exposure to the visible and near-ultraviolet radiation emitted by daylight fluorescent lamps in stimulating the formation of peroxides in two organic-soluble polymers, EHEC-Low and Ethocel S-100. At the low temperature of the experiment, the materials did not attain a maximum in peroxide content, although it is considered that a maximum would eventually occur. Under these conditions, 800 hours of exposure is equivalent to about 11 million lux-hours (Mlxh) or 1 million footcandle hours. A water-soluble cellulosic polymer, Klucel L, showed only a slight tendency to accumulate peroxides even after long exposure.

Attempts were made to determine the detrimental effect that peroxide formation might have on two aspects of aging that are of interest to a conservator. In one test, British Standard BS1006 blue-wool cloths were saturated with a coating of EHEC-Low. In another, inks based on solutions of organic-solvent-soluble dyes formulated with EHEC-Low were used to coat strips of filter paper. Upon exposure to the same bank of fluorescent lamps used to generate peroxides, the presence of the EHEC-Low did not noticeably influence the amount of fading of the blue-wool standards or of the organic-solvent-soluble inks. One should not conclude from this that the presence of peroxides in such films will not affect the fading of dyes and organic-

based pigments in contact with them, only that these two simple tests failed to reveal an immediate and obvious influence.

Photochemical Aging of Cellulose Ether Powders at 90 °C and 50% Relative Humidity

Because high relative humidity accelerates the degradation of cellulose, a test was made on the effect of high humidity on peroxide generation. The results in Table 6.5 indicate that high humidity apparently has a repressing effect on the rate of peroxide formation in comparison to the rates when humidity was not controlled, as illustrated by the results in Figure 6.8. After 186 hours at 90 °C under dry conditions, EHEC-Low and Ethocel S-100 had about 0.11 meq peroxide per gram of polymer, where there was less than 0.001 meq under the humid conditions. The influence of humidity on the aging of cellulose ethers warrants further research.

Table 6.5. Peroxides in cellulose ether powders aged at 90 °C and 50% relative humidity.

Material	Composition	Time, hours	Peroxides, meq/g
EHEC-Low	EHEC	0	0.0145
		168	0.0002
Ethocel S-100	EC	0	0.0001
		168	0.0009
Natrosol 250LR	HEC	0	0.00
		168	0.00
Klucel L	HPC	0	0.00
		168	0.00
Methocel A4C	MC	0	0.00
		168	0.00
Methocel K100-LV	MHPC	0	0.00
		168	0.00

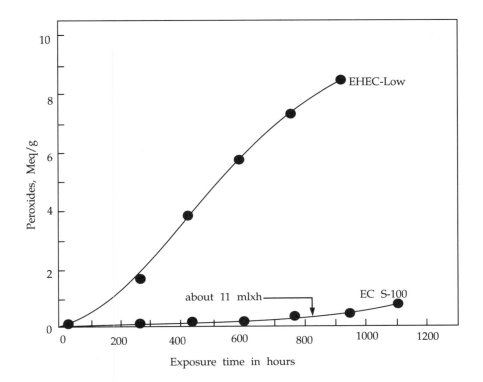

Figure 6.9. Peroxide formation in films of organic-soluble cellulose ethers (EHEC-Low and EC S-100) exposed under daylight fluorescent lamps.

Peroxides in Old Samples of Cellulose Ether Powders

The content of peroxides was examined in samples of various cellulose ethers that had been in containers on the laboratory shelf for periods of 5 to 13 years (Table 6.6). It was concluded that, if any appreciable amount of peroxide had formed while these samples were in cans at room temperature free from exposure to light, it had decomposed. Maximum concentrations as much as one hundred times greater were found in artificially aged products (Tables 6.3 and 6.4).

Table 6.6. Peroxide content found in 1987 in "shelf-aged" organic-soluble cellulose ethers.

Material	Date of Sample	Measured Peroxide, meq/g
EHEC-Low	3-74	0.003
Hercules EC T-50	6-81	0.032
Dow Ethocel S-7* (EC)	8-73	0.004

*This sample had an acrid odor when the bottle was opened.

Decomposition of Peroxides at 90 °C

A film of EHEC-Low was exposed under daylight fluorescent lights at a temperature of 23.5 °C and 50% relative humidity. After 1032 hours of exposure it was brittle and had accumulated 0.734 meq/g of peroxides. The film was then cut into small pieces and placed in a 90 °C, circulating-air oven. The samples were removed periodically and titrated for peroxide; the results are summarized in Table 6.7. The rapid rate of thermal decomposition of peroxide in this test helps explain why the maximum peroxide accumulation at 90 °C in a previous experiment (Fig. 6.8) was only about 0.110 meq/g: Peroxides readily decompose at high temperatures.

A plot of the logarithm of peroxide content as a function of time suggested that decomposition may have followed approximately first order decay at least for the first 10 hours, at which point more than 50% of the peroxide had decomposed.

Table 6.7. Decomposition of EHEC-Low peroxides at 90 °C.

Time, hours	Peroxide content, meq/g
0	0.734
4	0.500
7	0.416
16	0.289
24.5	0.241

Conclusions Regarding Peroxide Formation

The practical ramifications of the build-up of peroxides by organic-solvent-soluble cellulose ethers are not certain. Two simple tests revealed no obvious acceleration of the fading of pigments or dyes when formulated with or in contact with these coatings. Nonetheless, as discussed in Appendix G, it is known that peroxides are involved in the ultimate degradation of the ethers themselves; that is, in chain scission, which results in loss in degree of polymerization. It may be noted, for example, that the rise in photochemically produced peroxides shown in Figure 6.9 parallels the fall in intrinsic viscosity of the EHEC reported in Figure 6.12. Peroxide formation thus is an important factor in applications where long-term stability of coatings with respect to changes in DP is essential.

The tendency to form peroxides was observed primarily in the organic-soluble cellulose ethers; almost no peroxides were observed to be formed in the water-soluble types.

Fall in Intrinsic Viscosity of Cellulose Ethers During Accelerated Aging

In addition to studying discoloration, weight loss, and peroxide formation, measurements were made of the fall in viscosity of dilute solutions of the aged ethers. This sheds light on another aspect of degradation: the potential loss in molecular weight.

Powders Thermally Aged at 90 °C

The data obtained are summarized in Table 6.8 and Figures 6.10 and 6.11. Some ethers, Methocel K100-LV (MC), Methocel A4C (MC), and Natrosol 20L (HEC), were not amenable to measurement in a capillary viscometer owing to the formation of matter that was not readily resoluble.

With respect to loss in intrinsic viscosity, carboxymethylcellulose 7L1 (CMC) proved to be the most stable of the water-soluble types tested, with Klucel L (HPC) being the next most stable. The organic-solvent-soluble ethers (Fig. 6.11) exhibited a more rapid fall in intrinsic viscosity (indicating a more rapid loss of molecular weight) than did the water-soluble materials. This may be related to the fact that the organic-solvent-soluble ethers tend to develop peroxides under thermal-aging conditions.

Table 6.8. Changes in intrinsic viscosity (deciliters/g) at 25 °C as the result of thermal aging of cellulose ether bulk powders at 90 °C.

Time, hours	Organic-soluble (OS)				Water-soluble (WS)		
	Ethocel S-100* (EC)	Ethocel N-14* (EC)	EHEC-Low (OS-EHEC)	EHEC-High (OS-EHEC)	Klucel L (HPC)	Cellulose Gum 7L1** (CMC)	Natrosol 250L*** (HEC)
0	1.55	0.52	0.91	1.89	1.07	0.76	1.25
16	1.47	–	0.87	–	1.03	–	
40	1.37	–	0.80	–	0.96	–	
64	1.25	–	0.73	–	0.92	–	
88	1.02	–	0.69	–	0.78	–	
160	–	–	0.55	–	–	–	
168	0.59	–	–	–	–	0.71	Insolubles
216	–	–	–	0.53	–	–	
312	0.37	0.38	–	0.37	–	–	
336	–	–	–	–	0.58	–	
360	–	–	0.13	–	–	–	
480	–	0.23	–	0.14	–	–	
504	–	–	–	–	Insolubles	0.68	

*Organic-soluble (OS) polymers measured in 9/1 Ethanol/Toluene.

**Solvent 0.1N NaCl.

***Solvent 9/1 Water/Ethanol (Ethanol used as dispersant prior to water addition).

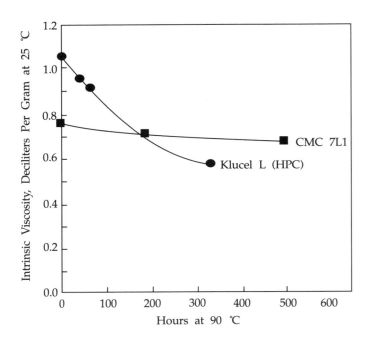

Figure 6.10. Change in intrinsic viscosity of powders of two water-soluble cellulose ethers during aging at 90 °C. Carboxymethylcellulose and Klucel L. (Data from Table 6.8.)

Figure 6.11. Change in intrinsic viscosity of powders of three organic-soluble cellulose ethers following aging at 90 °C. Ethylcellulose (EC) and organic-soluble ethylhydroxyethylcellulose (EHEC). (Data from Table 6.8.)

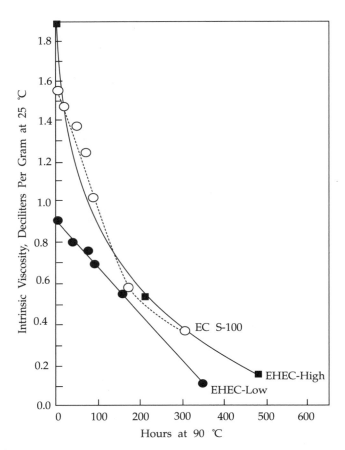

Exposure Under Fluorescent Lamps

Films of several cellulose ethers, prepared on glass as described above, were placed under daylight fluorescent lamps in a constant-environment room at 23.5 °C and 50% relative humidity. Intrinsic viscosity changes are summarized in Table 6.9 and are plotted in Figure 6.12. EHEC-Low began to show loss in intrinsic viscosity after 168 hours (2.4 Mlxh, about 220,000 footcandle hours). In contrast, Klucel L and CMC 7L1 remained essentially unchanged. One may recall that EHEC-Low showed a significant increase in peroxides when exposed under these conditions, beginning at 100 to 200 hours (Fig. 6.9); Klucel L showed no peroxide accumulation (Table 6.4).

Table 6.9. Intrinsic viscosity (deciliters/g) measurements of cellulose ether films aged under daylight fluorescent lamps at 23.5 °C and 50% relative humidity.

Time, hours	EHEC-Low EHEC 9/1 EtOH/Toluene	Klucel L HPC H_2O	Cellulose Gum 7L1 CMC 0.1N NaCl
0	1.13	1.03	0.68
168	1.15	1.03	0.69
336	1.00	1.02	0.68
504	0.73*	1.02**	0.66
752			0.68***

*Peroxide content 0.427 meq/g Film brittle.

**Film remained flexible.

***Film reasonably hard and stiff initially and did not change.

Figure 6.12. Change in intrinsic viscosity of three films of cellulose ethers exposed under daylight fluorescent lamps at 23.5 °C and 50% relative humidity.

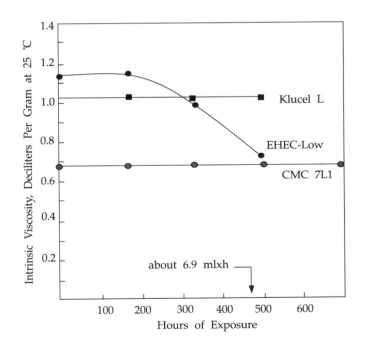

Brookfield Viscosity of "Shelf-Aged" Cellulose Ethers

Only small amounts of peroxide were found in old samples of several organic-solvent-soluble cellulose ethers (Table 6.6). However, the peroxide concentration may have had a higher value and subsequently declined. On the other hand, evidence of significant deterioration can be obtained if an old product ("shelf-aged") is found to have extensively diminished viscosity. Since the specified viscosity of products is often no more precise than a twofold range, either the precise viscosity of the original sample must have been measured or the viscosity of the shelf-aged polymer must have fallen well below the lowest specified viscosities. Table 6.10 summarizes measurements made on three ethylcellulose products, an ether known to deteriorate by a peroxide-induced mechanism, and on three water-soluble cellulose ethers, products that exhibit little tendency to form peroxides. The viscosity grades of 5- to 12-year-old samples of ethylcellulose products appear to have decreased considerably, whereas much less change appears to have occurred in Natrosol 250MR and Klucel M. The Culminal product may have significantly degraded; since it contained fragments of unreacted cellulose (Fig. 6.3), it may not be an MC of the highest quality.

Thus, although very low concentrations of peroxide were found in old samples of three organic-soluble types (Table 6.6), evidence suggests that a loss of viscosity grade may have occurred in three old samples of ethylcellulose and perhaps in a sample of Culminal methylcellulose and Natrosol 250MR. On the other hand, there was no evidence of marked deterioration in old samples of Klucel M. These results are not conclusive. Rarely would products be used after being on the shelf as long as those in Table 6.10. Nonetheless it is advisable for conservation laboratories to date all chemical products they acquire.

Table 6.10. Brookfield viscosity at 25 °C of 2% solutions of "shelf-aged" cellulose ethers.

Product	Approximate Date Acquired	In 1986–1987	In Fresh Samples	Lowest Specified Value
Organic-soluble				
Ethocel S-7 (EC)	1973	3	7	6
Ethocel S-100 (EC)	1981	25	100	90
Hercules T-50 (EC)	1981	11	43	25
Water-soluble				
Culminal (MC)	1981	700	1500	950
Klucel M	1981	4720	6000	4000
Natrosol 250MR (HEC)	1981	3840	5056	4500

Brookfield Viscosity of Aged Cellulose Ethers

Relationship Between Intrinsic Viscosity, Brookfield Viscosity, and Degree of Polymerization

From a technical point of view, perhaps it would have been desirable to determine the intrinsic viscosity of aged cellulose ethers by capillary viscometry. This was not practical, however, because many of the cellulose ethers developed bits of agglomerated matter, and these often clogged the viscometer. A Brookfield viscometer determines viscosity by measuring resistance to the turning of rotating spindles or drums of varying size and speed. The Brookfield viscosity of dilute solutions can be related to intrinsic viscosity and DP.

A survey of published information is presented in Figures 6.13, 6.14, and 6.15. Although the ratio of weight-average to number-average DP, DP_w to DP_n, is often 2.0, this is rarely the case with cellulose ethers (see Appendix I). As a consequence, only the available data has been used, whether DP_w or DP_n. The viscosity of 2% solutions of methylcellulose can be related to DP_w (Sarkar 1979) or DP_n (*Encyclopedia of Polymer Science and Technology* 1968:504); the latter are cited in Figure 6.13. Figures 6.14 and 6.15 are based on data in the technical literature on carboxymethylcellulose and Klucel hydroxypropylcellulose. For simplicity, the values of the Brookfield viscosity of 2% solutions, rather than the estimated values of DP, were generally used to follow degradation.

The Brookfield Viscosity of Solutions of Cellulose Ether Powders Aged at 90 °C

Hydroxyethylcellulose (HEC)

When Natrosol H and Natrosol M (HEC) bulk powders are thermally aged, there is a sharp decrease in the viscosity of 2% solutions of the polymers with time of aging (Fig. 6.16). After standing for five days, the solutions prepared from the aged polymers separate into two phases or zones: a clear, aqueous upper zone and a gelatinous, light brown, lower zone. The clear upper layer from the 1% Natrosol HR contained only 0.58% solids instead of the expected 1% as formulated; from the 2% Natrosol MR, there were 0.87% solids. In Arney's investigation, the formation of insoluble matter was noted in this ether (Fig. 4.4).

Hydroxypropylcellulose (HPC)

The decrease in the Brookfield viscosity of solutions of various Klucel bulk powders (HPCs) after heating at 90 °C is plotted in Figure 6.17. Again there is a sharp decrease in the viscosity of solutions of the aged polymers. Chain breaking is thought to be the main aspect of degradation. The solutions showed no separation into phases after standing.

Figure 6.13. Approximate relationship of Brookfield viscosity of 2% solutions of methylcelluloses (MC) of DS 2.0 at 25 °C versus number average degree of polymerization (DP$_n$). Data from technical literature of Henkel Company and also Bikales (Encyclopedia of Polymer Science and Technology, 1986). DP$_w$ data from Sarkar (1979).

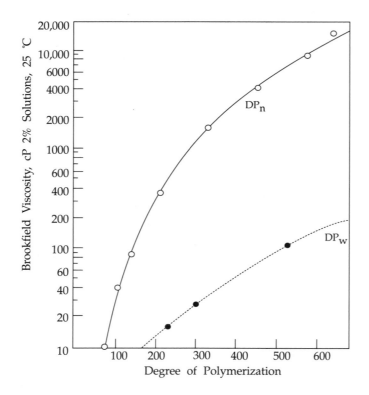

Figure 6.14. Approximate relationship of Brookfield viscosity of 2% solution of CMC of DS 0.7 at 25 °C versus weight average degree of polymerization (DP$_w$). Data from a technical brochure from the Aqualon Company.

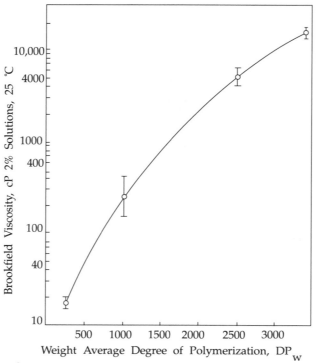

Figure 6.15. Approximate relationship of Brookfield viscosity of 2% solutions of hydroxypropylcellulose (HPC) of DS 2.1, MS 3.0, at 25 °C versus viscosity average degree of polymerization (DP_v, similar to DP_w). Data from technical literature of the Aqualon Company.

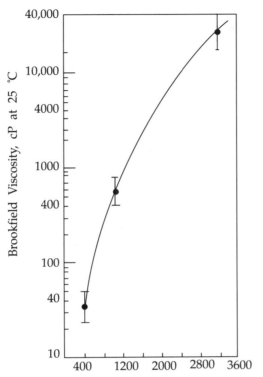

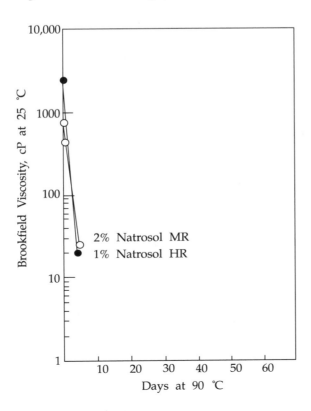

Figure 6.16. Fall in viscosity of Natrosols (HEC) maintained at 90 °C.

Figure 6.17. Fall in viscosity of solutions of Klucels (HPC) maintained at 90 °C.

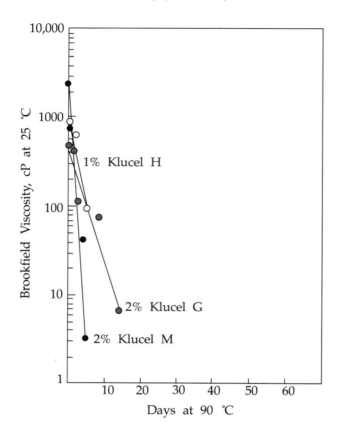

Figure 6.18. Fall in viscosity of solutions of methylcelluloses (MC) maintained at 90 °C.

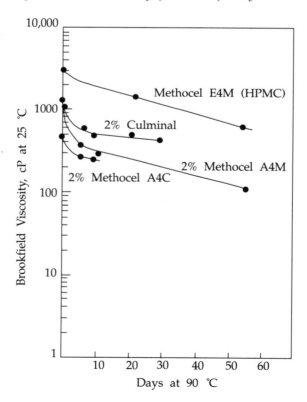

Figure 6.19. Fall in viscosity of solutions of carboxymethylcelluloses (CMC) maintained at 90 °C.

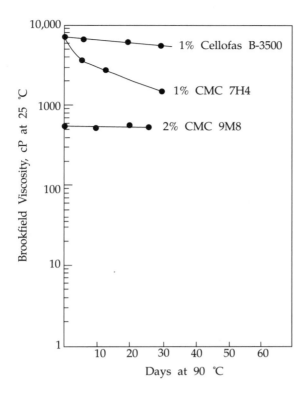

Figure 6.20. Summary illustrating the relative ranking of different classes of cellulose ethers as evidenced by the fall in viscosity of solutions maintained at 90 °C. Data taken from preceding figures.

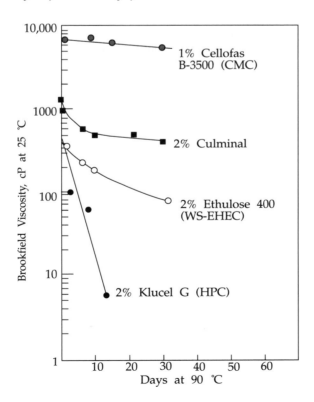

Methylcellulose (MC)

The Brookfield viscosity measurements on solutions of thermally aged methylcelluloses are plotted in Figure 6.18. After an apparent initial change in viscosity, these materials show only a gradual loss. They are obviously more stable than either the HEC or HPC polymers tested.

Hydroxypropylmethylcellulose (HPMC)

Figure 6.18 also shows a plot of the Brookfield viscosity of solutions of aged hydroxypropylmethylcellulose, Methocel E4M. The solution viscosities show a gradual decrease with aging. The stability is essentially the same as the most stable methylcelluloses.

Carboxymethylcellulose (CMC)

Brookfield viscosity data on solutions of several carboxymethylcellulose samples following thermal aging of bulk powders are plotted in Figure 6.19. The results indicate that CMC is notably stable with respect to loss of molecular weight. When attempting to establish the general behavior of CMC, undue emphasis should not be placed on the greater loss in DP in the 7H4 in this single experiment. The change is rather small as the analysis in Figure 6.21, to be discussed below, shows.

Relative Stability of Several Cellulose Ethers Commonly Used by Conservators

Fall in Viscosity

Certain cellulose ethers are readily available from conservation materials supply houses. These include Cellofas B-3500 (CMC), Culminal (MC), Ethulose 400 (WS-EHEC), and Klucel G (HPC). Figure 6.20, a summary of data from previous figures, shows the fall in Brookfield viscosity versus length of aging for these familiar materials. The graph shows the order of stability with regard to thermally induced chain breaking as follows: Cellofas B-3500 (CMC) > Culminal (MC) similar to Ethulose 400 (WS-EHEC) > Klucel G. Note that the stability is, in a general way, inversely related to the extent of substitution: Cellofas B-3500, DS = 0.75; Culminal, DS = 1.8; Ethulose, DS = 1.84; and Klucel G, DS = 2.6. In a sense, the noncellulosic character increases as thermal stability decreases (see Table 2.3).

Change in Inverse of Viscosity

It is difficult to compare the relative rates of deterioration of polymers that have different initial viscosity grades or intrinsic viscosities. One way to circumvent this problem and analyze deterioration from another point of view is to plot the change in $1/DP_{nt} - 1/DP_{no}$ against time, where the subscript o refers to the initial value and t refers to the value after a given period of aging. The slope of such curves is related to the fraction of bonds broken per unit of time (Feller, Lee, and Bogaard

1986). Values of DP_n were not directly determined in these studies, but one can make an approximate estimate by plotting the inverse of intrinsic viscosity, or the inverse of the Brookfield viscosity of dilute (2%) solutions of the polymers. This simplification is based on the well-known relation in polymer science between intrinsic viscosity and DP^a, with the assumption in this case that a is close to 1 (values between 0.79 and 0.905 are cited in Appendix H).

Figure 6.21 clearly indicates a greater rate of chain breaking for Klucel G relative to Ethulose 400, E4M hydroxypropylmethylcellulose, Culminal methylcellulose, and 7H4, the most rapidly changing carboxymethylcellulose sample in Figure 6.19. The Cellofas CMC in Figure 6.17 is not plotted because its slope would be even less than that of 7H4.

The methylcellulose types shown in Figure 6.18 are also included in Figure 6.21 since they have different initial Brookfield viscosities. The plot clearly shows the excellent stability of the hydroxypropylmethylcellulose E4M. The greater slope for the A4C and A4M methylcelluloses, indicating lower stability relative to the Culminal, was not as expected. Nonetheless, the weight loss of A4C and A4M relative to CMC, Ethulose 400, and Klucel M (Table 6.1), ranks them in the same order as in Figure 6.21. The A4M and E4M in Table 5.2 do not fall in the same order as the viscosity changes monitored in Figure 6.21, but the rates of weight loss reported in the table are so slight and similar that, in the case of these two products, the difference apparently is not significant.

All of the determinations of intrinsic viscosity or Brookfield viscosity of dilute solutions that appear in this report have been further calculated in terms of the change in the inverse of the viscosity. The results are considered to be linear with time, although in some cases a rapid initial stage of degradation seems to occur. Nonetheless, the analysis of degradation in this manner did not change the ranking of the generic classes of the cellulose ethers arrived at by measuring the fall of viscosity of their 2% solutions with time.

Photochemical Stability: Brookfield Viscosity Films Exposed Under Daylight Fluorescent Lamps

Pure cellulose is relatively stable when exposed to the action of visible and near-ultraviolet radiation both with respect to chain scission and to discoloration. It is not surprising to find that many cellulose ethers behave similarly. In the case of ethers that form significant thermally induced peroxides, however, it is recognized that near-ultraviolet radiation can enhance peroxidic reactions.

Hydroxypropylcellulose

The results obtained from aging Klucel G (HPC) film under daylight fluorescent lamps are presented in Figure 6.22 along with the results from thermally aging Klucel G at 90 °C as both a powder and a film. The figure shows that differences in physical form affect the rate at which the material degrades.

The film exposed to daylight fluorescent lamps at 23 °C shows only a minor decrease in Brookfield viscosity. The slow rate of deterioration seen here reflects the photochemical stability that one might expect to see under fluorescent lamps or under diffuse daylight in a museum environment. If one plots the inverse of the viscosity versus time (as in Fig. 6.21), the slope of data indicates the rate at which bonds are broken. When this is done for Whatman #42 filter paper and compared to the behavior of the Klucel G film, one can see (even though a precise comparison is not justified) that the rate of photochemically induced chain breaking in the Klucel is similar to cellulose itself (Fig. 6.23).

Methylcellulose

The data for aging a Culminal (MC) film under fluorescent lamps and thermally aging it as a powder at 90 °C are plotted in Figure 6.24. Again, a minor photochemical effect is evident.

Carboxymethylcellulose

Daylight fluorescent lamps have little effect on carboxymethylcellulose (Fig. 6.12 and Table 6.9). Even when CMC is exposed in a xenon-arc Fade-ometer® (Pyrex® filters), little loss in intrinsic viscosity occurs in the length of time required to cause a slight fading in an ISO R105 (BS1006:1971) blue-wool fading standard No. 6 (C. W. Bailie, Mellon Institute, unpublished results). Additional support is found in the *Tappi Journal*(1952), where it is stated that no appreciable embrittlement or discoloration is observed in CMC after 100 hours' exposure in a Fade-ometer (presumably carbon-arc).

Figure 6.21. Data from previous figures expressed in terms of the inverse of the Brookfield viscosity of solutions of various cellulose ethers during heating at 90 °C. The steeper slopes indicate greater rates of chain breaking.

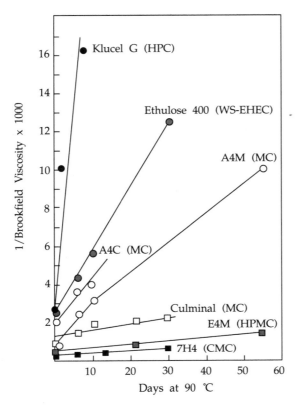

Figure 6.22. Comparison of effects of physical form of Klucel G on loss of Brookfield viscosity of 2% solutions as well as comparison of photochemical versus thermal aging.

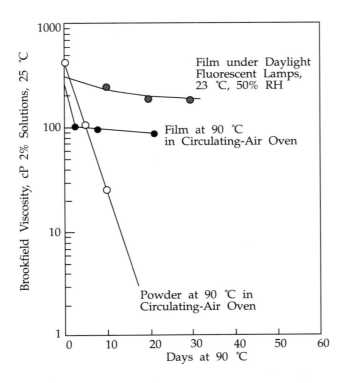

Figure 6.23. Photochemical aging of a film of Klucel G (HPC) compared to filter paper, expressed in terms of the inverse of the intrinsic viscosity. The similar slopes imply similar rates of chain breaking.

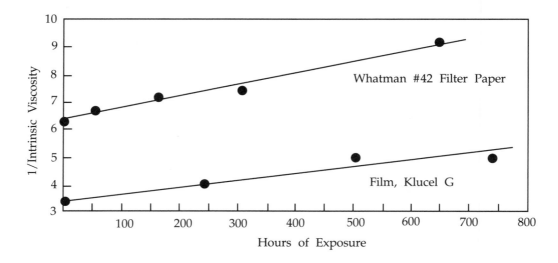

Figure 6.24. Aging of Culminal (MC) under various conditions.

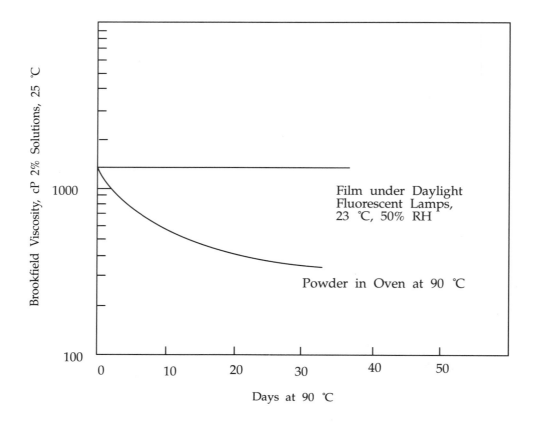

7 Conclusions

Cellulose Ethers Considered Unsuitable for Long-Term Applications

On the basis of our investigations, the use of the organic-solvent-soluble cellulose ethers, ethyl-cellulose (EC), and the organic-soluble type of ethylhydroxyethylcellulose (OS-EHEC), cannot be encouraged for long-term applications in conservation. This conclusion is based on the observed rapid drop in the intrinsic viscosities of the polymers in granular-powder form upon aging at 90 °C and also on their tendency as powders or as films to form peroxides at 90 °C or during exposure to fluorescent lights. The principal evidence of their lack of thermal stability is shown in Figure 6.11. A polymer that seriously degrades in less than 177 hours at 90 °C is considered to be thermally "unstable," potentially capable of significant deterioration in less than 20 years at ordinary temperatures. The potential long-term stability of ordinary hydroxyethylcellulose (a water-soluble ether) also seems highly questionable.

Organic-soluble ethylhydroxyethylcellulose powder loses considerable weight at 110 °C (Table 6.1) and at 90 °C (Table 6.2), evidence of chemical deterioration. It is also capable of considerable discoloration (Fig. 6.1). Moreover, this type of EHEC forms significant concentrations of peroxides when exposed to less than 11 million lux hours of daylight fluorescent lamplight (Fig. 6.8) and loses considerable intrinsic viscosity (Fig. 6.12) in less than 6.9 million lux hours, estimated to be equivalent to about 10 and 7 years, respectively, on a well-illuminated gallery wall (Feller 1975; Thomson 1978).[1]

An ethylcellulose sample did not lose as much weight as the OS-EHEC, nor did it discolor significantly at 90 °C and 110 °C. Nonetheless, this cellulose ether is well known to form peroxides (Fig. 6.8; Appendix H). As seen in Figure 4.2, the properties of various EC products vary considerably, but many show an apparent induction time of 75 to 250 hours at 95 °C after which they discolor rapidly. At 95 °C an "unstable" material can be expected to show serious changes in properties after about 100 hours; a material of excellent stability should be stable for more than 500 hours. Because of the known tendency of unstabilized ethylcellulose (and of course the higher alkyl ethers) to form peroxides, especially when enhanced by exposure to light (Koz'mina et al. 1965), and because of their potential for a sharp deterioration in properties following an induction period, it would seem prudent to avoid their use for long-term applications in conservation.

It also appears that hydroxyethylcellulose (HEC) should not be encouraged for long-term applications in conservation. Most of the unaged products examined had a light tan color that further discolored during thermal aging (Tables 6.1 and 6.2). Upon aging at 90 °C, HECs rapidly lost intrinsic (or Brookfield) viscosity (Fig. 6.16).

Although various commercial products behave differently, many discolor rapidly in less than 100 hours at 95 °C (Fig. 4.3), placing them in the proposed "unstable" class. Discoloration (Fig. 6.1) and loss of solubility (Fig. 4.4) can also occur during thermal aging. Enzyme-resistant types of HEC are available; perhaps these will be found to possess improved thermal stability.

Findings with Respect to Hydroxypropylcellulose

Considerable interest in hydroxypropylcellulose (HPC) has been shown by conservators, principally the type available as Klucel from the Aqualon Company (formerly from Hercules). For this reason, and because new test results indicate a lower stability rating than was suggested initially (Feller 1981b), the conclusions regarding this cellulose ether are discussed with separate emphasis.

The initial evidence regarding the thermal stability of the Klucels is seen in the results of an earlier investigation (Fig. 4.6). Here, products from two commercial suppliers discolored considerably in less than 100 hours at 95 °C. In the present investigation, bulk samples lost considerable weight and discolored at 110 °C and 90 °C (Fig. 6.1, Tables 6.1 and 6.2). Marked weight loss (Fig. 6.2) and loss of apparent intrinsic viscosity (Fig. 6.17) occurred in less than 7.4 days (177 hours) heating at 90 °C. In thin films and in low-percentage applications such as size (Figs. 6.4 and 6.7), the extent of discoloration may not be serious. The higher molecular weight grades, M and H, seem to be less stable than the lower, G and L (Table 6.1 and Fig. 6.4). Although the polymer has excellent photochemical stability towards visible and near-ultraviolet radiation (Figs. 6.12 and 6.23), as do many of the cellulose ethers that are water soluble or that have little tendency to form peroxides, the test results place this class of polymer in the thermally "unstable" class having an estimated potential for discoloration and significant loss of DP on the order of 20 years under moderate conditions of temperature. This conclusion places HPC in a lower classification of thermal stability than that assigned in 1981 (from "intermediate" to "unstable"). Perhaps the lower molecular weight grades can be considered of "intermediate" thermal stability. Certainly, more testing is desired.

Cellulose Ether of Intermediate Thermal Stability

Water-soluble ethylhydroxyethylcellulose (WS-EHEC), not available from an American manufacturer, has scarcely been evaluated in this or in the previous investigation by Arney. At worst this polymer could fall in the "intermediate" class of stability (Table 6.2; Figs. 6.7, 6.20, 6.21), but more extensive testing may show it to possess excellent long-term stability, potentially capable of giving good service for as long as 100 years under normal conditions in a museum, library, or archive.

Cellulose Ethers with Excellent Long-Term Stability

There seems to be little doubt about the generally excellent stability of methylcellulose (MC) products. Discoloration after more than 1000 hours at 95 °C is negligible (Figs. 4.1, 4.6, 6.5). Weight loss and discoloration at 110 °C to 90 °C is minimal (Tables 6.1 and 6.2). The resistance to loss of viscosity (decrease in molecular weight) after more than 37 days at 90 °C is good (Figs. 6.18, 6.21). The resistance to degradation by enzymatic action is excellent (Appendix F), and the resistance to acid hydrolysis tends to be greater than that of cellulose itself (Vink 1963; Gibbons 1952).

Hydroxypropylmethylcellulose (HPMC) products that are largely of methylcellulose composition with only a modest percentage of hydroxypropyl substitution tend to possess high stability equal to or better than methylcellulose (see Methocel E4M in Table 6.1 and Fig. 6.21).

Carboxymethylcellulose (CMC), customarily used in the form of its sodium salt, is also capable of excellent stability with respect to loss of weight and discoloration (Table 6.2, Figs. 4.1, 4.5). The polymer also is capable of excellent stability with respect to loss of viscosity grade when CMC powder is heated for more than 500 hours at 90 °C (Fig. 6.10) or 936 hours (39 days; Figs. 6.19, 6.21). It also has excellent photochemical stability (Fig. 6.12). Although generally of excellent stability, we rank it below that of methylcellulose. It is known that discoloration can sometimes occur (Table 4.1) and that CMC products of poor stability can be encountered; hence, the product chosen by the conservator must be evaluated individually.

There is a statement in Conley's review (1970) of Koz'mina's work that we cannot immediately explain, but will report for the record. He arranged some experimentally prepared cellulose ethers "in the following order of oxiation susceptibility: allylcellulose > carboxymethylcellulose > benzylcellulose > ethylcellulose > cyano-ethylcellulose." This seems to place CMC more easily oxidized than ethylcellulose. The results of the present tests, however, suggest that the CMC products in general possessed excellent stability.

Need for Testing

A second conclusion derived from these studies is that, because of variations in the raw material and in the chemical processing of cellulose ethers, products of the same generic chemical class can be found to be significantly different in terms of stability. This is in contrast to polymers such as poly(vinylacetate), poly(n-butylmethacrylate), ethylene-vinyl-acetate polymer, and certain other copolymers whose chemical composition can be reasonably well defined. As a result, individual commercial products must be tested in order to find the best performing product. A tentative simple test procedure has been suggested (see Chapter 3, the section titled, "A Simple Test of Thermal Aging").

Final Remarks

The purpose of these studies has been to rank the generic chemical classes of cellulose ethers with respect to their potential long-term stability. With this previously unavailable information at hand, the conservator should be able to form a sound judgment regarding the use of these materials for a given application. There are many applications that use only low concentrations of cellulose ethers or use materials that will be only in brief contact with an artifact. A viscosity-raising agent used at 1 or 2% concentration in a polymer emulsion or aqueous adhesive, for example, may not affect significantly the long-term stability of a coating or adhesive cast from such a formulation. When applied as a size at 1 or 2% concentration, discoloration, if it occurs at all, may scarcely be noticeable. The application of cellulose ethers of all types may be perfectly satisfactory in such situations.

The ready formation of peroxides in ethylcellulose and organic-soluble ethylhydroxyethylcellulose seems to discourage use of these particular materials for long-term applications. It is hoped that the other generic chemical classes of cellulose ethers have been ranked fairly by this investigation on the basis of their inherent thermal, essentially oxidative, stability; as a general rule, from most to least stable, we find: methylcellulose, carboxymethylcellulose, water-soluble ethylhydroxyethylcellulose, hydroxyethylcellulose, hydroxypropylcellulose, and organic-soluble ethylhydroxyethylcellulose and ethylcellulose.

Note

1. Because the samples on glass were backed by aluminum foil to increase the exposure, the equivalent exposure without such backing would be higher. However, even if these figures are doubled, they represent no more than 20 years under the conditions of a "well-illuminated gallery."

A Cellulose Ethers in *AATA*

As part of its commitment to the Getty Conservation Institute, the Research Center on the Materials of the Artist and Conservator reviewed the literature concerning the uses of cellulose ethers by conservators. This was done by consulting *Art and Archaeology Technical Abstracts (AATA)* through Volume 25, 1988. The abstracts in *AATA* are also available online in the Conservation Information Network's bibliographic database.

In the search, information was often indexed under cellulose with specific references to the cellulose ethers. The numbering system employed by *AATA* to designate individual abstracts has been retained. References are of the form XX-YYYY, where XX is the *AATA* volume number and YYYY is the reference number in that volume.

Uses of Cellulose Ethers

Cellulose ethers were developed for a wide variety of industrial and commercial uses. After reading the manufacturers' brochures, it is clear why an innovative conservator would try the polymers in various day-to-day aspects of conservation. For example, some commercial applications of carboxymethylcellulose are: as an agent to prevent soil redeposition in detergent formulations, as a textile and paper size, as an adhesive, and as a viscosity enhancer in aqueous solutions and emulsions. These applications readily suggest areas for experimentation by the conservator.

Methylcellulose has been used in industry as a binder for ceramics, as a thickener for aqueous solutions, for paper sizing and leather tanning, and as a coating to impart oil resistance. Hydroxyethylcellulose and hydroxypropylcellulose have many of the same uses as methylcellulose. Hydroxypropylcellulose is also used as a thickener for nonflammable paint removers.

AATA literature indicates that carboxymethylcellulose and methylcellulose were the ethers most widely used by conservators. The ability of the water-soluble ethers to increase viscosity allows aqueous solutions to be used in small areas with minimum flooding and migration. For the organic-solvent-soluble cellulose ethers—ethylcellulose and ethylhydroxyethylcellulose—only a few references were found for the former and none for the latter.

Although commercial grades are described in detail only in a few abstract citations, it appears that products with a 2% solution viscosity in the range of 400–4000 cP are favored by conservators.

Summary of Literature Search

Methylcellulose

Adhesive: (6)-B3-34; 10-604; 10-653; 11-107; 12-844; 13-192; 18-293; 18-1154; 21-1567; 21-1765; 23-1496.

Paper size: (6)-B3-34; 13-234; 14-875; 14-878; 15-347; 21-1567; 22-514.

Paper coating or strengthener: 7-770; 8-1263; 15-1236; 19-286.

Relining canvas: 10-738; 11-614; 18-1437; 19-1653.

Binder in hole-filling: 7-770; 9-569; 10-697; 22-753.

Binder in poultice: 9-607; 16-330.

Wood consolidant: (6)-A7-48; 11-548.

Paint consolidant: 18-1462.

Protective undercoat: 11-182; 12-183.

Biological resistance: (6)-B3-47; 13-862.

Use in mixes: 16-1854; 23-150.

Lubricant for pottery: 20-2032.

General uses in paper restoration: (6)-B2-13; 7-1130; 8-711; 20-1555.

Carboxymethylcellulose

Stone cleaner: 10-835; 16-831; 18-1577; 23-3006; 23-3077.

Cleaner for murals, frescoes, or stucco: 10-835; 12-478; 22-1934; 23-3029.

Leather or textile cleaner: 9-447; 11-161; 18-1349.

Adhesive: 21-1567; 22-468; 22-1782.

Paper or textile size: (6)-B3-27; 21-351; 21-1567; 22-907; 22-2144.

Protective coating for textiles: 11-182; 12-260.

Binder in poultice: 10-245; 16-1293; 21-1898.

Binder: (6)-B3-43; 21-1914.

Uses with wood: 14-167; 16-186.

Analysis for: 11-603; 21-613; 22-2144; 23-1604.

General uses: 9-558; 20-1555.

Water-Soluble Ethylhydroxyethylcellulose

Impregnation of textile: (6)-D3-5; 7-809; 9-194; 12-919.
Waterlogged wood: 13-913.

Other References

Hydroxyethylcellulose: 11-182; 11-603; 12-21; 13-817; 14-617; 16-186; 21-1765.
Hydroxypropylcellulose: 11-182; 11-603; 18-1180.
Ethylcellulose: 11-107; 15-897; 20-573; 20-1149; 22-1731.
General: (6)-E1-51; 9-593; 16-1036.

B Questionnaire on the Use of Cellulose Ethers by Conservators

There were 155 responses (33%) to the 467 questionnaires mailed in September 1986 to the members of the Book and Paper Group of the American Institute for Conservation. Conservators were most generous in sharing their experiences and knowledge concerning their use of cellulose ethers. Many added personal comments to amplify replies to questions that could have been answered by a simple yes or no. Some respondents informed us that they were not practicing conservators and thus could not answer the technical questions.

Question 1 *Are you acquainted with the use of cellulose ethers in the field of conservation?*
One hundred forty-four (92.9%) of the respondents indicated familiarity with cellulose ethers. Some indicated 10 to 20 years of experience; others were new users. Eight respondents stated that they were not active conservators. Only three indicated no familiarity with cellulose ethers.

Question 2 *Have you used them in your work?*
Cellulose ethers were used by 91.6% of the conservators who replied. Some had used only one of the ethers, while many had used all classes of ethers available.

Question 3 *How did you become familiar with them (publication, lecture, demonstration by colleague)?*
Conservators were sometimes introduced to the ethers through more than one source, hence, the following percentages total over 100%. Publications were mentioned by 42.6%. Key papers by Baker (1982, 1984), Schaeffer (1978), and Hofenk-de Graaf (1981) were mentioned. Lectures on cellulose ethers, often part of formal conservation training, were attended by 40% of the respondents. Finally, 44.5% reported learning about the ethers from colleagues.

Question 4 *For what purpose have you used them (adhesive, consolidant, size, etc.)?*
Conservators have used cellulose ethers as adhesives (81.9%), consolidants (60%), sizes (54.8%), and as an ingredient in poultices (34.8%). When used as an adhesive, some considered the low adhesive strength an advantage. Others mixed the ethers with wheat-starch paste or poly(vinylacetate) emulsions "for a stronger bond." Klucel G, a hydroxypropylcellulose, is widely used as a leather consolidant. By using ethers in poultices, advantage is taken of their ability to increase the viscosity of aqueous solutions. This permits the use of water in a localized area with minimal risk of flooding.

There were no indications of the use of cellulose ethers as surface coatings, unless their use as consolidants or sizes is considered closely related and the material is similarly exposed to light and the atmosphere.

Question 5 *With what materials have you used them (wood, paper, textiles, leather, etc.)?*
Since the questionnaire was sent to the Book and Paper Group of the American Institute for Conservation, it was not surprising that 85.2% of the respondents had used cellulose ethers with paper. Uses with leather (29%) were reported primarily by bookbinders. Klucel G was the most popular for use with leather because of its solubility in polar organic solvents such as ethanol. Only 13.5% of the respondents reported use of cellulose ethers with textiles and only 4.5% with wood. There were a few reports of use with parchment, feathers, papier-mâché, pigments, and flaking paint.

Question 6 *Which cellulose ethers have you used?*
Of the conservators surveyed, 77.4% have used methylcellulose, 44.5% hydroxypropylcellulose, 33.5% carboxymethylcellulose, and 12.3% a water-soluble ethylhydroxyethylcellulose. In a few cases the use of hydroxypropylmethylcellulose was reported.

 The most frequently cited were methylcelluloses Methocel A4C and Methocel A4M from Dow Chemical and Culminal from Henkel (Aqualon). Klucel G from Hercules was the hydroxypropylcellulose used almost exclusively by conservators. The most frequently employed carboxymethylcelluloses were Cellulose Gum 7H from Aqualon (formerly Hercules) and Cellofas B-3500 from ICI, Ltd. Water-soluble Ethulose 400 from Mo och Domsjo was the only ethylhydroxyethylcellulose reported. Ethylcellulose and OS-EHEC, the organic soluble cellulose ethers, were infrequently mentioned.

Question 7 *With what solvents have you employed them and at what concentrations?*
With the exception of Klucel G, cellulose ethers were used almost exclusively with water. For size, a 0.5% concentration was customarily cited. As an adhesive or consolidant, a 1% to 2% solution was used and as a poultice, a 2% to 4% solution. At the concentrations used, solutions with Brookfield viscosities of 400 to 4000 cPs were formed. This viscosity range appears suitable for most of the conservators' applications.

 With Klucel G, which is soluble in polar organic solvents, ethanol was the solvent of choice. Concentrations of 0.5% to 5% were noted and the material used mainly as a consolidant for leather.

Question 8 *Do you admix the ethers with any other material? What?*
Ninety percent of the conservators indicated that an ether, usually methylcellulose, was often mixed with wheat starch paste or poly(vinylacetate) emulsions for adhesive applications. Methylcellulose increases the "open time" or slippage, allowing

enough time for alignment after the substrates are in contact. A 50-50 blend of 2% methylcellulose with Jade 403 adhesive [poly(vinylacetate)] was mentioned several times. Klucel G was seldom mixed with another consolidant or adhesive.

In poultice applications, enzymes are often employed. Other additives that have been used with cellulose ethers include paper pulp, bleach, ammonia, detergents, calcium carbonate, water colors, and animal glue.

Question 9 *What mixing equipment did you use to prepare solutions?*
Generally, conservators used what they had available. Blenders and magnetic stirrers were employed by those who had them. Jars, beakers, and bowls with stirring rods, spatulas, and stirring sticks were the utensils used by a majority of the respondents. It is not clear how the very viscous solutions were prepared by hand. Several commented that "material seemed to settle out."

A question on the technique of mixing was not included in the questionnaire. This was unfortunate and should be the subject of future inquiries.

Question 10 *Have you noticed a loss of solution viscosity with aging?*
Most (63.2%) conservators make only enough solution for a particular project and consequently have no experience with aged solutions. Some mentioned that solutions appeared stable after several months or even 2 to 3 years. Nonetheless, a large number of conservators (25.8%) noticed a loss in viscosity of their solutions.

Question 11 *Do you use a preservative with your solutions? Give name if possible.*
The majority of conservators (87.9%) reported using no preservative with their solutions. Of the 7.1% who did, thymol or o-phenylphenol were the preservatives of choice. Most conservators do not store solutions for long periods of time—a sound practice.

Question 12 *Have you noticed any brittleness in treated material?*
Only 5.8% of the conservators reported noticing brittleness in treated objects, while 79.3% reported not having noticed brittleness. In cases where brittleness was noted, there was a comment that "too much" cellulose ether might have been used in the particular treatment.

Question 13 *From what source did you obtain your ethers?*
Samples of material were obtained directly from the manufacturer or from a conservation materials supply house. Dow and Hercules (now Aqualon) were the principal manufacturers mentioned.

Question 14 *What positive or negative comments do you have on the use of cellulose ethers in conservation?*

Apparently conservators have had disparate experiences. Contradictory opinions—difficult to reverse/generally reversible, no discoloration/sometimes discolors—indicate the need for further information and technical study of these materials.

Positive Comments:	Negative Comments:
Ethers are readily available	Not a "strong" adhesive
Solutions are easy to prepare and use and do not spoil	Sometimes discolors
Generally they are reversible	Difficult to reverse or remove residues
Very useful as a poultice material	Klucel tends "to streak leather"
Good "weak" adhesive	Causes "curling" of treated object
Promote "slip" of wheat-starch paste	Methylcellulose causes "glossiness"
Useful in cleaning formulations	Treated object sometimes lacks flexibility
No discoloration	No advantage over natural materials
	There are no long-term aging data

Question 15 *What is your estimate of the life of a treatment involving cellulose ethers?*

This question provoked answers ranging from "short-term" to infinite. The responses generally reflected a feeling of insecurity by the conservators and a desire for information about the long-term stability of cellulose ethers. There were many requests for the results of the present study.

C Cellulose Ethers Available to Conservators

U.S. Manufacturers

In the United States, several chemical companies manufacture cellulose ethers. Following is a list of these companies, the products they offer, and the trade names of the products.

Dow Chemical Company, Midland, Michigan 48640
　　Methylcellulose (MC): Methocel A
　　Methylhydroxypropylcelluloses (MHPC): Methocel E, F, J, and K
　　Hydroxybutylmethylcellulose (MHBC): Methocel HB

Aqualon Company, Wilmington, Delaware 19850
　　Sodium carboxymethylcellulose (CMC): Cellulose Gum
　　Hydroxyethylcellulose (HEC): Natrosol
　　Hydroxypropylcellulose (HPC): Klucel
　　Methylcellulose (MC): Culminal
　　(also MHPC, MHEC)

Hercules, Incorporated, Wilmington, Delaware 19899
　　Ethylhydroxyethylcellulose (EHEC)
　　Ethylcellulose (EC)

Union Carbide Corporation, New York, New York 10017
　　Hydroxyethylcellulose (HEC): Cellosize HEC

All of the above products are offered in various grades, providing a range of solution viscosities.

Manufacturers Outside the United States

Carboxymethylcellulose is made by most industrial suppliers of cellulose ethers. A few of the seventeen manufacturers and their trade names noted in the *Encyclopedia of Polymer Science and Technology* (1986) are Courlose® (British Celanese), Cellofas (ICI), Tylose (Kalle), Cellufix® (Svenska Cellulosa), and Blanose® (Societé Noracel). At the time of publication of the *Encyclopedia*, HEC and EC were only produced in the United States. Cellofas A and Edifas® A were ethylmethylcelluloses of approximate DS 0.4 in methoxyl and 0.9 in ethoxyl, produced by ICI in Great Britain. Modocoll E is EHEC manufactured by Mo och Domsjo in Sweden. Many of these are also noted in Table 2.5.

Suppliers of Conservation Materials

Catalogs from two suppliers of conservation materials were examined with reference to the availability of cellulose ethers. Both offered a carboxymethylcellulose, Cellofas B-3500, made by ICI. Suggested applications included its use as a general purpose paper and textile adhesive. Its uses for reinforcing textiles and paper with nylon or polyester netting were mentioned, as well as for mounting paper and textiles on a stiff backing for displays.

One firm offered a methylcellulose (Culminal from Aqualon) as an adhesive for paper tears, a silk-to-silk adhesive, and as a barrier resin. Its use as a size for marbling was also suggested. Klucel G, a hydroxypropylcellulose from Aqualon, was offered by one firm with a suggestion for its use as a leather consolidant. Ethulose 400 (a water-soluble ethylhydroxyethylcellulose from Mo och Domsjo) was offered as a consolidant for brittle fibers. The fact that it gives a matte finish when deposited from solution was mentioned.

All of the suggested uses cited by the conservators' supply catalogs are found in *Art and Archaeology Technical Abstracts* (*AATA*).

D Technical Notes on Methylcellulose and Carboxymethylcellulose

This report is not intended to be a textbook on cellulose ethers; there are a number of books that discuss the properties of these polymers very well (Butler and Klug 1980; Whistler and BeMiller 1973; Davidson and Sittig 1962). Some of the best and most readily available discussions of the chemistry and industrial applications of these materials can be found in the *Encyclopedia of Polymer Science and Technology* (1968) or in Kirk, Othmer et al. *Encyclopedia of Chemical Technology* (1968:638–652). Rather, this report attempts to present a brief review of the properties and principal features of the cellulose ethers of greatest interest to conservators. For the convenience of the conservator, a more extensive discussion of the two most stable cellulose ethers is presented.

Methylcellulose (MC)

Methylcellulose is one of the most widely used cellulose ethers among conservators. A few years ago, the principal methylcelluloses were: Methocel A, manufactured by Dow; Culminal, from Henkel (now Aqualon); Tylose MB, by Hoechst; Metolose® SM from Shin-Etsu; and Methofas® M from ICI. This polymer is packaged as a white powder having little or no odor or taste. Methylcellulose has no ionic charge; hence, the viscosity of its solutions is little affected by pH. Small amounts of salts can, however, increase the viscosity of its solutions (*Encyclopedia of Chemical Technology* 1968:648). It is considered stable for many practical applications over a pH range of 3 to 11, although, like cellulose, high acidity or high alkalinity can lead to a lowering of its molecular weight. The degree of water retention can range from 5 to 12% by weight. The polymer will form clear, flexible films that can act as a barrier to oils and greases. Most commercially available methylcelluloses have a relatively high degree of substitution (DS 1.5–1.9), which makes them comparatively enzyme-resistant. There are types available with increased resistance to enzymes that may have as much as MS 0.7 to 1.0 in hydroxypropyl groups present (HPMC). In a water solution, methylcellulose will not support the growth of microorganisms; neither will this polymer inhibit microorganism growth if aqueous solutions are contaminated.

In industry, MC is used as a thickener, as a binder and lubricant, and as a suspension aid and emulsifier. It is metabolically inert and has uses in pharmaceuticals and prepared foods. In the field of conservation it has been used primarily as an adhesive, consolidant, or size.

The primary solvent used with MC is water; however, its solubility characteristics are quite different from those of inorganic salts. The dissolution mechanism for

methylcellulose involves swelling and hydration. There is no sharp limit to solubility (saturation) as with salts; in practice, the concentration is limited principally by the viscosity that the user needs and is equipped to handle. Methylcellulose solutions have a gelation temperature of about 55 °C; therefore, the powder is insoluble in hot water above that temperature. The best solution of this polymer is made in water at 0 to 5 °C. If the ease of solubility becomes a problem, hydroxypropylmethylcelluloses are often substituted. The *Encyclopedia of Polymer Science and Technology* (1968:502) gives a table showing how the temperature at which gelation sets in is raised from 56 °C to as much as 90 °C by judicious regulation of hydroxypropyl and methyl groups during manufacture.

All viscosity grades of methylcellulose are pseudoplastic, although they exhibit Newtonian behavior below a certain shear rate. The shear rate where Newtonian behavior changes to a shear-thinning behavior decreases with increasing molecular weight and concentration. Thixotropy (the situation in which, at constant stress, the viscosity of solutions drops with time) also is most apparent with highly viscous forms of MC, HPMC, HEC, and MHEC, or at high concentrations of these.

The relationship between DP_n and the viscosity of 2% solutions of MC, shown in Figure 6.13, is based on the data of Chamberlin and Kochanny (1969). The data of DP_w is from Sarkar (1979). The relationship between the viscosity of 2% solutions and intrinsic viscosity is also given in the *Encyclopedia of Polymer Science and Technology* (1968).

Perhaps the most notable characteristic of methylcellulose solutions is their ability to form gels when heated and to form a sol in a reversible manner when the temperature is lowered. The simple explanation usually given is that water molecules become associated with the methylcellulose, facilitating solution. When the temperature is raised (or when salts are added) this association is diminished to a point at which the polymer separates out. A more detailed explanation has been provided by Kato and his associates (1978). The explanation given by Kato is that a crystalline or "crystallite" network of trimethylglucose units, perhaps 4 to 8 units in length, seems to form in the gel state. The gels can be seen to be birefringent when examined under a polarizing microscope and exhibit a definite X-ray diffraction pattern. A plot of the inverse of the melting temperature of the gel (1/Tm, in degrees Kelvin) against log V_2x is linear, where V is the volume fraction of the cellulose ether in the gel and x is its DP. When the ether is made in the usual way by heterogeneous reaction of alkali cellulose and methylene chloride, the fraction of trimethylglucose units is reported to be equal to $(DS/3)^3$ where DS is the degree of substitution.

Dissolving methylcellulose

The key to dissolving methylcellulose in water is to achieve thorough dispersion before the powder begins to dissolve, otherwise lumps form that can be very difficult to break up. To avoid this problem, advantage is taken of its insolubility in hot water. The recommended procedure for dissolving methylcellulose is as follows:

First, heat about one-third of the required volume of water to 80–90 °C. Then add the methylcellulose powder to the hot water with agitation. Continue agitating until the particles are thoroughly wetted and evenly dispersed. Remove from heat and add the rest of the water as cold water or ice, continuing agitation. The solution should be cooled to below 10 °C (for maximum clarity, cool to 0–5 °C for 20–40 minutes). Agitate until smooth; once cold this should take only a few minutes, but the process can take as long as an hour.

If other dry powdered ingredients are to be used in the formulation, they can be combined with the methylcellulose and blended dry. When the ratio of other ingredients to methylcellulose is greater than 3:1, it may not be necessary to use hot water to disperse the methylcellulose thoroughly with the other pulverized ingredients.

Nonaqueous solvents, such as mixtures of methyl alcohol and methylene dichloride, can be used with certain types of methylcellulose. In special applications, advantage can perhaps be taken of the fact that MC can be applied in an organic solvent and removed in water, or vice versa.

If hot water is not available, then the water should be agitated and the methylcellulose powder added very slowly to prevent agglomeration. Cold water will help speed dissolution.

Safety, Toxicity, and Handling Requirements

The health and flammability hazards of methylcellulose are slight; its reactivity hazard is minimal. Methylcellulose is not metabolized by humans; oral ingestion of large amounts (10 grams) may have a laxative effect. There are no known carcinogenic effects.

The dust of this material presents the only real hazard. Contact with eyes can cause mild irritation. Inhalation may cause respiratory irritation. In case of eye contact, immediately flush with water for at least 15 minutes. If inhaled, patient should be removed to fresh air; treat any irritation symptomatically.

The dust can also be flammable when suspended in air. Do not use around open flame or sparks. Should fire occur, it can be extinguished using any conventional method.

If spilled, the powder can be slippery. Thoroughly sweep up and flush the area and the residue with water. There are no special disposal requirements.

Methylcellulose should not be stored next to peroxides or other oxidizers. To protect the quality of the powdered or granular bulk material, store in a sealed container in a dry place away from heat and sunlight.

Carboxymethylcellulose

This water-soluble polymer, introduced in 1947, is made by reacting sodium monochloroacetate with alkali cellulose. It is almost always sold as the sodium salt, but rather than using the longer name—sodium carboxymethylcellulose (NaCMC)—it is usually designated simply as carboxymethylcellulose (CMC). There were at least forty manufacturers throughout the world in 1973. Many produce only a rather impure technical grade. The polymer can be purchased both in a highly purified (99% active ingredient) and in a technical grade (55–65% CMC). When in doubt concerning purity, conservators should request the "food grade." During manufacture, purification of the raw product can be achieved by extracting contaminant salts with alcohol-water mixtures without dissolving the polymer. In 1969, about 30% of the CMC manufactured was used in the textile industry, 25% in detergents, and 8% in the paper industry. Sizing with CMC makes fabrics easier to clean and more difficult to soil. It provides a valuable constituent in water-dispersible adhesives. As a size for paper, it can decrease porosity and increase grease-resistance. It can be used to retard water loss from drilling muds; Batdorf and Rossman (1973) show that a polymer with a degree of substitution (DS) of 1.20 is more effective in this regard than one of DS 0.70.

Batdorf and Rossman (1973) state that the most common DS range is 0.4 to 0.8, with most of the substitution taking place on C_6 and C_2 of the anhydroglucose unit of cellulose. Hercules also sells two types with a DS of 1.2 to 1.4. Water solubility is achieved with a DS of about 0.4; lower DS types (ca. 0.3) are soluble in alkali. The degree of polymerization of the underlying cellulose chains in most commercial types is said to range between 500 and 2000. As noted in Appendix D, Bach Tuyet, Iiyama, and Nakano (1985) describe the analysis of the position and degree of carboxymethyl substitution in cellulose, mannan, and xylan. Upon hydrolysis to the sugars, the authors calculated the distribution of substitution on $C_2 : C_3 : C_6$ as 2.1 : 1 : 1.8 for glucose, 9.8 : 1 : 10.0 for ivory nut mannan, and 4.5 : 1 for xylan (for C_2 and C_3; there is no alcoholic OH on C_6 in xylan). In the review on NMR analytical techniques in Appendix F, the data of Ho and Klosiewicz (1980) are noted concerning the distribution of substituents on C_2, C_6, and C_3 at various degrees of substitution.

The standard method for analysis of the degree of substitution of sodium carboxymethylcellulose is to convert the sodium salt to the acid form by a mixture of HNO_3 and alcohol (Whistler 1963). The sample is then washed and dried. It is then mixed with a measured amount of 0.5N NaOH and the excess of NaOH determined by titration with 0.4N HCl. The DS was calculated as

$$DS = \frac{0.162A}{1-0.058A}$$

where A = meq NaOH/g of sample. The influence of low concentrations of COOH on solubility has been discussed in Chapter 2 (see especially "Effect of Carboxyl Groups, Carboxymethylcellulose").

Solutions of the polymer are said to be reasonably stable over a pH range from 4 to 10. However, a rapid increase in degradation sets in in the range of pH 6 to 3 (*Encyclopedia of Polymer Science and Technology* 1968). The pH of the neutral sodium salt is 8.25.

The ether has a high moisture content ranging up to 20% of its weight or higher in a very high relative humidity environment. At 80% RH the moisture content of CMC of DS 0.4 is about 21%, 28% at DS 0.7, and 30% at DS 1.2. Clear, flexible films can be formed that are resistant to oils, greases, and organic solvents. Carboxymethylcellulose is subject to enzymatic attack, but is comparatively resistant to bacterial growth due to its high sodium content. Phenol, orthocresol, and sodium benzoate have been used as preservatives. The polymer is metabolically inert. The refractive index of the air-dried film is 1.515.

Carboxymethylcellulose is soluble in either hot or cold water, insoluble in organic solvents. It will dissolve in water rapidly, but has a tendency to form lumps. It is recommended that the powder be added to the vortex of vigorously agitated water. The rate of addition should be slow enough to allow the particles to separate and become wetted, but fast enough to minimize the rapid thickening of the solution.

The viscosity of carboxymethylcellulose solutions is affected by solutes such as salts. Divalent and trivalent positive ions can precipitate CMC. If a salt is dissolved in water prior to addition of the polymer, the salt inhibits breakup of crystalline areas, and the resultant solution will have a much lower viscosity. However, if the polymer is dissolved first, the subsequent addition of NaCl will have only a small effect on viscosity. Kloow (1982) discusses the influence of particle size and uniformity of substitution upon the rate of dissolution and also upon the effect of sodium chloride on viscosity.

Solutions of carboxymethylcellulose are non-Newtonian; that is, the viscosity of its solutions will be Newtonian at low shear rate but will decrease at a critical shear rate. For example, a solution will appear to be a viscous syrup as it is poured from a bottle, but then behave as a thin liquid when spread as a lotion by hand, spatula, or brush. When such stress is removed, the liquid immediately reverts to its original, very viscous state. This is known as pseudoplasticity, and is most prominent in medium- and high-viscosity types due to the tendency of the long-chain molecules to orient in the direction of the flow when stressed.

Low-viscosity types have less tendency to be pseudoplastic, but the solutions often exhibit thixotropy. Thixotropy is a time-dependent viscosity change in which, if a solution remains at rest for a period of time, it appears to become much more viscous (in some cases even setting to a gel). When sufficient force is exerted on a thixotropic solution, the apparent viscosity is once again reduced. This property is valuable in uses such as the application of paints to walls and ceilings where a generous application might otherwise flow once the brush is removed.

Safety, Toxicity, and Handling Requirements

Health and flammability hazards are slight; the reactivity hazard is minimal. Carboxymethylcellulose is not metabolized by humans, but may have a laxative effect if a large amount (10 grams) is orally ingested. There are no known carcinogenic effects and no known medical conditions that would be aggravated by exposure.

Contact of the finely-divided dust with the eyes may cause mild irritation; immediately flush with water for at least 15 minutes (remove contact lenses). Inhalation of the dust may cause respiratory irritation; remove to fresh air and treat irritation symptomatically.

When suspended in air, the dust is flammable; do not use around open flame or sparks.

Additions to Adjust Physical Properties

Recipes and formulations for particular applications of MC and CMC in industry are often published by suppliers; commercial users develop many proprietary formulations. Additives of various types for various purposes are included in these formulations. Conservators have made little attempt to modify these polymers except by admixture with wheat-starch paste or poly(vinylacetate) to increase "the open time" in adhesives; in poultice applications, enzymes have been employed; other additives mentioned in Appendix B include paper pulp, bleach, ammonia, detergents, calcium carbonates, water colors, and animal glue.

On what kind of technical knowledge are these additions based? With a stable, unreactive polymer such as CMC, application research must be carried out to determine if such additives really achieve the desired effect. If a less stable polymer exhibits desired characteristics, a modification in formulation using a more stable polymer should be investigated. In the field of conservation, such research programs could be invaluable. In the future, a conservation research institute could supply this service, along with a continuous quality control program for industrial products.

E Enzymatic Degradation of Cellulose Ethers

Although more resistant than cellulose itself, cellulose ethers are nonetheless subject to loss of molecular weight owing to the action of cellulase enzymes released by fungi and molds. Indeed, one of the key ways of characterizing cellulose ethers is by enzymatic degradation, for this is considered to occur primarily on neighboring anhydroglucose units (AGU) that are unsubstituted (UAGU). Thus, the more substitution is complete (generally, the higher the DS), and the more uniform it is throughout the cellulose chain, the more resistant a cellulose ether will be to enzymatic attack. Wirick (1968a, 1968b) of Hercules has published a number of papers on this subject. He presents a curve, for example, of the progress of enzymatic attack on carboxymethylcellulose varying from DS 0.41 to 1.30, using Cellase® 1000 (a product of Wallerstein Laboratories, Staten Island, New York, now obtainable from G. B. Fermentations, Des Plaines, Illinois) as the celluloytic enzyme complex. A phosphate buffer at pH 6 and temperatures of 25 to 37 °C were used with the enzyme protected by 100 ppm of a biocide (Ottasept extra, 4-chloro-3,5-xylenol). Wirick reports that at a DS of 2.45 the CMC is virtually resistant to enzymatic attack.

In the case of methylcellulose, Wirick and others conclude that enzymatic chain scission occurs next to isolated unsubstituted anhydroglucose units (UAGUs). Wirick states that, enzymatic attack also takes place on UAGUs in hydroxyethylcellulose.

Klug et al. (1973) conclude that the number of chain breaks in enzymatic attack is directly related to the mole percent of unsubstituted anhydroglucose units (UAGU) present and is not influenced by the nature of the substituent group (i.e., the generic type of ether). This point of view has also been expressed by Klop and Kooiman (1965). The latter authors also state that the DP of the cellulose derivatives does not affect the rate of enzymatic hydrolysis.

Gelman (1982), in CMC ethers of DS 0.77 to 0.81, found 19.6 to 23.0% unsubstituted anhydroglucose units along the chain by studying the extent of hydrolysis by cellulase enzymes. In contrast, CMC at a higher DS, 0.94 to 1.11, hydrolyzed to a lesser extent, having only 9.0 to 15.9% UAGU in the chain. Glass (1980) reports that CMC usually has a greater uniformity of substitution than HEC and therefore tends to be more resistant at a given level of substitution. It is also possible that the ionic character of CMC may repulse the cellulase enzyme (Sarkar, personal communication).

With HEC, enzymatic attack proceeds rapidly at multiple adjacent UAGU sites and much more slowly at sites adjacent to isolated UAGUs. Apparently the degradation of methylcellulose and hydroxypropylcellulose proceeds in much the

same manner, but since these are normally sold with higher DS values than the HEC polymers, the practical rate of enzymatic attack on MC or HPC polymers tends to be lower than for HEC products (Table E.1).

Table E.1. Enzymatic degradation of commercially available cellulose ethers. Data of Wirick 1968a.

Polymer	DS	Number Average of Polymerization, DP_n		Percent Rentention of DP_n
		Original	After Enzymatic Attack	
CMC	0.79	910	62	6.8
HEC	1.2	570	38	6.7
MC	1.85	275	41.5	15.1
HPC	2.1	325	235	72.0

There has been considerable discussion in the emulsion paint trade concerning whether traces of oxidizing agents or free-radical-generating catalysts remaining in paint could cause loss in the molecular weight of cellulose ethers and hence loss in the viscosity of paints formulated with them. British studies (Springle 1988) convincingly demonstrate that most cases of viscosity loss in stored paints are due to enzymatic action; the effects of oxidizing agents at the concentrations likely to remain in paint is negligible in comparison to the effect of only a few parts per million of celluloytic enzymes. A test methodology was described to distinguish between these two possible causes of viscosity loss. This was done primarily by comparing, after 24 hours, paint samples with and without a mercury-containing compound to inhibit mold growth. The addition of 0.02% ascorbic acid to the sample, on the other hand, would accelerate the loss of viscosity if oxidizing impurities were the cause.

Conservators rarely store solutions of cellulose ethers over long periods of time because of the possibility of enzymatic degradation. Under sterile conditions, however, stability of more than a year is possible. As a precaution, conservators can store their solutions for brief periods in a refrigerator. In planning laboratory tests of the relative thermal stability of solutions, one may wish to assure the inhibition of enzymatic activity. Heating solutions at 80 °C for 30 minutes or at 100°C for 1 minute will usually provide satisfactory protection against loss of viscosity due to microbiological action. Cellulase in aqueous solutions can usually be destroyed by heating the solution for 15 minutes at 50 °C at a pH of 9–10. Most manufacturers also provide lists of suitable preservatives. Thymol at 0.1% in the total solution and phenol at 0.3% represent the usual range of concentration of fungus and mold inhibitors.

F Peroxide Formation in Ethylcellulose

Although conservators are perhaps rarely concerned with the use of ethylcellulose, the chemistry of its thermal degradation is well known. In order to establish beyond any doubt the reasons for avoiding the use of this particular ether, it is useful to review the mechanism by which it deteriorates. The mechanism is likely to be much the same in organic-soluble ethylhydroxyethylcellulose.

The thermal oxidative degradation of ethylcellulose, an organic-soluble ether, has been studied in detail by the Russian chemist Koz'mina (1968), who showed that thermal aging involved the formation of peroxides, the rate of their formation being influenced by the temperature. The energy of activation for peroxide development in the range 69–130 °C (calculated from the Arrhenius equation) was found to be 25 to 26.7 kcal/mole. Peroxides tend to accumulate, reach a maximum, and then decrease (Fig. 6.8). The oxidation of ethylcellulose leads to the elimination of an ethoxyl group from the ether, which should result in a gradual return to the solubility characteristics of cellulose rather than those of the ether.

Prior to Koz'mina's studies, Evans and McBurney (1949) examined the effect of short-wavelength ultraviolet radiation (a mercury-vapor lamp) on the oxidation of ethylcellulose, a wavelength region that may not cause the same types of degradation as visible and near-ultraviolet.

Koz'mina and his associates, on the other hand, carried out extensive studies of the thermal deterioration of ethylcellulose and analogous ethers. Upon aging at temperatures between 100 and 130 °C, they found that both the inverse of the induction period and the steady-state rate of absorption of oxygen obeyed the Arrhenius relationship (that is, that the logarithm of the rate is proportional to the inverse of the absolute temperature; Kurlyankina and Koz'mina 1963). The formation of low-molecular weight decomposition products such as acetaldehyde and formic acid began with the very first reactions with oxygen. Low-molecular-weight peroxides are also formed from reactions such as

$$CH_3CH_2 - OOH + H - \overset{O}{\overset{\|}{C}} - CH_3 \longrightarrow CH_3CH_2 - OO - \overset{\overset{H}{|}}{\underset{\overset{|}{O}{H}}{C}} - CH_3$$

About 80 to 90% of the oxygen is consumed in oxidizing the ether groups, and 10 to 20% is involved in oxidizing aldehyde groups to carbonyl, and to form formic acid, carbon dioxide, carbon monoxide, and low-molecular-weight peroxides.

The chief decomposition pathways are projected as follows, with C_1 and C_2 representing the number 1 and 2 carbon atoms in the anhydroglucose structure of cellulose as customarily numbered:

$$
\begin{array}{c}
H\!-\!\underset{O}{\overset{①}{C}}\!-\!O \\
O\!-\!\overset{②}{HC}\!-\!OCH_2CH_3 + O_2 \xrightarrow{\ 1\ }
\quad
H\!-\!\underset{O}{\overset{①}{C}}\!-\!O \\
O\!-\!\overset{②}{HC}\!-\!O\!-\!\underset{OOH}{CHCH_3} \ \Big\downarrow 2
\end{array}
$$

$$
\overset{②}{HC}\!-\!O\!-\!\underset{\overset{\|}{O}}{CCH_3} \ \xleftarrow{\ 3\ } \ \overset{①}{HC}\,OOH + \overset{②}{HC}\!-\!O\!-\!\underset{O\cdot\ +\ \cdot OH}{CHCH_3} \ \Big\downarrow 4
$$

$$
\overset{②}{HC}=O + \underset{\overset{\|}{O}}{HCCH_3}
$$

By making carbon atom C_1 radioactive, it was possible to show that the formic acid, HCOOH, came from the breaking apart of the cellulose chain at that point (step 2 in the scheme; Koz'mina et al. 1963).

As shown in the chemical reaction scheme, the oxidative attack, leading to the formation of peroxides (step 1) occurs on the alkyl group of the alcohol. The rate of peroxide formation under conditions of thermal oxidation and the ultimate level of peroxide formation is greater the larger the alkyl group in the ether (Kozlov et al. 1963). During thermal aging, the molecular weight begins to decrease following a period of induction, at about the time the build-up of peroxides begins to decrease. The degree of substitution also begins to decrease as the side chains are degraded in the oxidation process. These details were elucidated by thermal-aging studies at 110 °C on samples of ethyl, heptyl and nonyl cellulose ethers.

The maximum number of peroxide groups formed at these high temperatures is 10 to 12 per 100 anhydroglucose units in the chain. The fact that the peroxide concentration passes through a maximum is typical of thermal auto-oxidation reactions (Koz'mina 1968); a higher maximum concentration of peroxides is built up as the temperature decreases. In Figure 4 of Koz'mina's publication (1968), the results of heating at 100, 110, and 120 °C are shown; these same reactions, of course, can also occur at room temperature.

Koz'mina (1968) also shows that ethylcellulose stored in the lab for two years no longer exhibited an induction time with respect to the loss of molecular weight or gain in oxygen when heated at 130 °C. The practical implication of this finding is that samples of ethylcellulose left standing on the shelf for some time are likely to deteriorate more rapidly due to the fact that the induction time before deterioration sets in has been shortened if not eliminated.

In a homologous series of cellulose ethers, the rate of thermo-oxidative degradation increases as the alkyl group becomes larger (Kozlov et al. 1963). (Much the same effect takes place in cellulose esters of fatty acids. Thus, cellulose acetates are relatively more stable than butyrates; caproates are less stable.) The author points out that this result may be influenced by the fact that the second-order transition temperature falls rapidly as the length of the alkyl groups increases in such derivatives. Thus, the softer and more flexible polymers, with longer alkyl groups in their structure, will be in a more fluid or mobile state at high temperatures, thereby enhancing chemical reactions within the polymer.

Peroxide formation in polymers usually initiates extensive oxidation reactions that lead to the ultimate degradation of the polymer. Koz'mina's work has demonstrated that peroxide formation in ethylcellulose leads to a loss of induction time and the formation of volatile peroxide compounds as well as the direct loss in the degree of polymerization.

McBurney's and Koz'mina's findings have been briefly summarized by Conley (1970).

G Complete Characterization of Cellulose Ethers: Distribution of Substituents

It is difficult to characterize a cellulose ether completely; a statement regarding the degree of substitution (DS) is not sufficient. The reported value of DS is usually an average, and at any level of DS below 3.0 the individual pyranose rings may have from zero to three substitutions. A reasonably complete characterization of a particular cellulose ether would involve a statement as to the average degree of substitution (and kind, if a mixed ether) on each carbon atom on the pyranose ring, as well as a statement of the number of unsubstituted anhydroglucose units (UAGU) present (S_0) (Reuben 1984). Information on the former can be found by hydrolyzing the cellulose ether into substituent glucoses and analyzing these by chromatographic techniques (Hodges et al. 1979). An attack by enzymes reveals much about the number of UAGUs present (Klug, Winquist, and Lewis 1973). Stratta's (1963) early study of hydroxyethylcellulose serves as an example of the way in which these complex substitutions can be analyzed. It must be realized, however, that such an analysis requires considerable experience and is time-consuming and costly.

Stratta defined two key parameters: (1) molar substitution (MS), the average number of ethylene oxide molecules per anhydroglucose unit (AGU), and (2) the degree of substitution (DS), the number of positions on the AGU that, on average, are occupied by ethylene oxide appendages. There is theoretically no limit to the MS. The maximum DS is, of course, 3. The average chain length of ethylene oxide groups is MS/DS.

Stratta developed a kinetic interpretation of the analytical results, assuming that the relative velocity constants for etherification of the hydroxyl groups on C_2, designated k_2, on C_3, designated as k_3, and on C_6, designated as k_6, are in a ratio of 3 to 1 to 10 respectively. For the newly-formed hydroxyethyl groups, the relative velocity constant was assumed to be 20, designated as k_x. Thus, the relative velocity constants for substitution on the cellulose hydroxyls, according to Stratta, are $k_2 = 3 : k_3 = 1 : k_6 = 10 : k_x = 20$. A table in his paper shows how closely the experimentally determined mole percentages of substituents agree with the calculated amounts based on these rate constants.

Figure G.1 gives an example of the calculated relative mole percent of each component as a function of DS and MS using the assigned rate constants for k_2, k_3, k_6 and k_x. Each of these curves can be further divided. Figure G.2 gives the example of the calculated relative concentrations of all anhydroglucose units (AGUs) monosubstituted at C_6 (designated as S_6; see notations at the top of Figure G.1), giving the

mole percent of those units substituted with none, one, two, and three ethylene oxide units at each level of DS.

The proposed rule-of-thumb requirement for solubility is an MS of 1.0. Based on the information illustrated in Figure G.1, Stratta prepared a table giving the disposition of substitution expected in a water-soluble HEC. At an MS of 1.0, it was calculated that 45% of the AGUs would still be unsubstituted. One can also compute the number of unsubstituted units that can exist in a sequence. Figure G.3 gives the probability of finding either substituted or unsubstituted AGUs in a given sequence in HEC having an MS of 1.0. Unsubstituted AGU sequences will generally range from 1 to 6.

Data in Figure G.1 can be used to determine the character of partially reacted products. Thus, one can see that HEC of DS 1.4 contains about 40 mole percent groups reacted on carbon atom 6 (S_6); about 25% having disubstitution, occupying carbon atoms 2 and 6 (S_{26}). Stratta pointed out that, when a completely accessible alkali cellulose is hydroxyethylated at optimum conditions, the variation of DS and side-chain length with respect to MS can be described by statistical analysis. The ideal relationship is shown by the full-line curves in Figure G.4a and G.4b. Excellent agreement with three published analyses is seen.

Figure G.1. Distribution of anhydroglucose units substituted in various positions and to various degrees by hydroxyethyl groups at DS of 0 to 3. In the diagrams below, the x shows the position or positions substituted; S_0, S_6, S_{23}, S_{236}, etc. are the customarily used notations for the different types of substitution. Data of Stratta (1963) reproduced with the permission of the publisher.

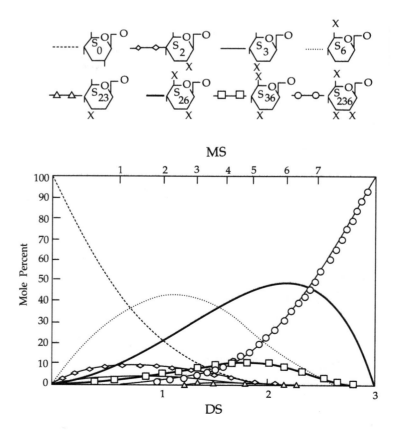

Figure G.2. Distribution of anhydroglucose units substituted to various degrees on carbon atom 6 by hydroxyethyl addition as a function of the overall degree of substitution of hydroxyethylcellulose from DS 0 to 3. Data of Stratta (1963) reproduced with the permission of the publisher.

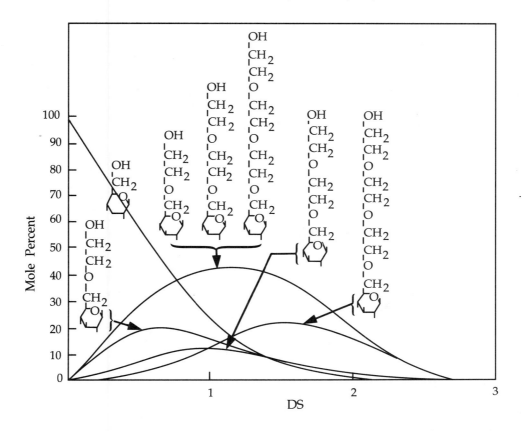

Figure G.3. Probability of finding sequences of substituted or unsubstituted anhydroglucose units in hydroxyethylcellulose of MS 1.0. Data of Stratta (1963) reproduced with the permission of the publisher.

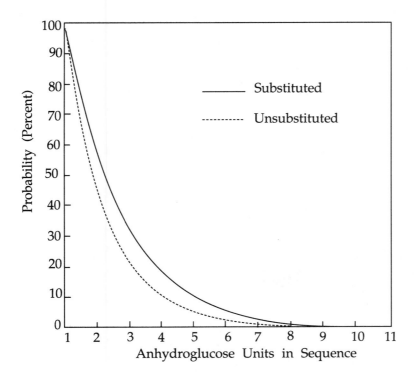

Figure G.5 shows the results of Stratta's more extensive analyses of a number of industrial HEC products. The data obtained on low MS materials are in good agreement with the theoretical relationships, indicating that hydroxyethylation has taken place at the maximum number of positions along the cellulose chain and that the resultant pendant groups (represented by MS) are as short as possible. Nearly all commercial samples are clustered about a DS of one. As seen in Figure G.5b, some samples with high MS values had longer pendant groups, averaging 2.7 to 2.9 oxy-ethylene units compared to 1.6 to 1.8 in the average samples.

Determination of MS values was done by the method used by Morgan (1946). The DS was carried out by an unpublished method described at an international meeting by J. M. Quinchone in 1959.

Reuben (1984) also describes the mathematical treatment used to analyze the degree of substitution in this polymer. Degradation with cellulolytic enzymes was used to detect primarily the points in the chains containing adjacent unsubstituted glucosyl residues. His detailed study of the mechanism of enzymatic attack shows that the bond next to a glucose unit having substitution on O-6, the beta-glucosyl(1-4)-6-O-substituted glucosyl bond, would also be attacked. Thus, to describe substituents thoroughly, the total molar substitution (MS), the number of unsubstituted glucosyl units (S_o), and the number of vicinal dihydroxy positions (V_{23}) could be measured chemically. Wirick's much earlier paper (1968b) deals with the same basic questions.

Glass (1980) has published a series of curves in which the actual analysis of unsubstituted AGUs and 2,3 diols (V_{23}) for a given MS were compared to the values computed for different values of k_2, k_3, k_6 and k_x. By comparing the experimentally determined substituents with those calculated from various values of k_1, k_2, etc., the values of the specific rates of substitution (the k's) can be estimated and then used to plan the preparation of polymers with desired properties such as resistance to enzymatic attack.

The purpose of this appendix has been to show just how complicated the complete characterization of a cellulose ether is and to illustrate the results of such an analysis in the case of HEC. Application of nuclear magnetic resonance techniques promises to make this task much easier in the future (see Appendix H). Nonetheless, the tedious methods of chemical analysis provide the most accurate results.

Figure G.4. Dependence of degree of substitution (DS) and of average chain length in relation to MS of hydroxyethylcellulose. Data points are based on published analyses. Data of Stratta (1963) reproduced with the permission of the publisher.

Figure G.5. Dependence of degree of substitution (DS) and of average chain length in relation to MS of hydroxyethylcellulose. Published values (□) and values obtained from analysis of various production grades of commercial hydroxyethylcellulose (○). Compare these data with diagram in Figure G.4. Data of Stratta (1963) reproduced with the permission of the publisher.

H Analysis of Cellulose Ethers

Standard Method of Testing Cellulose Ethers

ASTM Method D1439-83a essentially carries the above title. The standard covers methods for the determination of the following characteristics: (1) moisture content (basically, oven drying at 105 °C); (2) degree of etherification of both crude and highly purified CMC (the latter involving an acid-base titration in acetic acid/dioxane, measured potentiometrically); (3) viscosity (measured with a Brookfield viscometer); (4) purity (an "active ingredient" determination for crude grades); (5) concentration of sodium glycolate; and (6) concentration of sodium chloride. ASTM D1347-64, Standard Methods of Testing Methylcellulose, gives test procedures for moisture, ash content, chlorides, alkalinity, iron, heavy metals, methoxyl content, viscosity, solids, and density.

Standard methods for determining moisture, viscosity, and ash content in hydroxyethylcellulose and hydroxypropylcellulose are given, respectively, in the Natrosol and Klucel brochures from Aqualon.

Determination of Degree of Polymerization

The following are formulas for the relationship of intrinsic viscosity and degree of polymerization for different cellulose ethers.

Methylcellulose: $[\eta]_{H2O} = 2.92 \times 10^{-2} DP_w^{0.905}$ (Wirick 1968a)

Carboxymethylcellulose: $[\eta]_{0.1N\ NaCl} = 1.8 \times 10^{-2} DP_w^{0.79}$ (Wirick 1968a)

Hydroxyethylcellulose: $[\eta]_{H2O} = 1.1 \times 10^{-2} DP_w^{0.87}$ (Brown, Henley, and Öhman 1963)

Hydroxypropylcellulose: $[\eta]_{H2O} = 1.17 \times 10^{-2} DP_w^{0.90}$ (Wirick 1968a)

$[\eta]_{EtOH} = 7.2 \times 10^{-3} DP_w^{0.90}$ (Wirick and Waldman 1970)

Determination of Molar Substitution by Nuclear Magnetic Resonance

Nuclear magnetic resonance (NMR) techniques have proven useful in elucidating the structure of cellulose ethers. New applications are developing rapidly; hence, the methods cited may not be the latest or the most effective. Nonetheless, a few representative procedures will be described to illustrate the principles and potentialities of the technique. Whereas NMR provides good information, the chemical methods described in "Standard Methods of Testing Cellulose Ethers" are the methods of choice, and analyses provided with the commercial samples are generally obtained by those methods.

Cellulose and cellulose ethers can be hydrolyzed to yield the individual substituted or unsubstituted hexoses. Clemett (1973) of Unilever Research, Wirral, Cheshire, UK, has described in simple terms how one is able to determine the molecular substitution (MS) of cellulose ethers using NMR on the hydrolysates. Figure H.1a compares the relatively unresolved details observable in the spectrum of ethylhydroxyethylcellulose with the much better resolved spectrum of the hydrolysates (Figure H.1b). The area under the peaks at A represents the contributions of the single hydrogen on carbon-1 of the anhydroglucose unit. The total area at B (at 3.7 ppm) contains contributions from 6 hydrogens (H) in the anhydroglucose unit: 4 H's on the hydroxyethyl groups, and 2 H's from the ethyl (secondary H's). The remaining 3 H's of the ethyl group produce the triplet at area C (1.15 ppm). The H's on the hydroxyl groups in the sugars exchange with the H's from H_3O^+ in the acidic solution used to hydrolyze the ether and appear at 8.2 ppm, sufficiently removed from the region of interest to pose no problem.

Figure H.1. NMR spectrum of an ethylhydroxyethylcellulose (EHEC) in 36% HCl (a) immediately after dissolution, (b) after hydrolysis at 50 °C for 1.5 hours. Data of Clemett (1973) reproduced with the permission of the publisher.

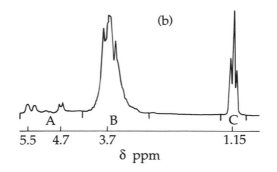

On this basis the MS of ethyl group equals C/3A (1/3 the area under peak C divided by the area of A). The MS of hydroxyethyl equals (B - 2/3C - 6A)/4A. In the case of methylcellulose, MS of methyl equals (B - 6A)/3A.

In an early article on this subject, Parfondry and Perlin (1977), also pointed out that mild acid hydrolysis is useful in obtaining spectra of highly substituted MC, CMC, and HEC polymers (DS 1.5 to 2.8), whereas those of lower degree of substitution (DS less than 1) can be analyzed by partial degradation with enzymes.

Hydroxyethylcellulose (HEC)

DeMember et al. (1977) analyzed samples of Hercules 250L (now a product of Aqualon), an HEC of approximate MS 2.5. Particularly interesting were a series of measurements made on six different lots of the polymer, indicating that the MS of the commercial product can vary from 2.68 to 2.85 (based on wet chemical determination) and the DS from 1.30 to 1.44, with experimental deviations of ± 0.15 and ± 0.07, respectively. Wirick (1968b, had determined similar values on this same product. The authors describe, in considerable detail, their technique using a Varian CFT-20 Spectrophotometer.

Hydroxypropylcellulose (HPC)

Lee and Perlin (1982) of McGill University describe the analysis of HPC in which the characteristics of Klucel E are presented along with data on the chemical shifts found in various ethers of 2-hydroxypropanol. The DS on both oxygen-2 (O-2, the oxygen attached to carbon atom 2 in the anhydroglucose ring) and on O-6 was found to be about 0.9–1.0 and on O-3, about 0.5, for a total DS of about 2.5. Molar substitution on the individual carbons was found to be about 1.5–1.6 on O-2 and O-6 and 0.9–1.0 on O-3; the overall MS (molecular substitution) of hydroxypropyl units thus appeared to be 4.0.

As found with other cellulose derivatives, hydrolysis with 3 molar H_2SO_4 at 95 °C resulted in superior NMR signal dispersion. Hydrolysis and sodium borohydride reduction techniques were used to further characterize the hexose fragments and their particular substituent groups.

In a later article (1983), Lee and Perlin pointed out that highly substituted HPC can be depolymerized rather easily by methanolysis in cases in which the usual acid hydrolysis procedures would be ineffective. They refluxed the methanolic solutions of HPC for 18 hours at a concentration of 10% HCl.

In an initial article by Ho and his associates (1972) of the Hercules Research Center, Wilmington, Delaware, the analysis of Klucel E is described in which the DS was found to be 2.6 ± 0.2 and the MS, 4.2 ± 0.2. Their method for determination of DS is based on a comparison of the integrated areas under the spectral peaks in the NMR curves shown in Figure H.2; area A represents the methyl protons and area B the remaining protons.

Figure H.2. NMR spectrum of hydroxypropylcellulose (HPC) at 5% concentration in $CDCl_3$ solvent. Data of Ho, Kohler, and Ward (1972) reproduced with the permission of the publisher.

The authors describe a direct ratio method. Each of the hydroxypropyl substituents brings to the cellulose skeleton three methyl protons and three other protons from methylene and methyne groups. Also, there are ten protons resulting from each cellulosic unit regardless of its MS value, with seven C-H protons and three O-H protons. Therefore, if the integrated area from methyl protons is designated as A in Figure H.2 and the area from the remaining protons as B, one can readily calculate MS of the hydroxypropylcellulose by the equation:

$$MS = \frac{10A}{3(B - A)} \tag{1}$$

By use of this procedure for the analysis of a typical commercial sample of Klucel , an MS of 4.2 was obtained, with a 95% confidence interval of ± 0.2. The precision for the measurement of MS is thus about 5%. The precision is relatively low, caused by the fact that uncertainties in the measurement of each individual peak area are multiplied in the mathematical calculation. However, the authors point out that the advantage of the NMR method is speed of analysis. Moreover, NMR does not require any primary standards for sample titration or for instrument-response calibration. It doesn't even require knowledge of the sample weight. A complete analysis for a single sample can be done within an hour.

Another method for determining MS involved titrating the OH groups by reacting them with trichloroacetylisocyanate and noting the increase in the intensity of a shifted frequency of the hydrogens on end methyl groups as the result of this reaction. Each cellulose unit will have three OH groups regardless of the degree of substitution. Hence, the titration yields the number average molecular weight, DP_n. From this information, the formula weight of the HPC can be found (the extra formula weight over that of cellulose alone gives the weight of hydroxypropyl units per anhydroglucose unit, and thence, the MS).

Carboxymethylcellulose (CMC)

Ho and Klosiewicz (1980) hydrolyzed CMC in 20% H_2SO_4 at about 90 °C to yield substituted glucoses which were then analyzed by proton NMR to determine the degree of substitution in this type of polymer. The results of the analysis of the distribution of substituents on C_2, C_3, and C_6 are shown in Figure H.3. Reuben and Connor (1983) also describe the analysis of CMC by NMR.

Figure H.3. Calculated curves and experimental values of the distribution of substituents in carboxymethylcellulose as a function of DS. Data of Ho and Klosiewicz (1980) reproduced with the permission of the publisher.

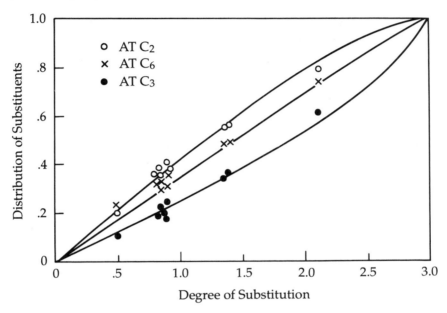

Infrared Spectra

Infrared is generally considered not sensitive enough to be used to determine precise values of DS. Nonetheless, it often can indicate the generic class of cellulose ether. Infrared spectra of five types of cellulose ethers appear in the atlas published by the Federation of Societies for Coatings Technology (1980). Nonetheless, a library of spectra is presented here for ready reference. The spectra were obtained using a Nicolet DX Fourier transform instrument. Films of the cellulose ethers were cast from 1% solutions on silver chloride disks for the water-soluble types and on sodium chloride for the organic soluble types.

The wave numbers of the principal absorption bands are noted on the spectra directly as they were recorded by the "peak picker" program of the Nicolet spectrometer. High confidence should not be placed in the last significant figure; nonetheless, the fact that the peak at 1375 ± 1 cm^{-1} appears in nearly every one of the spectra, measured on several different occasions, suggests the general reliability of a peak-selecting program.

Different commercial brands and molecular weight grades were examined; nonetheless, it is only necessary to publish representative spectra of each generic type. Infrared analysis will not distinguish different molecular weight grades of a polymer. On the other hand, different degrees of substitution or molar substitution can affect the relative peak height and, therefore, can be discerned. This is most prominently displayed in the alcohol band at about 3400 cm^{-1}. A generic class of ether with a very low degree of substitution, such as carboxymethylcellulose, shows a very large, broad absorption band in this region, often over 300 cm^{-1} wide. As the degree of substitution is increased this tends to become smaller and sharper. Comparing the spectra of the two ethylhydroxyethylcelluloses illustrates this point. For water-soluble Ethulose, the band at 3442 cm^{-1} is smaller than the corresponding one in CMC, but is still substantial. For the organic-solvent-soluble variety, highly substituted with ethyl groups, this peak, here seen at 3483 cm^{-1}, is small. A modest alcohol absorption can also be seen in the spectrum of ethylcellulose, which is only available as an organic-solvent-soluble product.

Another closely related pair is Methocel A4C, a methylcellulose, and Methocel E4M, a hydroxypropylmethylcellulose. The spectra of these two are virtually identical; however, the methylhydroxypropylcellulose is somewhat more substituted and therefore has a smaller, sharper peak at 3463 cm^{-1} in comparison to methylcellulose.

Methocel E4M Methylhydroxypropylcellulose

EHEC–Low Ethylhydroxyethylcellulose

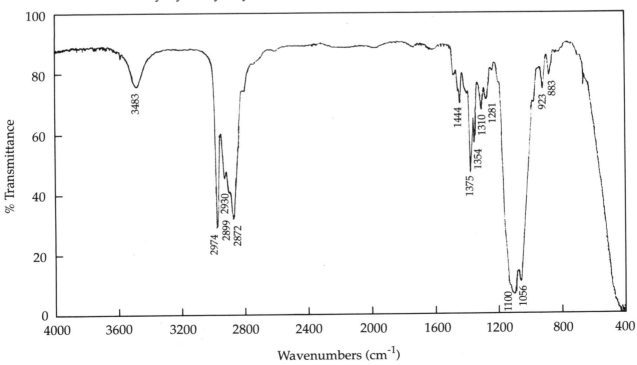

Ethocel Ethylcellulose

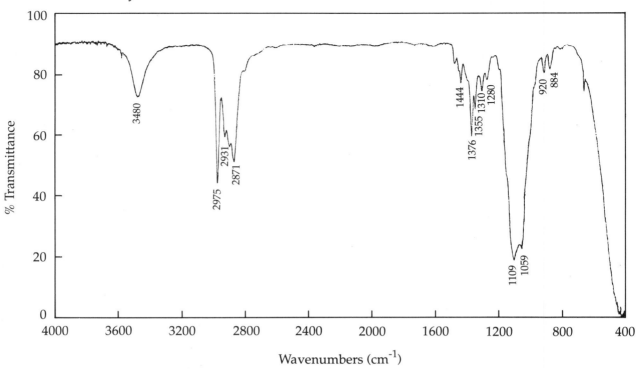

Ethulose Ethylhydroxyethylcellulose

Cellofas B-3500 Carboxymethylcellulose

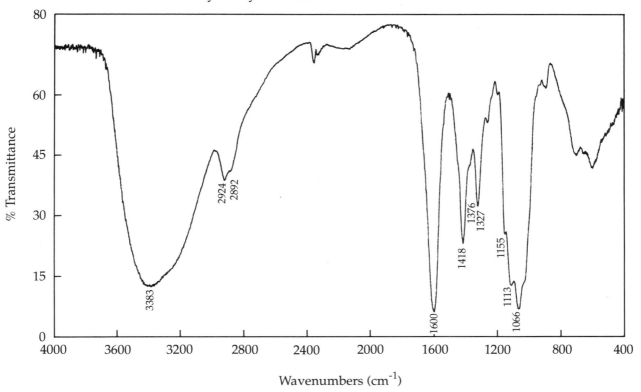

Klucel G Hydroxypropylcellulose

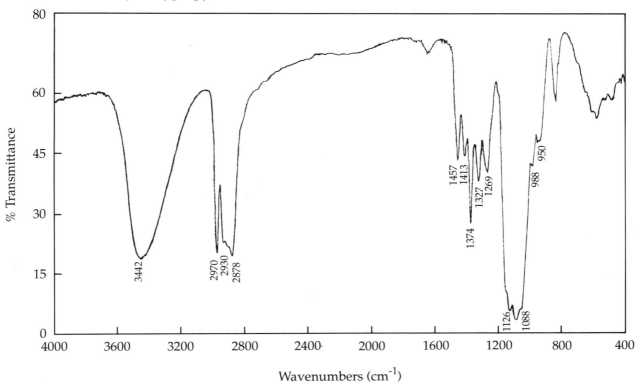

Natrosol Hydroxyethylcellulose

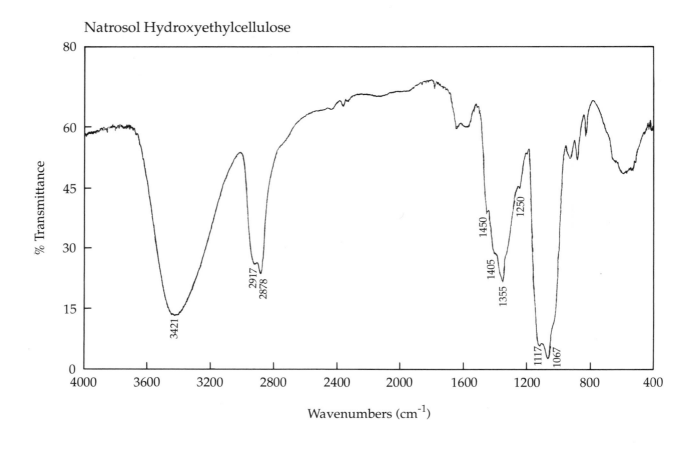

Methocel A4C Methylcellulose

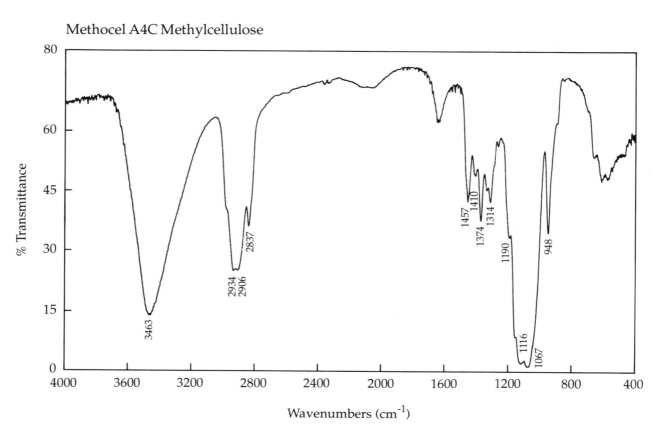

I The Relationship of Molecular Weight and Intrinsic Viscosity

When the kinematic viscosity of a solution is measured in a capillary viscometer, the ratio of the flow time of the solution, t, to the flow time for the solvent, t_0, is called the relative viscosity. When the densities of the solvent and solution are essentially the same (i.e., in very dilute solutions), the relative increase in the viscosity of the solvent caused by dissolved polymer $(\eta - \eta_0)/\eta_0$ or $(\eta/\eta_0) - 1$, where η is the viscosity with the polymer present and η_0, the viscosity of the solvent, is called the specific viscosity, η_{sp}. The ratio of the specific viscosity to the concentration of polymer, $\eta_{sp/c}$, is called the reduced viscosity. The value of $\eta_{sp/c}$ that is characteristic of the polymer may be obtained by extrapolating $\eta_{sp/c}$ to zero concentration. The specific viscosity at zero concentration is defined as the intrinsic viscosity.

Most publications in the United States express concentrations in grams per 100 milliliters of solution and intrinsic viscosity in deciliters per gram. Plots of $\eta_{sp/c}$ versus concentration are usually linear up to about 0.5% concentration for polymers having specific viscosities of less than 4 to 5 deciliters per gram.

The weight average molecular weight (M_w) of a polymer is related empirically, but not absolutely, to its intrinsic viscosity $[\eta]$ by the Mark-Houwink equation,

$$[\eta] = KM_w^a$$

where K and a are constants independent of molecular weight over four decades of molecular weight, but dependent on the nature of the polymer, the solvent, and the temperature. In poor solvents, a is 0.5. In good solvents, a is between 0.65 and 0.85 for polymers whose molecules are soft coils; higher values indicate molecular stiffness and molecular asymmetry. Equations that apply to cellulose ethers have been noted in Appendix H.

For a given polymer-solvent combination, the constants K and a can be evaluated from viscosity measurements and from molecular weights determined on carefully prepared fractions. Suitable molecular weights are provided by light-scattering measurements, or by a study of sedimentation and diffusion. Molecular weight will be referred to in the following discussion. However, the corresponding degree of polymerization, whether determined by viscosity, weight average or number average methods (DP_v, DP_w, DP_n) can be obtained simply by dividing the stated molecular weight by the weight of the monomeric units used to build up the polymer structure. (This passage is based on remarks found in Miller 1966).

Number Average Molecular Weight

In most polymers the molecules are not of the same size (weight) but are distributed over a skewed bell-shaped distribution of molecular weights. The average molecular weight obtained by viscosity techniques (M_v) falls between the number average M_n and weight average M_w, but is closer to the latter. When the values for the exponent a in the Mark-Houwink equation are less than 0.7, M_w and M_v are similar.

The number average M_n, or arithmetic mean of all the molecules present, may be obtained by actually counting the molecules. The molecules may be counted by analysis of the end-group, specifically tagged atoms, or chromophoric groups, in a polymer chain. Similar values are obtained by indirect counting: osmometry, cryoscopy, and ebullioscopy.

The number average M_n (or DP_n) assumes that each molecule makes an equal contribution to polymer properties regardless of its size or weight. Facetiously, this is equivalent to saying that hash made from one horse and four chickens is 80% chicken hash. Thus, the number average M_n for three macromolecules with individual molecular weight values of 10,000, 200,000, and 390,000 is 600,000/3 or 200,000. The number average molecular weight is a good index of physical properties, such as impact and tensile strength, but is not a good index of other properties such as flow.

Weight Average Molecular Weight

Light scattering and sedimentation equilibrium (ultracentrifugation) techniques, which measure molecular size, yield weight average molecular weights, M_w. These values, in which each molecule contributes in accordance with its weight, are obtained by dividing the summation of the square of the molecular weight values by the summation of the molecular weights of all the molecules present. Thus, M_w for the three macromolecules with molecular weights of 10,000, 200,000, and 390,000 would be equal to $[(10)^2 + (200)^2 + (390)^2] \times 10^6/(600 \times 10^3) = 320{,}333$. The hash that was called 80% chicken by the number average approach would be shown by the weight average approach to be essentially horse hash with a trace of chicken.

In polydisperse systems, the weight average values, M_w and DP_w, are always greater than the number average. In monodisperse systems, M_w would be equal to M_n. Thus, the ratio M_w/M_n may be used as a measure of the molecular weight distribution or as an index of polydispersity. For polymers having the most probable distribution of molecular weights, M_w is equal to $2M_n$, but in the case of cellulose ethers the factor often is greater than 2; Brown, Henley, and Öhman (1963) describe a CMC product where the ratio of M_w/M_n is 3.7. A comparison of DP_w and DP_n in the case of methylcellulose can be seen in Figure 6.13. (This section reflects the discussion of the subject provided by Seymor 1971).

References Cited

Bach Tuyet, L.T., K. Iiyama, and J. Nakano

 1985 Preparation of Carboxymethylcellulose from Refiner Mechanical Pulp IV. Analysis of Carboxymethylated Polysaccharides by Use of ^1H-NMR. *Mokuzai Gakkaishi* (Journal of the Wood Research Society) 31:14–19.

Bailie, C.W., R.M. Johnston-Feller, and R.L. Feller

 1988 The Fading of Some Traditional Pigments as a Function of Relative Humidity. *Materials Research Society Symposium Proceedings* 23:287–292.

Baker, C.A.

 1982 Methylcellulose and Sodium Carboxymethylcellulose: Uses in Paper Conservation. *American Institute for Conservation of Historic and Artistic Works*, Book and Paper Group, 10th Annual Meeting, Postprints.

 1984 Methylcellulose and Sodium Carboxymethylcellulose: An Evaluation for Use in Paper Conservation Through Accelerated Aging. *Adhesive and Consolidants*, Paris Congress, 2–8 September, IIC Preprints: 55–59.

Batdorf, J.B., and J.M. Rossman

 1973 In *Industrial Gums*. 2d ed. R.L. Whistler and J.N. BeMiller, eds. New York: Academic Press: 700.

Berg, C.J., W.R. Jarosz, and G.F. Salathe

 1967 Performance of Polymers in Pigmented Systems. *Journal of Paint Technology* 39:436–453.

Bhattacharjee, S.S., and A.S. Perlin

 1971 Enzymatic Degradation of Carboxymethylcellulose and Other Cellulosic Derivatives. *Journal of Polymer Science, Part C* 36:509–521.

Brown, W., D. Henley, and J. Öhman

 1963 Studies on Cellulose Derivatives, Part II. The Influence of Solvent and Temperature on the Configuration and Hydrodynamic Behavior of Hydroxyethylcellulose in Dilute Solution. *Makromolekulare Chemie* 64:49–67.

 1964 Sodium Carboxymethyl Cellulose, an Experimental Study of the Influence of Molecular Weight and Ionic Strength on Polyelectrolyte Configuration. *Arkiv for Kemi* 22:189–206.

 1980 Hydroxypropylcellulose. In *Handbook of Water-Soluble Gums and Resins*. R.L. Davidson, ed. New York: McGraw-Hill.

Chamberlin, T.A., and G.L. Kochanny, Jr.

1969 The Degradation of Methylcellulose by Ionizing Radiation. *Macromolecules* 2(1):88–93.

Clemett, C.J.

1973 Determination of the Molar Substitution of Cellulose Ethers Using Proton Magnetic Resonance. *Analytical Chemistry* 45(1):186–188.

Cohen, S.G., H.C. Haas, L. Farney, and C. Valle, Jr.

1953 Preparation and Properties of Some Ether and Ester Derivatives of Hydroxyethylcellulose. *Industrial and Engineering Chemistry* 45:200–203.

Conley, R.T.

1970 *Thermal Stability of Polymers*. New York: Marcel Dekkev: 523–547.

Conrad, C.M., V.W. Tripp, and T. Mares

1951 Thermal Degradation in Tire Cords, Part 1: Effects on Strength, Elongation, and Degree of Polymerization. *Textile Research Journal* 21(10):726–739.

Davidson, R.L., and M. Sittig

1962 *Water-Soluble Resins*. New York: Reinhold Publishing Company.

DeMember, J.R., L.D. Taylor, S. Trummer, L.E. Rubin, and C.K. Chiklis

1977 Carbon-13 NMR of Hydroxyethylcellulose: An Accurate Method for Structural Determination. *Journal of Applied Polymer Science* 21:621–627.

Encyclopedia of Polymer Science and Technology

1968 Cellulose Ethers 3:459–548.

Evans, E.F. and L.F. McBurney

1949 Ultraviolet Light Stability of Ethylcellulose. *Industrial and Engineering Chemistry* 41:1256–1259.

Federation of Societies for Coatings Technology

1980 *An Infrared Spectroscopy Atlas for the Coatings Industry*. Philadelphia. Reprinted in 1985.

Feller, R.L.

1964 Control of the Deteriorating Effects of Light upon Museum Objects. *Museum* 17:57–98.

1975 Speeding Up Photochemical Deterioration. *Institut Royal du Patrimoine Artistique Bulletin 15:135–150.*

1981a The Thermal and Photochemical Stability of Water-Soluble Resins. Final Report to the National Museum Act.

1981b Talk given at the annual meeting of the American Institute for Conservation of Historic and Artistic Works in Philadelphia during Workshop on Adhesives. Recorded on tape.

1987a Comments on the Measurement of "Yellowness" in Pulp and Paper. *American Institute for Conservation*, Book and Paper Group Annual, Vol. 6. Washington, D.C.: 56–67.

1987b Some Factors to be Considered in Accelerated Aging Tests. *American Institute for Conservation of Historic and Artistic Works*, Preprints, 15th Annual Meeting, Vancouver, B.C.

Feller, R.L., S.B. Lee, and J. Bogaard

1986 The Kinetics of Cellulose Degradation. In *Historic Textile and Paper Materials: Conservation and Characterization*. H.L. Needles and S.H. Zeronian, eds. Advances in Chemistry Series 212, American Chemical Society: 329–346.

Gelman, R.A.

1982 Characterization of Carboxymethylcellulose: Distribution of Substituent Groups Along the Chain. *Journal of Applied Polymer Science* 27:2957–2964.

Gibbons, G.C.

1952 The Homogeneous Acid Hydrolysis of Methyl Cellulose. *The Journal of the Textile Institute*. Transactions 42:T25–T37.

Glass, C., ed.

1986 *Water-Soluble Polymers*. American Chemical Society, Advances in Chemistry, Series 213. Washington, D.C.

Glass, J.E., A.M. Buettner, R.G. Lowther, C.S. Young, and L.A. Crosby

1980 Hetrogeneous Ethoxylation of Cellulose: Influence of Alkali and Available Water Concentration on Substituent Distributions. *Carbohydrate Research* 84:245–263.

Hammett, L.P.

1970 *Physical Organic Chemistry*. 2d ed. New York: McGraw-Hill.

Ho, F.F.-L., R.H. Kohler, and G.A. Ward

1972 Determination of Molar Substitution and Degree of Substitution of Hydroxypropyl Cellulose by Nuclear Magnetic Resonance Spectrometry. *Analytical Chemistry* 44(1):178–181.

Ho, F.F.-L., and D.W. Klosiewicz

1980 Proton Nuclear Magnetic Resonance Spectrometry for Determination of Substituents and Their Distribution in Carboxymethylcellulose. *Analytical Chemistry* 52:913–916.

Hodges, K.L., W.E. Kester, D.L. Weiderrich, and J.A. Grover

 1979 Determination of Alkoxyl Substitution in Cellulose Ethers by Zeisel-Gas Chromatography. *Analytical Chemistry* 51:2172-2176.

Hofenk-de Graaf, J.

 1981 Hydroxypropylcellulose, a Multipurpose Conservation Material. *ICOM Committee for Conservation*, 6th Triennial Meeting, Ottawa, 81/14/9:1-7.

Horie, C.V.

 1987 *Materials for Conservation*. London: Butterworths.

Jullander, I.

 1957 Water-Soluble Ethylhydroxyethylcellulose. *Industrial and Engineering Chemistry* 49:364–368.

Kato, T., M. Yokayama, and A. Takahashi

 1978 Melting Temperatures of Thermally Reversible Gels—IV. Methylcellulose-water Gels. *Colloid and Polymer Science* 256:15–21.

Kirk, R., D. Othmer, H. Mark, and A. Standen, eds.

 1968 Cellulose Ethers. In *Encyclopedia of Chemical Technology*. 2d ed. Vol. 4. New York: Interscience Publishers: 638–652.

Kloow, G.

 1982 CMC—A Diversified Thickening Agent. *Specialty Chemicals* 2(2):12–13.

Klop, W., and P. Kooiman

 1965 The Action of Celluloytic Enzymes on Substituted Celluloses. *Biochimica et Biophysica Acta* 99:102–120.

Klug, E.D.

 1952 U.S. Patent 2,610,180 issued September 5, 1952.

 1971 Some Properties of Water-Soluble Hydroxyalkyl Celluloses and Their Derivatives. *Journal of Polymer Science, Part C* 36:491–508.

Klug, E.D., D.P. Winquist, and C.A. Lewis

 1973 Studies on the Distribution of Substituents in Hydroxyethylcellulose. In *Water-Soluble Polymers*. N.M. Bikales, ed. New York: Plenum Press: 401–416.

Kozlov, M.P., O.P. Koz'mina, Ye. A. Plisko, and S.N. Danilov

 1963 Mechanism of Oxidation of Cellulose Ethers by Oxygen—XV. Effect of the Chain Length of the Substituent in Aliphatic Cellulose Ethers on the Rate of Their Oxidation. *Polymer Science USSR* 4:1089–1093.

Koz'mina, O.P.

1968 On the Mechanism of Thermo-oxidative Degradation of Cellulose Ethers. *Journal of Polymer Science, Part C* 16:4225–4240.

Koz'mina, O.P., V.I. Kurlyankina, V.A. Molotkov, and P.A. Slavetskaya

1965 The Synthesis and Oxidation of Ethylxylan. *Polymer Science USSR* 7:1057–1062.

Koz'mina, O.P., V.I. Kurlyankina, S. Zhdan-Pushkina, and V.A. Molotkov

1963 The Mechanism of Oxidation of Ethyl Cellulose Ethers by Oxygen—XII. The Synthesis and Oxidation of Ethyl Cellulose from Cellulose Labelled with Radiocarbon at Glucosidic Carbon Atom. *Polymer Science USSR* 4:1160–1164.

Kurlyankina, V.I., and O.P. Koz'mina

1963 Mechanism of the Oxidation of Cellulose Ethers by Oxygen—XIV. Ethylcellulose Oxidation. *Polymer Science USSR* 4:1498–1507.

Lee, D.-S., and A.S. Perlin

1982 ^{13}C-NMR Spectral and Related Studies on the Distribution of Substituents in O-(2-hydroxypropyl) Cellulose. *Carbohydrate Research* 106:1–19.

1983 Use of Methanolysis in the Characterization of O-(2-hydroxypropyl) Cellulose by ^{13}C-NMR Spectroscopy. *Carbohydrate Research* 124:172–175.

Lemieux, R.U., and C.B. Purves

1947 Quantitative Estimation as Acetic Acid of Acetyl, Ethylidene, Ethoxy, and a-Hydroxyethyl Groups. *Canadian Journal of Research* 25B:485–489.

McBurney, L.F.

1949 Oxidative Stability of Ethylcellulose. *Industrial and Engineering Chemistry* 41:1251–1256.

Mantell, C.L.

1985 *The Water Soluble Gums.* New York: Hafner Publishing Company. Reprint of 1947 edition.

Martinelli, G., and L.S. Santucci

1981 Resistenza e Stabilita della Carta. IX. Collatura con Gelatria, Alcool Polivinilico e Ossietilcellulosa; Venti Anni Dopo. *Bollettino dell Istituto Centrale per la Patalogia del Libro* 37:55.

Masschelein-Kleiner, L.

1971/ The Cleaning of Old Textiles. Preliminary Remarks. *Institut Royal du Patrimoine*
1972 *Artistique Bulletin* 13:215-222.

Masschelein-Kleiner, L., and F. Bergiers

 1984 Influence of Adhesives on the Conservation of Textiles. *Adhesives and Consolidants*, Paris Congress, 2–8 September, IIC Preprints: 70–73.

Meltzer, Y.L.

 1976 *Water-Soluble Resins and Polymers, Technology and Applications.* Park Ridge, N.J.: Noyes Data Corporation: 141.

Miller, M.L.

 1966 *The Structure of Polymers.* New York: Reinhold Publishing Corporation: 195–197.

Morgan, P.W.

 1946 Determination of Ethers and Esters of Ethylene Glycol. *Industrial Engineering Chemistry,* Analytical Edition, 18(8):500–504.

Niemela, K., and E. Sjöström

 1988 Identification of Products of Hydrolysis of Carboxymethylcellulose. *Carbohydrate Research* 180:45–52.

Parfondry, A., and A.S. Perlin

 1977 [13]C-NMR Spectroscopy of Cellulose Ethers. *Carbohydrate Research* 57:39–49.

Quinchon, J., and P. Lhoste

 1960 Tension Superficielle des Solutions Aqueuses d'Hydroxyethylcellulose. *Société de Chimie Biologique Bulletin* 503–504.

Raff, R.A.V., I.W. Herrick, and M.F. Adams

 1966 Archives Document Preservation I. *Northwest Science* 40:17–24. *AATA* 6B3-27.

Raff, R.A.V., M.F. Adams, and R.D. Ziegler

 1967 Archives Document Preservation II. *Northwest Science* 41:184-195. *AATA* 7-246.

Reese, E.T.

 1971 Biological Degradation of Cellulose Derivatives. *Industrial and Engineering Chemistry* 49:89–93.

Reuben, J.

 1984 Description and Analysis of (Hydroxyethyl)cellulose. *Macromolecules* 17:156–161.

Reuben, J., and H.T. Conner

 1983 Analysis of the Carbon-13 NMR. Spectrum of Hydrolysed O-(Carboxymethyl)cellulose: Monomer Composition and Substitution Patterns. *Carbohydrate Research* 115:1–13.

Sarkar, N.

 1979 Thermal Gelation Properties of Methoxyl and Hydroxypropyl Methylcellulose. *Journal of Applied Polymer Science* 24:1073–1087.

Schaffer, E.

 1978 Water Soluble Plastics in the Preservation of Artifacts Made of Cellulosic Materials. *ICOM Committee for Conservation*, 5th Triennial meeting, Zagreb, 78/3/7/1-16.

Seymor, R.B.

 1971 *Introduction to Polymer Chemistry*. New York: McGraw-Hill: 55–56.

Springle, W.R.

 1988 Liquifaction of Cellulosic Paint Thickeners. Part 1. Degradative Effects of Redox and Enzymic Contamination. *Journal of Oil and Colour Chemists Association* 71:34–38; (Part 2)71:109–113.

Stratta, J.J.

 1963 A Statistical Analysis of the Distribution of Substituents for Soluble and Insoluble Hydroxyethyl Cellulose. *Tappi Journal* 46:717–722.

Tappi Journal

 1952 *Protein and Synthetic Adhesives for Paper Coating* 9:156.

Thomson, G.

 1978 *The Museum Environment*. London: Butterworths.

Verdu, J., V. Bellenger, and M.O. Kleitz

 1984 Adhesives for the Consolidation of Textiles. *Adhesives and Consolidants*, Paris Congress, 2–8 September, IIC Preprints:64-69.

Vink, H.

 1963 Degradation of Some Polymers in Aqueous Solutions. *Die Makromolekulare Chemie* 67:105–123.

 1966 Degradation of Cellulose and Cellulose Derivatives by Acid Hydrolysis. *Die Makromolekulare Chemie* 94:1–14.

Whistler, R.L.

 1963 *Methods of Carbohydrate Chemistry*. Vol. 3: Cellulose. New York: Academic Press.

Whistler, R.L., and J.N. BeMiller, eds.

 1973 *Industrial Gums*, New York: Academic Press.

Winger, H.W., and R.D. Smith

 1970 *Deterioration and Preservation of Library Materials*. Chicago: University of Chicago Press: 62–63.

Wint, R.F., and K.G. Shaw

 1986 Nitrocellulose, Ethylcellulose and Water-Soluble Cellulose Ethers. In *Applied Polymer Science*. R.W. Tess and G. W. Pochlein, eds. American Chemical Society Symposium Series 285, Washington, D.C. 2d ed.

Wirick, M.G.

 1968a A Study of the Enzymic Degradation of CMC and Other Cellulose Ethers. *Journal of Polymer Science* 6(A-1):1965-1974.

 1968b Study of the Substitution Pattern of Hydroxyethylcellulose and Its Relationship to Enzymic Degradation. *Journal of Polymer Science* 6(A-1):1705–1718.

Wirick, M.G., and M.H. Waldman

 1970 Some Solution Properties of Fractionated Water-Soluble Hydroxypropylcellulose. *Journal of Applied Polymer Science* 14:579–597.

Yokota, H.

 1986 Alkalization Mechanism of Cellulose in Hydroxypropylcellulose Preparation Process. *Journal of Applied Polymer Science* 32:3423–3433.

Zappala-Plossi, M.

 1976/ Indagine su Adesivi per il Restauro di Documenti Cartacei. *Bollettino dell Istituto*
 1977 *Centrale per la Patalogia del Libro* 34:35–51.

Zappala-Plossi, M., and P. Crisostomi

 1981 Consolidation de la Couche Picturale des Eluminures avec Polymers Synthetiques Purs. *ICOM Committee for Conservation*, Ottawa, Paper 81/14/7.

Zappala-Plossi, M., and L. Santucci

 1969 Resistenza e Stabilita della Carta. VIII. Indagini Sulla Collatura. *Bollettino dell Istituto Centrale per la Patalogia del Libro* 28:97–117.

Supplementary References

Alexandrovich, M.K., O.P. Koz'mina, and L.G. Shekhunova
> 1963 Mechanism of the Oxidation of Cellulose Ethers by Oxygen–XII. Effect of
> Organometallic Complexes (Chelates) on the Oxidation Process. *Polymer Science
> USSR* 4:944.

Baird, G. S., and J.K. Speicher
> 1968 Carboxymethylcellulose. In *Water-Soluble Resins*. 2d ed. R.L. Davidson and
> M. Sittig, eds. New York: Van Nostrand Reinhold.

Balser, K., and K. Szeblikowski
> 1981 Cellulose Ethers—Present and Future Aspects of Utilization (in German).
> *Papier* 35:578–585.

Bartelmus, G., and R. Ketterer
> 1977 Analyses of Cellulose Ether Groups (in German). *Fresenius' Zeitschrift für
> Analystische Chemie* 286(3/4):161–190.

Borrmeister, B., H. Dautzenberg, and B. Phillip
> 1979 Determination of Methyl-Cellulose Substituent Distribution by Thin-Layer
> Chromatography. *Cellulose Chemistry and Technology* 13 (16):683–692.

Butler, R.W., and E.D. Klug
> 1980 Hydroxypropylcellulose. Chapter 13 in *Handbook of Water-Soluble Gums and
> Resins*. R.L. Davidson, ed. New York: McGraw-Hill.

Chateryee, P.K., and R.F. Schwenker, Jr.
> 1972 Characterization of Cellulose Derivatives by Differential Thermal Analysis.
> *Tappi* 55(1):111–115.

Davidson, R.L.
> 1980 *Handbook of Water Soluble Gums and Resins*. New York: Academic Press.

Donescu, D., K. Gosa, I. Diaconescu, N. Carp, and M. Mazare
> 1980 A Study of Degradation Reaction of Hydroxyethylcellulose in Presence of
> Potassium Persulfate. *Colloid and Polymer Science* 258:1363–1366.

Eastman, N.C., and J.K. Rose
> 1968 Hydroxyethylcellulose. In *Water-Soluble Resins*. 2d ed. R.L. Davidson and
> M. Sittig, eds. New York: Van Nostrand Reinhold.

Esterbauer, H., J. Schurz, and A. Wirtl

 1985 Viscometric and Colorimetric Studies on the Hydrolysis of Carboxymethyl-cellulose by Cellulose Enzymes. *Cellulose Chemistry and Technology* 19:341–355.

Focher, B., A. Marzetti, V. Sarto, P.L. Beltrame, and P. Carniti

 1984 Cellulosic Materials Structure and Enzymatic Hydrolysis Relationships. *Journal of Applied Polymer Science* 29:3329–3338.

Friese, P.

 1975 New Apparatus for Determining Methylhydroxyethyl- and Methylhydroxyethyl Cellulose and Related Compounds (in German). *Zeitschrift für Analytische Chemie* 274(4):291–299.

Hamacher, K., and H. Sahm

 1985 Characterization of Enzymatic Degradation Products of Carboxymethylcellulose by Gel Chromatography. *Carbohydrate Polymers* 5:319–327.

Irwin, V.L., and M.M. Williams

 1980 Viscosity Loss in Hydroxyethyl Cellulose Thickened Latex Paints Caused by Chemical Oxidants: Method of Detection. *Journal of Coatings Technology* 52:71–74.

Jullander, I.

 1954 Ethers, Cellulosiques Solubles Dans L'eau. *Chimie et Industrie* 71 (2):288–299.

 1955 Solubility Properties of Non-ionic Water-soluble Cellulose Ethers in Mixtures of Water and Alcohol. *Acta Chemica Scandinavica* 9 (10):1620–1633.

 1955 Water Solubility of Ethyl Cellulose. *Acta Chemica Scandinavica* 9:1291–1295.

Jullander, I., and K. Brune

 1950 Light Absorption Measurements on Turbid Solutions. *Acta Chemica Scandinavica* 4:870–877.

Kohn, R., and I. Furda

 1967 The Determination of a Carboxyl Group Distribution Pattern in Linear Polysaccharides. *Die Makromolekulare Chemie* 102:259–262.

Kohne, H., Jr.

 1959 Use of CMC as a Coating Adhesive. *Tappi* 42 (4):294–298.

Krause, P., G. Bartelmus, and H. Wurm

 1975 Determination of Average Degree of Substitution of Hydroxyethylcellulose (in German). *Deutsche Farben-Zeitschrift* 29(8):337–340.

Kurlyankina, V.I., A.B. Polyak, and O.P. Koz'mina

　　1960　Investigation of Mechanism of Oxygen Oxidation of Cellulose Ethers—VII. *Polymer Science USSR* 2 (12):1850–1853.

Lindberg, B., U. Lindquist, and O. Stenberg

　　1987　Distribution of Substituents in O-(2-hydroxyethyl)cellulose. *Carbohydrate Research* 170:207–214.

Makes, F.

　　1984　Enzymatic Removal of Lining Paste from Paintings. *ICOM Committee for Conservation*, 7th Triennial Meeting, Copenhagen, 10–14 September, Preprints. Working Group: Structural Restoration of Paintings on Canvas, Vol. I, 84/2/26-30.

Miller, T.G., and R.J. Hronek

　　1985　Determination of Carboxymethyl Substitution in Cellulose Ethers by Zeisel Reaction and Liquid Chromatography. *Analytical Chemistry* 57:2091–2093.

Mironov, D.P., V.N. Mironova, and I.V. Parfenov

　　1975　Determination of Hydroxyl Groups in Highly Substituted Cellulose Ethers. *Zavodskaya Laboratoriva* 41 (6):694–695.

Powell, G.M.

　　1980　Hydroxyethylcellulose. In *Handbook of Water-Soluble Gums and Resins*. R.L. Davidson, ed. New York: McGraw-Hill.

Ramnas, O., and O. Samuelson

　　1968　Determination of the Substituents in Hydroxyethyl Cellulose. *Svensk Papperstidning* 71:674–678.

Ravines, P., N. Indictor, and D.M. Evetts

　　1989　Methylcellulose as an impregnating agent for use in paper conservation. *Restaurator* 10:32–46.

Reuben, J.

　　1986　Description and Analysis of Cellulose Ethers. In *Cellulose Structure, Modification and Hydrolysis*, R.A. Young and R.M. Rowell, eds. New York: Wiley-Interscience.

Rosell, K.G.

　　1988　Distribution of Substituents in O-ethylcellulose. *Carbohydrate Research* 177:289–298.

Sachse, K., and K. Metzner

1982 Substitution in Cellulose Ethers. Part I. Determination of Glucose Units According to Number and Type of Ether Substituents Using Quantitative Thin-Layer Chromatography. *Analyst* 107:53–60.

Scheffel, K.G.

1968 Methyl- and Hydroxy Propyl Methyl-Cellulose Derivatives. In *Water-Soluble Resins*. 2d ed. R.L. Davidson and M. Sittig, eds. New York: Van Nostrand Reinhold.

Shah, N.H., J.H. Lazarus, P.R. Sheth, and C.I. Jarowski

1981 Carboxymethylcellulose: Effect of Degree of Polymerization and Substitution on Tablet Disintegration and Dissolution. *Journal of Pharmaceutical Sciences* 70 (6):611–613.

St. John Manley, R.

1956 Properties of Ethyl Hydroxyethyl Cellulose Molecules in Solution. *Arkiv-for Kemi* 9(44):519–581.

Utz-Hellmoth, F.

1985 Cellulose Ethers—Synthesis, Application and Analytical Aspects. In *Cellulose and Its Derivatives*. J.F. Kennedy, G.O. Phillips, D.J. Wedlock, and D.A. Williams. New York: Halsted Press.

Wirick, M.G., and J.H. Elliott

1973 A One-point Intrinsic Viscosity Method for Hydroxyethylcellulose, Hydroxypropylcellulose, and Sodium Carboxymethylcellulose. *Journal of Applied Polymer Science* 17:2867–2875.

Index

N

in organic solvents 20
stages of 20
solubility-temperature relationships 29
solution viscosity
effect of pH on 23
solutions
rheological behavior of 33
spectrophotometric reflectance measurements 59
Springle, W.R. 114
stability
defined 37
improving "unstable" or "intermediate"
materials 40
intermediate class 42, 47
long-term 37–38, 40
material reference standards for 38, 43
natural gums 47
of alkoxyalkyl ethers 63
of alkyl ethers 63
of carboxymethylcellulose 47, 55, 71
of cellulose ether solutions 114
of cellulose ethers 48, 88
of ethylcellulose 47, 55
of ethylhydroxyethylcellulose 47, 55, 94
of hydroxyethylcellulose 47, 55, 93
of hydroxypropylcellulose 47, 55, 94
of hydroxypropylmethylcellulose 89
of methylcellulose 47, 55, 71, 94
of poly(vinylalcohol) 47
of poly(vinylpyrrolidone) 47
of proprietary products 40, 55
of solutions 114
photochemical 37–38, 42
possible influence of molecular weight 51
ranking in 37, 88, 96
standards of 37, 40
thermal 38, 41, 54–55
stability of polymers
thermal stability, material reference standard 38
classifications 42, 44
conclusions of National Museum
Act testing 51, 54
discoloration, measurement of 45
material-standard "controls" 43–44, 50
minimum exposure to light during tests 43
proposed tests 43
standards used in this investigation 40
test for ethylcellulose 44
testing individual products 51
tests for 44
viscosity loss 45
weight loss 45
stable viscosity 23
starch 10
compared to carboxymethylcellulose 71
statistical analysis

variation of DS and side-length chain of MS 120
Stratta, J.J. 119–123
structure
of cellulose 9–10
of various celluloses 10, 16
substitution
See degree of
sunlight
resistance to 23
surface tension 27

T

temporary use, class T 37
testing, need for 40, 55, 95
thermal aging 41–42, 72
effect of humidity on 42, 76
effect on reflectance of powdered polymers 51
of bulk powders 63, 87
of cellulose ethers 47, 51, 68, 73, 79
of CMC 51
of EHEC-WS 51
of filter paper 6, 50, 68
of HPL 51
of hydroxyethylcellulose (HEC) 51, 87, 93
of methylcellulose (MC) 5, 51, 88
of Natrosol H 87
of Natrosol M 87
of newsprint 51
of rag paper 51
of Tylose 5
thermal decomposition
of peroxides 78, 115
thermal stability 38, 42, 63, 93
classifications 41, 44
effect of light on 43
loss of 22
of cellulose ether solutions 114
proposed test of 43
thermal sterilization
of cellulose ether solutions 114
thixotropy
defined 33, 108
of solutions 111
Thomson, G. 42, 93
thymol
as a fungus and mold inhibitor 114
as a preservative 103
Tylose 5
manufacturer 17, 107
yellowing of under accelerated aging 63

U

ultraviolet absorbers
improving "unstable" materials 40

Credits

Cover design: Joe Molloy

Text design, coordination, and supervision: Irina Averkieff

Typography: Ventura/Adobe Postscript Palatino

Printing: Westland Graphics, Burbank, California

Figures 2.7, 2.9, 2.10, 2.11, 2.13, 2.14 are reproduced, with permission, from an article by E.D. Klug titled, "Some Properties of Water-Soluble Hydroxyalkyl Celluloses and Their Derivatives" appearing in *Journal of Applied Polymer Science* 36: 491–508. ©1971 John Wiley & Sons.

Figures G1–G5 are reproduced, with permission, from an article by J.J. Stratta titled, "A Statistical Analysis of the Distribution of Substituents for Soluble and Insoluble Hydroxyethyl Cellulose" in *Tappi Journal* 46: 717–722. ©1963.

Figure H1 is adapted, with permisssion, from an article by C.J. Clemett titled "Determination of the Molar Substitution of Cellulose Ethers Using Proton Magnetic Resonance" in *Analytical Chemisty* 45 (1): 186–188, Figure 1. ©1973 American Chemical Society.

Figure H2 is adapted, with permission, from an article by F.F.-L. Ho, R.H. Kohler, and G.A. Ward titled, "Determination of Molar Substitition of Hydroxypropyl Cellulose by Nuclear Magnetic Resonance Spectrometry" in *Analytical Chemistry* 44 (1): 178–181, Figure 1. ©1972 American Chemical Society.

Figure H3 is adapted, with permission, from an article by F.F.-L. Ho and D.W. Klosiewicz titled, "Proton Magnetic Resonance Spectrometry for Determination of Substituents and Their Distribution in Carboxymethylcellulose" in *Analytical Chemistry* 52: 913–916, Figure 5. ©1980 American Chemical Society.